BLACK ATLANTIC

BLACK ATLANTIC
POWER PEOPLE RESISTANCE

Edited by **Victoria Avery**
and **Jake Subryan Richards**

with contributions by

Jack Ashby · Victoria Avery · Isaac Ayamba · Jacqueline Bishop
Justin M. Brown · Peggy Brunache · Sokari Douglas Camp · Esther Chadwick
Isabelle Charmantier · Alissandra Cummins · Benjamina Efua Dadzie
Sandra De Rycker · Lauren Gardiner · Grada Kilomba · Julie Chun Kim
Wanja Kimani · Jimena Lobo Guerrero Arenas · Brenda Locke · Chiedza Mhondoro
Mary-Ann Middelkoop · Mathelinda Nabugodi · Joshua Nall · Alexis Peskine
William Pettigrew · Keith Piper · Habda Rashid · Jake Subryan Richards
Edwin Rose · Eleanor Stephenson · Henrietta Ward

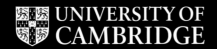

PHILIP WILSON PUBLISHERS
Bloomsbury Publishing Plc
50 Bedford Square, London, wc1b 3dp, UK
29 Earlsfort Terrace, Dublin 2, Ireland

BLOOMSBURY, PHILIP WILSON PUBLISHERS and the PHILIP WILSON
logo are trademarks of Bloomsbury Publishing Plc

First published in Great Britain in 2023

Published on the occasion of the exhibition:
Black Atlantic: Power, People, Resistance
The Fitzwilliam Museum, Cambridge, 8 September 2023–7 January 2024

A catalogue record for this book is available from the British Library
Library of Congress Cataloguing-in-Publication data has been applied for

ISBN: 978 1 78130 123 4

2 4 6 8 10 9 7 5 3 1

Designed and typeset in Roc and Macklin
Printed and bound in Türkiye by Elma Printing & Finishing

To find out more about our authors and books visit www.bloomsbury.com
and sign up for our newsletters

Contents

Content notice
This book is about enslavement and racism. It includes objects linked to violence and exploitation. To call attention to the historic and ongoing racialised inequalities, the collective terms 'Black' and 'Indigenous' are capitalised throughout while 'white' is not.

Foreword

Luke Syson,
Director and Marlay Curator,
The Fitzwilliam Museum

On the cover of this book, and included in this exhibition, is a striking drawing by Barbara Walker which confronts and addresses the suppression and erasure of Black lives within European visual culture. Looking again at historic portraits, especially those made during the peak period of the trans-atlantic slave trade, in which Black figures were almost always marginalised, scarcely noticed in the titles such portraits received, Walker brilliantly reworks them. Here, a Black man, tenderly, exquisitely drawn in graphite, now has a prominence, in contrast to the embossed white figures who almost disappear before our eyes. He has become a full protagonist, a person with an assumed life history, an individual identity.

In drawings like this, Walker turns the viewer into a kind of detective, stimulating lines of enquiry. Who in the past were placed centre stage? Who were given support roles, or were pushed into the background? Whose names do we know, and who were anonymised, forgotten? Who, in other words, had power enough to ensure their stories were told, and, even centuries later, how? It was a great privilege last year to talk to the artist about how she sees portraits by European artists of the past in which Black 'servants' semi-appear, about her own experience growing up British in a Jamaican family in Birmingham, and about how issues of race, class, power, gender, representation and belonging have shaped her practice. Her artistic-archival investigations powerfully centre the truths and values of Black presences, past and present, and help us arrive at a more complete art history, one which stimulates new and collective forms of public knowledge and understanding.

The writing of history has always been about choice and omission, about the stories a dominant culture emphasises and those it neglects. Discoveries in archives, or of new images and artefacts, can be immensely exciting. But their rescue from forgotten places will depend on what the historian is looking for, upon the already determined destination of the (re)search, and on a prevailing consensus about what is important or inter-esting and what is considered unworthy of attention. Similarly, the analysis of works of art and material culture has tradition-ally relied on a rather narrow set of questions that has limited their whole, complex meanings. Even when historical context is brought into play — understanding that an image or artefact is the product of the moment it was made — usually the beliefs and experiences of only certain people who were part of that moment have been considered. This neglect is less often, I suspect, about deliberate erasure than an ingrained blinkered-ness, an ignoring that has been entrenched across the centuries. The institutions which give authority to those who write and teach history and art history today were often founded or funded by the people whose power and wealth derived from their involvement in the trade in human beings and in

commodities whose production depended on enslaved labour. In Britain — not least in Cambridge — our histories of people, and the things they did and thought and made in the past, have therefore been shaped by attitudes that are only now being recognised as fundamentally much the same deep-seated assumptions of privilege.

This obliviousness, these prejudices and unconscious biases, are part of the history of history. Black lives are represented in numerous legal records, literature, texts, artefacts, and works of art from across Europe. Historically many of these people were enslaved or worked as servants in the West, but others were artists, writers, composers, politicians, landowners, or nobles like the 1st Duke of Florence, Alessandro de' Medici. Just like the Black figures in the paintings Walker has studied so carefully, these peoples' lives have been insufficiently considered, their full identities emerging only now. And this collective obliviousness, what we have forgotten and why, is as true at the Fitzwilliam Museum and Cambridge as in any other part of our country.

The Fitzwilliam was founded at a time when British global trading was inextricably linked to the appropriation of land, the establishment of colonies and the enslavement of people across the terrain we now call the Black Atlantic: Africa, Europe, the Caribbean, North and South America. The 7th Viscount Fitzwilliam, educated at Cambridge, left his collection to the University and a large sum of money for the founding, building and endowment of the University Museum. His money had come in substantial part from his Anglo-Dutch merchant grandfather's trade in enslaved people, and his active investment in Britain's slave-trading companies, including the Royal African Company and the South Sea Company. His collection shows that Fitzwilliam's sense of what was beautiful and important was connected to assumptions about the superiority of Europeans and consequently of the art they made: Dutch and Italian paintings and prints, music by composers like George Frederick Handel and medieval European manuscripts. This set the collecting agenda for the Museum for the two centuries to come, and as the Museum's collection grew, it became ever more focused on art from those parts of the world that Fitzwilliam's intellectual and artistic heirs considered 'civilised': Dynastic Egypt, the parts of Asia with which Europe traded as 'equals', and of course, Western Europe. Even Sydney Cockerell, recognised as one of the most acquisitive of directors in the twentieth century, banished any pieces of African art that the Fitzwilliam had acquired to the University's Museum of Archaeology and Anthropology. And, until quite recently, it did not occur to Cambridge historians and art historians, perhaps sharing the perspectives of those whose art and actions they were reviewing, to contest established collecting modes or to

ensure and validate a wider range of perspectives. People and places have therefore been left out, becoming essentially unrepresented in the Museum's collection except by historic dehumanising and demeaning objects and images made to shape and reinforce societal attitudes of prejudice and racism. Forms of historical resistance to oppression by those oppressed have been insufficiently recognised; and cumulatively, these suppressions, silences and erasures have been scarring for those whose ancestors were affected and fracturing for us all.

What this book and accompanying exhibition show us is that visual and material culture are integral in shaping social narratives that can be used to justify and reinforce biases and prejudices with devastating human consequences. Contemporary art that responds to these historic pieces can help us see them more clearly, exploring or confronting our past in such a way as to help us construct our futures. As individuals, as museums and as a society, it is incumbent upon us to understand our whole histories so as to recognise the living legacies of racism that have become baked into our systems, structures, practices and approaches. As a museum, we can tell and reflect on these histories, becoming spaces for conversation and sharing knowledge, and for examining a plethora of evidence, so as to play a significant part in increasing comprehension and reframing attitudes and to boost and sustain real and lasting change. The Fitzwilliam must listen and be open to opinions and perspectives that challenge inherent or longstanding cultures and systems, and we must give space for more representative histories that look towards a more just future. These won't always be easy conversations to have; we won't always get things right, and a publication and exhibition like these, for all of us at the Museum, are only the start.

As we embark upon our own journey towards a more equitable Fitzwilliam, fully acknowledging we cannot take it on our own, I join with the curators in thanking representatives of our communities in Cambridge and Cambridgeshire for their insights and their ambitions for this project. I would like to express my gratitude to all the contemporary artists whose works are shown here. This book and exhibition, and those to follow, represent an enormous collective effort on the part of colleagues across the Fitzwilliam, the University of Cambridge Museums consortium and beyond. We are deeply indebted to them all, as we are to the lenders to the exhibition and to the authors of this book. Many of those individuals are named within the curatorial acknowledgments. But there are two that they necessarily omit. I am grateful to the Lead Curator of this exhibition, Jake Subryan Richards, from whom I have learned so much while we have worked together, for all that he has brought to the Fitzwilliam through this project, and to the London School of Economics for ensuring that this collaboration could

take place. The exhibition would not be happening without his sterling curatorial partnership with Victoria Avery, not least in her brilliant work leading the editing of this volume. Our next legacies-related exhibition, opening in February 2025, will feature her research on the Cambridgeshire family and network of Abolitionist Olaudah Equiano. It will take us back to Haiti to explore resistance by those who were enslaved, as well as the efforts as ally by Cambridge-educated Thomas Clarkson both in Britain and the Caribbean. Barbara Walker's extraordinary drawing, with which I began, has been purchased for the Fitzwilliam collection, which will continue to grow so that our research and presentations become richer, more complex and more representative.

Most important of all, we will ensure that our work is truly collaborative, not just in seeking advice, but by endeavouring to join conversations and efforts led by others, not least in West Africa and the Caribbean. This is only the beginning. We will continue to listen. And we will continue to act.

Black Atlantic: definition

'Black Atlantic' refers to the creation and transmission of cultures by people of the African diaspora as they confronted Atlantic enslavement and empire and their pernicious afterlives.

It was first used by Robert Farris Thompson in his book *Flash of the Spirit: African and Afro-American Art and Philosophy* (1983) to describe the shared artistic practices and belief systems among people of the African diaspora. Paul Gilroy developed the concept in *The Black Atlantic: Modernity and Double Consciousness* (1993). He argued that through the movement of people, ideas and material goods across the Atlantic, Black cultures transcended the boundaries of any single place. In this sense, the Black Atlantic represents a rich conceptual space for limitless imagination, transmission and exchange.

This book and associated exhibition, as well as the Fitzwilliam's future series of related exhibitions, explore the history of the Black Atlantic and the powerful Black Atlantic political visions that have shaped — and which continue to shape — our world.

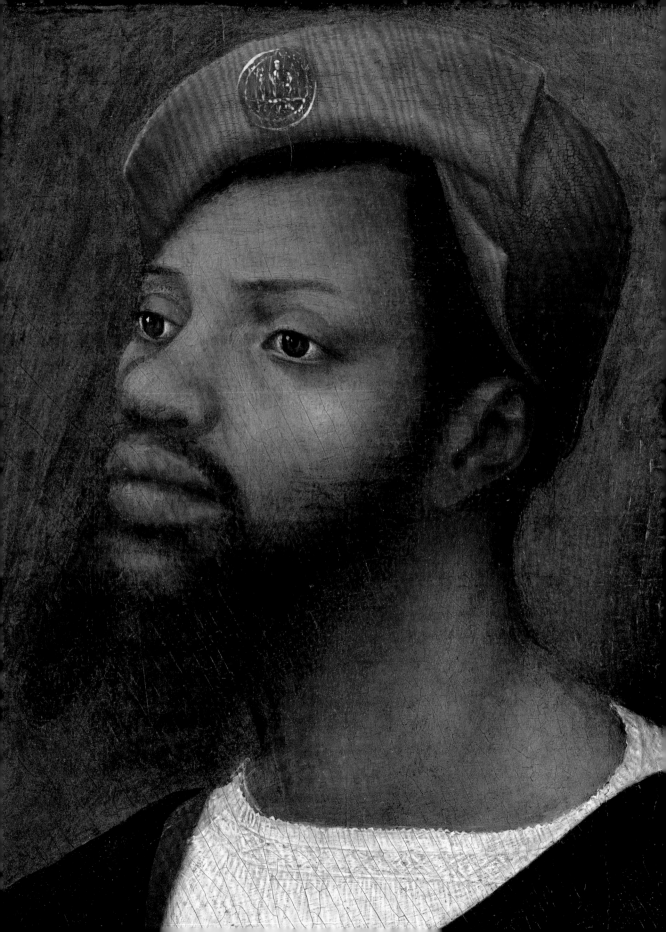

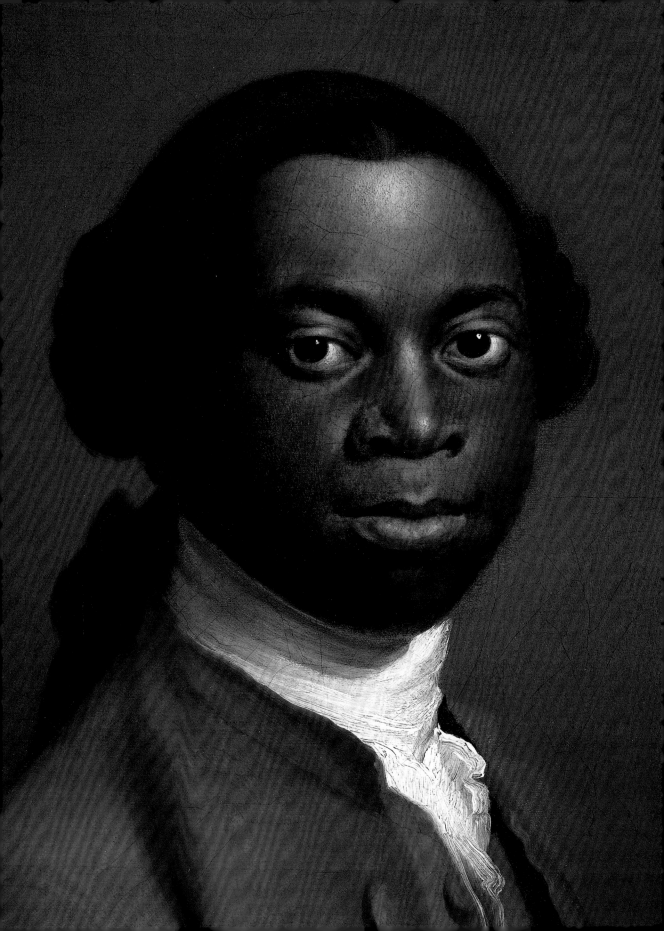

Introduction

We all tell stories. Stories help us make sense of our world. They help us distinguish fact from fiction and history from myth.

This story is about what happened when European empires colonised the Americas and transported more than 12.5 million people from Africa to these colonies as slaves between 1400 and 1900. Colonial enslavement affected every part of the Atlantic world, including Cambridge. Asking new questions about how it shaped the University of Cambridge Museums has led to discoveries about the objects they hold, the people who collected them and how their stories connect Cambridge to global history.

These objects reveal the wealth that Cambridge drew, and continues to draw, from Atlantic enslavement. They also demonstrate that people have always resisted enslavement. By resisting colonial slavery, people produced new cultures that continue to shape our world. These cultures are known as the Black Atlantic.

By rethinking our shared histories, and looking again through the lens of contemporary artists, we can create a better story: one of repair and freedom.

Detail of 1

Who gets remembered and why?

1

Unrecorded maker, England
Portrait of a Man in a Red Suit
*c.*1740—80 · oil on canvas

Royal Albert Memorial Museum & Art Gallery,
Exeter City Council: 14/1943 · donated
by Percy Moore Turner, 1943 · photo:
© Royal Albert Memorial Museum &
Art Gallery, Exeter City Council

In Spring 2023, this painting was
renamed by Exeter curators, revising
earlier suggestions that it represented
one of two famous eighteenth-century
Black African commentators on enslave-
ment, Olaudah Equiano or Ignatius
Sancho. Research continues into the
sitter's identity: was he a free man,
a valued servant, or neither? Where,
when and why was he painted?

On this spread are two people connected by the history
that created the Black Atlantic. Both paintings were made in
England in the second half of the eighteenth century by artists
who skilfully suggest an individual, living presence.

The name of the Black man has been lost or was never recorded.
An outdated interpretation suggested he was Olaudah Equiano
(*c.*1745—1797), a prominent writer and abolitionist who got
married and lived in Cambridgeshire towards the end of his
life. But the fact that after decades of research his identity still
remains unknown highlights the ways in which the dominant
culture in Britain has failed to record Black sitters' identities
and histories.

2

Joseph Wright of Derby
1734–1797
Portrait of The Hon.
Richard Fitzwilliam, Future
7th Viscount Fitzwilliam
of Merrion 1745–1816
1764 · oil on canvas

Fitzwilliam Museum, University of
Cambridge: 1 · given by Robert Fitzwilliam
Hallifax, 1819 · photo: © The Fitzwilliam
Museum, Cambridge

In 1764, sporting the gold nobleman-
status gown of Trinity Hall, Cambridge,
19-year-old Richard Fitzwilliam had
his MA graduation portrait painted.
Commissioned by his college tutor
Samuel Hallifax, the portrait was
inherited by Hallifax's son, Robert
Fitzwilliam Hallifax — so-called
because Fitzwilliam was his godfather
— and given to the Museum in 1819.
The painting entered the collection
as object number one.

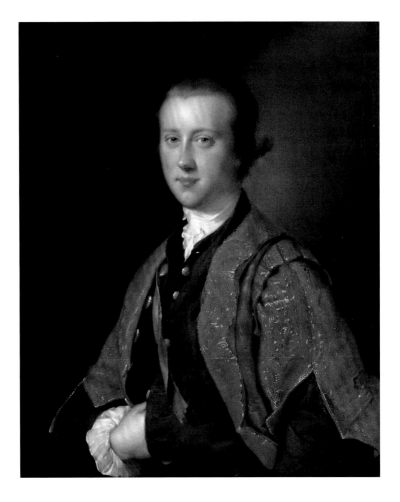

The name of the white man is Richard Fitzwilliam, future 7th Viscount (1745–1816). At his death, Fitzwilliam bequeathed the enormous sum of £100,000 together with his substantial library and art collection to the University of Cambridge, where he had studied. This bequest funded the building of the Fitzwilliam Museum named in his honour, and still supports it today. Fitzwilliam's collection became the Founder's Bequest. At the time, the fact that Fitzwilliam's riches came from a grandfather made wealthy in part by the transatlantic trade in enslaved African people was not deemed problematic.

Institutions choose which facts they record and the stories they tell. This book tells for the first time across the University of Cambridge Museums a more complete story.

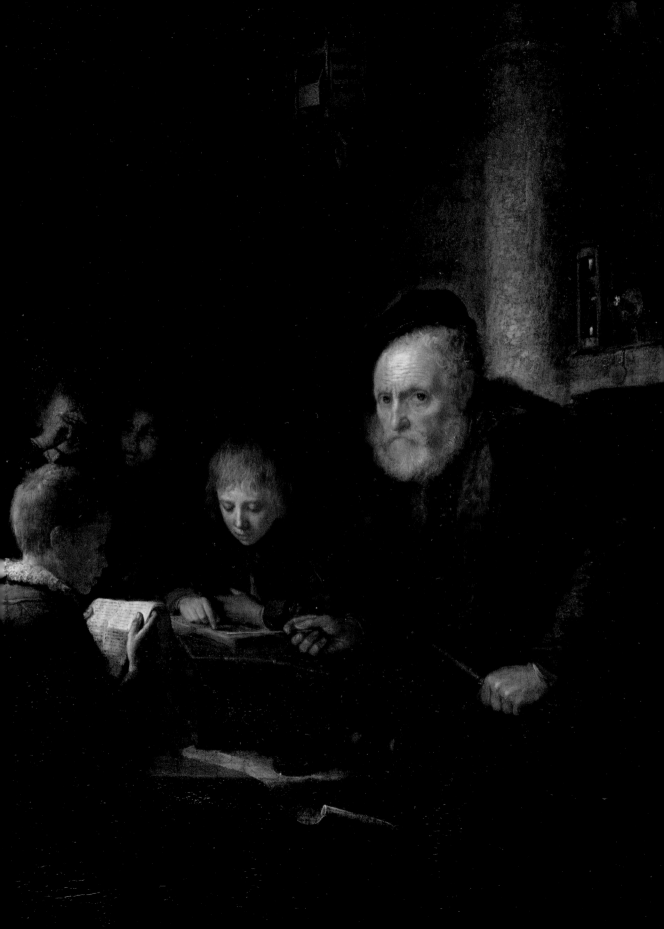

Reimagining the Dutch connection: the Fitzwilliam Museum in a world of Atlantic enslavement and empire[1]

Jake Subryan Richards

1. Funding for a research trip to the Nether-
lands came from the British Art Network
Emerging Curators Group. My thanks to
Sarah Turner, Mark Hannam, Martin Myrone,
Bob Gelsthorpe, Cherry Leonardi, Naomi
Carlisle, Matt Turner, Zirwat Chowdhury,
Sarah Thomas and Jacqui McIntosh for
comments on drafts of this essay. I am grate-
ful to the two anonymous peer reviewers for
their constructive comments. I also thank the
audience who gave me feedback on a paper
related to this essay that I presented at the
Paul Mellon Centre in October 2022.
2. See also Gerrit Dou, *De avondschool*
(*c.*1660–5), Rijksmuseum, Amsterdam:
SK·A-87, which features girls as well as boys
as pupils. Wayne Franits, *Dutch Seventeenth-
Century Genre Painting: Its Stylistic and
Thematic Evolution* (New Haven, CT and
London, 2004), chapter 8.
3. South Sea Company, Minutes of the Court
of Directors, 7 September 1711–1 August 1712,
Add MSS 25494, British Library (hereafter
BL), London 23 July 1712, fol. 249.
4. [Christopher Cock], *A Catalogue of the
Genuine Collection of Pictures of His Grace
James Duke of Chandos, Lately Deceas'd:
Consisting of Great Variety of Valuable
Pictures, by the Most Celebrated Italian,
French and Flemish Masters [...] Which Will
Be Sold by Auction, by Mr. Cock* (s.l., 1747), p. 4.

It is dark outside, perhaps early in the morning or late at
night, and so the boys must study by candlelight [3]. Their
stern schoolmaster stands in the light, supervising their work.
The boys are arranged in a recessional line, fading into the
darkness behind him. One boy, near the back of the room, is
crying. Would this lesson ever end? As the schoolmaster locks
eyes with the viewer, he makes a bargain with us: knowledge
comes at the price of hard work. The owners of this painting
appreciated the world of industrious Dutch burgher education
created by Gerrit Dou's schoolmaster.[2] William, Prince of
Orange, and the highest executive official (stadtholder) of the
Dutch Republic, displayed the painting at his Het Loo Palace
in the Netherlands. In 1689, he became King William III of
England. The painting was sold in 1713, and at some point the
painting entered the collection of James Brydges, first duke
of Chandos. From 1705, Chandos was paymaster-general of
the British armed forces abroad. He was also a commissioner
of and investor in the South Sea Company (SSC), a British
joint-stock company designed to manage the national debt
and which participated in the transatlantic trade in enslaved
African people.[3] In 1747, a former director of the South Sea
Company, the Anglo-Dutchman Matthew Decker, bought
The Schoolmaster at auction from Chandos's indebted estate.[4]

Eventually, Decker's art collection and vast wealth including
from his SSC investments passed to his grandson, Richard, 7th
Viscount Fitzwilliam. Fitzwilliam also at some point acquired
a second source of investment in the SSC: New South Sea
Company Annuities, which restructured the existing capital
in the Company in 1733. The SSC continued to participate in
slave-trading during the 1730s. In 1816, Fitzwilliam died. In his
will, Fitzwilliam bequeathed to 'the Chancellor, Masters and

Scholars of the University of Cambridge all my capital stock in the New South Sea Annuities' plus his collection of artworks, books and manuscripts. He wished that the dividends and proceeds from the annuities would build 'a good, substantial and convenient Museum, Repository or other Building' for preserving and growing the collections.[5] Decker's art collection, including *The Schoolmaster*, and two sources of profit in SSC investments formed a major part of the founding of the Fitzwilliam Museum.

The journey of Dou's *Schoolmaster* from William of Orange to Matthew Decker to the Fitzwilliam Museum is at first glance unexpected — and intriguing. Somehow, people like Decker, and institutions like the South Sea Company, had come to form a shared world between the Restoration of the Stuart monarchy in 1660 and the founding of the Fitzwilliam Museum in 1816. There was a 'Dutch connection' between the seventeenth-century United Provinces and a university museum in a landlocked city in the East of England, but its full history has yet to be told.[6] New research, presented in this essay for the first time, reveals the origins of the wealth that derived from this connection, and how it went on to shape the visual and material culture of the Fitzwilliam Museum. The essay concludes by outlining how we might collectively think about the consequential bonds of history and power among everyone affected by this Anglo-Dutch world that stretched between Europe, Africa and the Americas.

Exploring these issues has required research that weaves together the analysis of iconography with that of ownership and wealth. It builds on previous findings about the founding of the Museum.[7] The research needed a novel approach that could trace how Dutch art, Dutch commercial practices and Anglo-Dutch finances produced the Fitzwilliam Museum's Founding Bequest. Research began by exploring the wealth of the Founding Bequest through the Fitzwilliam Museum's records of its collections and related materials in the archives of the University of Cambridge, Hoare's Bank and the National Archives of the United Kingdom. I then analysed how this wealth shaped material and visual culture by situating the Fitzwilliam Museum in Anglo-Dutch history. An array of visual sources and secondary literature helps to reconstruct this history. The outcome of this approach is that it encourages a rethinking of the role of institutions in producing knowledge and conserving our collective heritage. It invites assessment of the long-term consequences of the Dutch connection. Dou's *Schoolmaster* enthralled William, Chandos and Decker, reflecting their political power, financial interests and cultural outlook. The painting's owners combined military conquest with transoceanic commerce, thereby helping to expand Atlantic racialised enslavement.

5. Will of The Right Honorable Richard Fitzwilliam Viscount Fitzwilliam of Ireland, proved 22 February 1816, PROB 11/1577/416, The National Archives of the United Kingdom, fol. 7. I have modernised some orthography and punctuation when quoting from primary sources to help clarify meaning.
6. Paul Woudhuysen (ed.), *The Dutch Connection: The Founding of the Fitzwilliam Museum* (Cambridge, 1988).
7. The role of Decker's wealth from enslavement and colonial trades, and its connections to the founding of the Fitzwilliam Museum, are noted in Charles Wilson, 'Introduction: The Dutch Connection', in Woudhuysen (ed.) 1988, p. 14; *University of Cambridge Advisory Group on Legacies of Enslavement: Final Report* (Cambridge, 2022), p. 18.

4

**Studio of Rembrandt
Harmensz van Rijn**
1606—1669
*Portrait of a Man in
Military Costume* · 1650
oil on panel made of South
American woods capomo
and marmelero

The creation of the Anglo-Dutch world

Between the Dutch Republic's first break from the Spanish
Empire in 1566 and the global age of revolutions in the later
eighteenth century, the world of Atlantic enslavement
expanded and deepened dramatically. In South and Central
America, enslaved people worked in silver and gold mines.
In South America, the Caribbean and North America, they
produced major commodities such as sugar, indigo and tobacco
on plantations. Consumers in Europe had access to these slave-
produced goods. Merchants, scholars and statesmen devised
new financial instruments such as maritime insurance to
manage the risks involved in transoceanic imperial commerce.
In the sixteenth century, the Spanish and Portuguese were the
dominant imperial powers. By supplanting these empires, in
the seventeenth century the Dutch Republic's empire became
the leading force in this world.[8] The Dutch possessed trading
forts on the West African coast for the purchase and trans-
shipment of captive people. The Dutch West India Company
(Westindische Compagnie, WIC), supported by the Dutch state,
established colonies with enslaved populations in Brazil, in the

8. Julie Hochstrasser, *Still Life and Trade in
the Dutch Golden Age* (New Haven, CT, 2007);
Eveline Sint Nicolaas and Valika Smeulders
(eds), *Slavernij: het verhaal van João, Wally,
Oopjen, Paulus, Van Bengalen, Surapati,
Sapali, Tula, Dirk, Lohkay* (Amsterdam, 2021).

Caribbean islands of Aruba, Bonaire, Curaçao, Sint Maarten, Saba and Sint Eustatius, and in New Netherland, a colony in North America. The WIC also participated in the colonisation of Suriname. In the late seventeenth century, Britain imported many Dutch techniques such as joint-stock companies, public debt to finance large naval and military forces, and even a Dutch monarch — William III. The British surpassed the Dutch as the preeminent Atlantic empire. By using public debt, successive British governments managed to expand the state's capacity to wage war against enemies in Europe and around the world. Britain's war-making capacity resulted in dominance of maritime trading routes and the conquest of new territorial possessions in the Americas. Instead of separate national stories, these importations and exchanges produced a shared Anglo-Dutch Atlantic world, with the two empires connected by the flow of people, capital, goods and culture.[9]

The legacies of Dutch slaveholding in artistic production were systemic, as a selection of artworks from the Fitzwilliam Museum reveals. One legacy was material. Enslaved indigenous and African workers cut trees and transported them from the interior of Dutch Brazil to the coast. By 1650, Rembrandt's studio had obtained some of these woods, where they formed the panel for the *Portrait of a Man in Military Costume* [4].[10] The man adopts the pose of the 'Renaissance elbow', which artists used to convey a masculine desire to protect and control.[11] Another legacy was representational. Rembrandt depicted Black people with sensitivity throughout his career, but we need to look beyond the Fitzwilliam Museum's collections to see this brilliance. In his study *Two African Men* [5] of 1661, which is in the Mauritshuis in The Hague, Rembrandt dramatically reworks the Renaissance elbow.[12] Here, the right-hand man's elbow becomes a support for the left-hand man's head, as they act out a scene in costume. Rembrandt represents the fullness of the friendship between the two men in a way that would almost completely disappear from European art until the second half of the twentieth century.[13] When placed alongside each other, the *Man in Military Costume* and *Two African Men* do not just have elbows in common. This pair of pictures also suggests how the system of Atlantic enslavement extracted raw materials from the Americas and narrowed the ways in which artists and viewers in Europe could represent Black people.

Many material legacies of slavery took their places through illustration within representation. Dou, who painted *The Schoolmaster*, framed his small canvases with archways, tables and windows. These framing devices set scenes in which people consumed the new goods that imperial networks supplied. In *c*.1650, Dou painted himself as a gentleman smoking, which was later turned into a print by Aert Schouman [6].[14] Here, the man relaxes by an open window as though he has just pulled

9. Harold J. Cook, *Matters of Exchange: Commerce, Medicine, and Science in the Dutch Golden Age* (New Haven, CT; London, 2008); Lisa Jardine, *Going Dutch: How England Plundered Holland's Glory* (London, 2009).

10. For Rembrandt's panel, see Woudhuysen (ed.) 1988, p. 46. Rembrandt used panels composed of tropical woods including mahogany and capomo for other paintings. See Peter Klein, 'Table of Dendrochronological Data', in Ernst van de Wetering et al., *A Corpus of Rembrandt Paintings. IV The Self-Portraits* (Dordrecht, 2005), pp. 648—58.

11. On the 'Renaissance elbow', see Joaneath Spicer, 'The Renaissance Elbow', in Jan N. Bremmer and Herman Roodenburg (eds), *A Cultural History of Gesture* (Ithaca, NY, 1991), pp. 84—128; and on posture more generally, see Harry Berger, 'Fictions of the Pose: Facing the Gaze of Early Modern Portraiture', *Representations*, no. 46 (1994), pp. 87—120.

12. One interpretation suggests that the men were in fact two brothers: Bastiaan and Manuel Fernando. See Mark Ponte, 'Black in Amsterdam Around 1650', in Elmer Kolfin and Epco Runia (eds), *Black in Rembrandt's Time* (Zwolle, 2020), p. 57. On the Black community in seventeenth-century Amsterdam, see Mark Ponte, '"Al de swarten die hier ter stede comen": Een Afro-Atlantische gemeenschap in zeventiende-eeuws Amsterdam', *Tijdschrift voor Sociale en Economische Geschiedenis* [*The Low Countries Journal of Social and Economic History*], 15, no. 4 (March 2019), pp. 33—62; Kolfin and Runia (eds), 2020.

13. Elmer Kolfin, 'Black Models in Dutch Art between 1580 and 1800: Fact and Fiction', in *Black Is Beautiful: Rubens to Dumas* (Amsterdam, Zwolle, 2008), pp. 71—87.

14. Aert Schouman's mezzotint is based on Gerrit Dou's self-portrait painting, *Man Smoking a Pipe, c*.1650, Rijksmuseum, Amsterdam: SK-A-86.

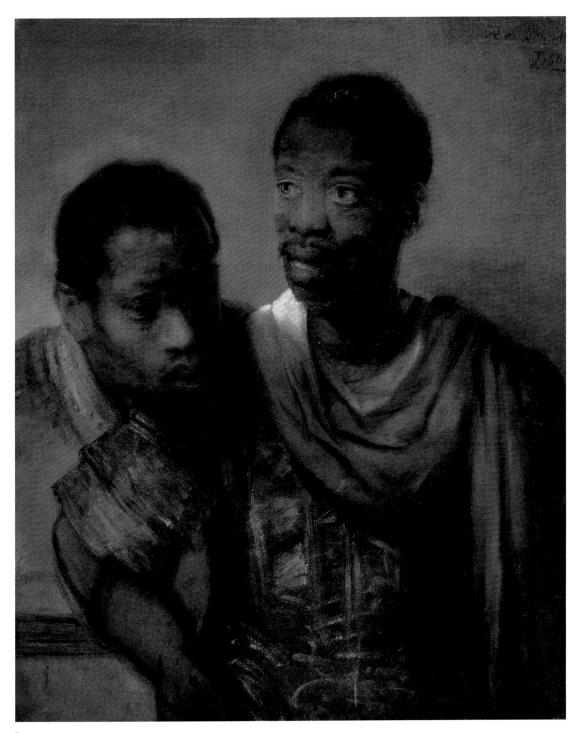

5
Rembrandt Harmensz van Rijn · 1606—1669
Two African Men · 1661 · oil on canvas

The Mauritshuis, The Hague: 685 · photo: Mauritshuis, The Hague
[not in exhibition]

back the curtain to get some air. In fact, Schouman, as print-maker, has softened his brow compared with Dou's painting, accentuating the gentlemanly expression. The book in front of him suggests a continued commitment to learning. The man holds the pipe with composure. The pipe itself holds something just as telling: tobacco. Dou's gentleman smokes a product grown by enslaved labourers. Burgher virtue required not just disciplined study but also the refined consumption of commodities that enslaved people across the Americas had produced.

Smoking was not confined to the wealthiest Dutchmen: in Adriaen van Ostade's *Peasants Smoking* [7], three down-at-heel men gather around a table outside a dishevelled room. The fence behind them is broken and there are rags thrown over it. One man stands while two men sit at the table immersed in their smoking. The standing man pours beer from a pitcher. The highly saturated colours, such as the blue and red jackets and the orange lighting of the entire space, add to the warmth and revelry. Seventeenth-century Dutch paintings show that a wide range of people consumed tobacco produced by enslaved

6
Aert Schouman · 1710—1792
after Gerrit Dou · 1613—1675
Man Smoking a Pipe
mid-eighteenth century
mezzotint on paper

Fitzwilliam Museum, University of Cambridge:
P.10719-R · given by John Charrington, 1933
photo: © The Fitzwilliam Museum, Cambridge
[not in exhibition]

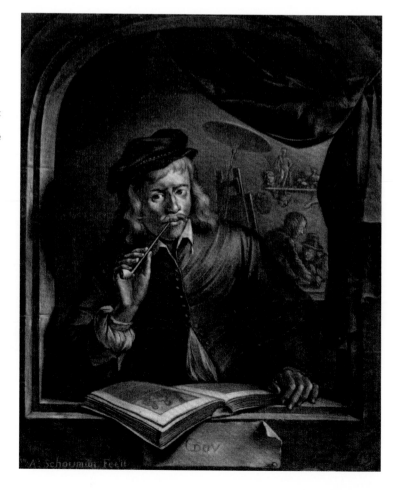

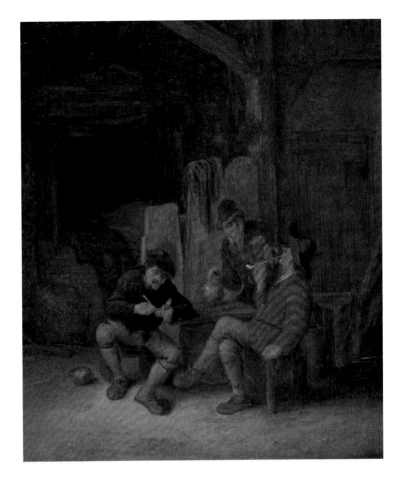

7

Adriaen van Ostade
1610—1685
Peasants Smoking
mid-seventeenth century
oil on panel

Fitzwilliam Museum, University of
Cambridge: 64 · given by Augustus Arthur
Vansittart, 1876 · photo: © The Fitzwilliam
Museum, Cambridge

people, a trend that would accelerate with the consumption of
sugar, coffee and cocoa in Britain in the eighteenth century.

From the Restoration of 1660 onwards, the British political
and commercial elite sought to challenge Dutch supremacy
in global trade. Led by James, Duke of York, the Company of
Royal Adventurers sought to dislodge the Dutch WIC, and
establish a British monopoly on trade from the West African
coast. Under the command of Captain Robert Holmes, British
warships sailed to West Africa for two violent expeditions.
They aimed to establish trading forts for the Company's agents,
where they could trade European goods for African captives.
Slaving ships would then transport the captive people to the
Americas as slaves. In 1661, the first expedition to the Gambia
suffered from a lack of manpower and depleted provisions.
The 'King of Barra', also known as the mansa of Niumi, allied
with fellow African regional leaders to force the expedition to
abandon their proposed fort.[15] For a second expedition of 1664,
James instructed Holmes to avenge Dutch attacks on British
ships. With implicit support from William Coventry, James's
secretary and the commissioner for trade and plantations,

15. 'Captain Robert Holmes his Journalls of
Two Voyages in to Guynea in his M's Ships
the Henrietta and the Jersey', Sea MSS.
no. 2698, Pepys Library, Magdalene College,
Cambridge, especially fol. 119 on the out-
come of the first expedition.

16. Ibid., fol. 136. Assuming that Holmes's expeditions focused on the Gold Coast, 'Aja' likely referred to the fort Egya. A less likely possibility is that it referred to a location in the Allada Kingdom in the Bight of Benin. The RAC established a fort at Egya on a more long-term footing by 1674. On the Egya fort, see Robin Law (ed.), *The Local Correspondence of the Royal African Company of England, 1681–1699. Vol. 1: The English in West Africa, 1681–1683* (London, 1997), p. 143.

17. *A True and Exact Relation of the Prince of Orange His Publick Entrance into EXETER* (London, 1688).

18. John Carswell, *The South Sea Bubble* (London, 1960), p. 57. See more generally, Perry Gauci, 'Decker, Sir Matthew, first baronet (1679–1749), political economist and merchant', *Oxford Dictionary of National Biography* (December 2021).

19. The Portuguese and Dutch had previously held the Asiento. Demand for enslaved labourers outstripped supply by the holders of the Asiento contract, resulting in the widespread clandestine trafficking and purchase of captive African people in the Americas. See Hochstrasser 2007, p. 220; Gregory E. O'Malley, *Final Passages: The Intercolonial Slave Trade of British America, 1619–1807* (Chapel Hill, NC, 2016), pp. 145–6.

20. 'A proposal for the enlarging, improving, and establishing the trade of Great Britain, and lessening the publick debts, by the South Sea Company [...]' (undated, pre-1713), The Houghton (Cholmondeley) Papers, Ch(H), Political Papers, 88/127, Cambridge University Library (hereafter CUL); 'Advantages of Asiento' (undated), 88/139, Ch(H), Political Papers, CUL; 'Abstract of most material articles of Asiento contract' (undated), 88/129, Ch(H), Political Papers, CUL; Carl Wennerlind, *Casualties of Credit: The English Financial Revolution, 1620–1720* (Cambridge, MA, 2011), chapter 6.

21. Voyages: The Trans-Atlantic Slave Trade Database, https://www.slavevoyages.org/voyages/jJXM8Im4 (accessed 6 May 2023).

22. South Sea Company, Minutes of the Court of Directors, 7 September 1711–1 August 1712, Add MSS 25494, BL, London, 19 March 1711, fol. 126.

Holmes seized several Dutch ships and helped to establish temporary forts at Anomabu and Aja.[16] This West African episode formed the prelude to the Second Anglo-Dutch War (1665–7) in which England fought the Netherlands for control of global trade. Holmes raided the Vlie Estuary in the Netherlands. Despite early victories by the English, the Dutch triumphed in the war. Their maritime successes were celebrated in patriotic paintings like Abraham Storck's naval battle scene [8], which shows the Dutch ship *De Zeven Provincien* (The Seven Provinces) sinking an English ship. This geopolitical setback did not dampen enthusiasm among the Stuart monarchy, navy and mercantile elite to build a slave-trading empire. Under a new charter from 1672, the Company of Royal Adventurers became the Royal African Company. With support from James, who ruled as King James II (1685–8), it grew into Britain's leading slave-trading firm. The Stuart ruling establishment helped to make slave-trading and colonisation central to British geopolitical strategy and economic growth.

Following periods of warfare over imperial trade routes, the Dutch and English agreed to peace, which could even culminate in alliance. In 1688, leading politicians wished to depose James II for fear of a Catholic succession. They invited William of Orange and his wife, James's daughter, Mary, to England to assume the throne. William landed in the south and marched on Exeter. He entered the town processing with '200 Blacks brought from the Plantations of the Netherlands in Americ[a], [wearing] Imbroyder'd Caps lined with white Fur, and plumes of white Feathers, to attend the Horse[s]'.[17] This procession represented his colonial power. The revolution brought numerous Dutch people to Britain, who transformed science, politics and finance. They contributed to establishing joint stock companies and the Bank of England. One such Dutchman was Matthew Decker [9]. He was born in Amsterdam and came to England for a career as a merchant. Decker's financial expertise and political connections afforded him a prominent role in financing the British military during the War of the Spanish Succession (1701–14).

Between 1711 and 1712, Decker also acted as a founding director of the South Sea Company, which combined slave-trading with managing the national debt. The prime minister, Robert Harley, established the SSC to turn illiquid government debt into liquid company shares. The cost to the government of borrowing money had risen dramatically due to a long period of interimperial warfare. By offering public creditors equity in the SSC in exchange for repayment on the loans that they had made, Harley hoped to reduce this cost. In England's emergent system of parliamentary political parties, Harley aimed for the SSC to offer his Tory government a counterweight to the Bank

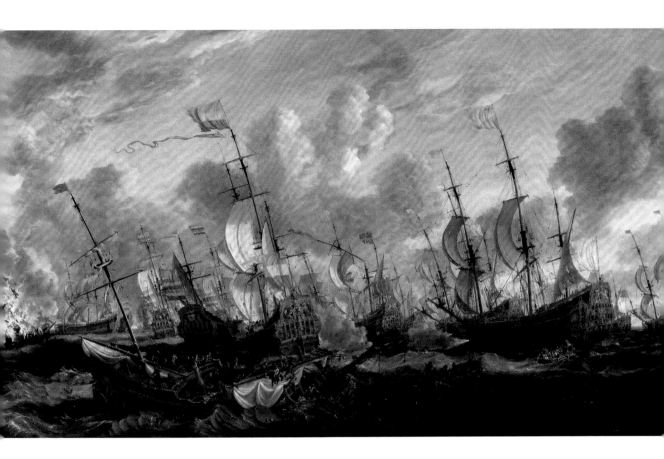

of England and East India Company, which the rival Whigs dominated. Decker subscribed to £49,271 worth of SSC stock.[18] The Company received a monopoly on trade to South America. In 1713, as part of a peace agreement with Spain, the British Crown received the Asiento contract for transporting captive people from Africa to Spanish colonies in the Americas.[19] At the founding of the Company, Harley had aimed for it to obtain the Asiento. The Crown duly assigned it to the Company. This commercial privilege for slave-trading helped to increase market confidence in the Company's profitability, and by extension, in the government's capacity to service the national debt.[20] As the Asiento holder, the South Sea Company rather than the Royal African Company traded in captive people to the Spanish Americas, and indeed the latter became a contractor for the former. Over the next 30 years, the Company transported approximately 41,000 people into slavery in the Americas, with large numbers going to Rio de la Plata, Portobello, Jamaica and Barbados.[21]

Decker knew that the Company would profit from the trans-atlantic slave trade: in 1711, he and his fellow directors held a meeting where they discussed trade with Africa.[22] Decker resigned as a director before the Company's slaving voyages

9

Theodorus Netscher
1661—1728

Portrait of Sir Matthew Decker, Baronet 1679—1749

c.1720 · oil on canvas

Fitzwilliam Museum, University of Cambridge:
443 · bequeathed by Richard, 7th Viscount
Fitzwilliam, 1816 · photo: © The Fitzwilliam
Museum, Cambridge

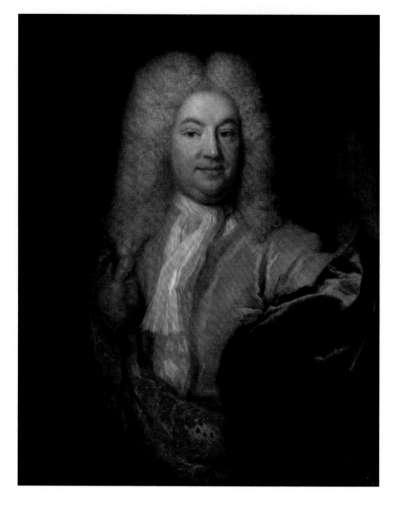

23. There were various SSC annuity
schemes that included the Company
buying back shares from shareholders in
exchange for paying a low interest-bearing
annuity for a fixed term, see the following
illustrative examples: 'Part of a subscription
list for shares w/ annuity at 5%, drawn up
at South Sea House', 15 October 1720, The
Houghton (Cholmondeley) Papers, Ch(H),
Political Papers, 88/24, CUL; 'A proposal for
reducing Five Millions of the SSC capital into
annuities at 6 pounds, 6 pounds 10 shillings,
or 7 pounds per cent per annum for life, by
way of lottery at 100 pounds per ticket,
and 11 millions into 4 per cent transferable
annuities' (no date, pre 1727), 88/99, Ch(H),
Political Papers, CUL; 'Capital Stock of the
South Sea Company amounting to £33 802
000 [...]' (undated, after 1729), 88/109,
Ch(H), Political Papers, CUL.
24. Account of the Executor of Fitzwilliam,
Richard, Viscount Fitzwilliam, Ledger 41,
fol. 330r, Hoare's Bank Archive, London.

began. Over one hundred years later, at the time of his death,
Fitzwilliam had acquired 10,000 New South Sea Company
annuities, which were created in 1733 in a capital reconstruction
of the Company.[23] On 28 May 1816, Fitzwilliam's executor sold
them at 63.25%, after brokerage receiving £6312 10s into his
account at Hoare's Bank to help settle Fitzwilliam's estate
and found the Museum.[24] The incomplete historical record
for financial firms and personal accounts for the period 1711—
1816 presents a complex interpretative challenge. It prevents a
definitive conclusion about how much profit Decker made from
his SSC investment, and how far and in what ways this profit
entered the Fitzwilliam family by the marriage of Decker's
daughter, Catherine, to Richard Fitzwilliam (the Founder's
father) in 1744. It is also unclear who made the investment
in the New annuities, and how the total profit from these two
investments contributed to the Founding Bequest.[25] In any
scenario, SSC investors knew that what made the Company
profitable was slave-trading, and this profit in the form of
Decker's wealth and art, plus from the subsequent investment

25. The Church of England has traced profits from SSC annuities into Queen Anne's Bounty, which formed part of the Church's perpetual endowment fund. The CofE's archive of accounts enables more precise tracing of profits from investments into the institution than is possible for the Fitzwilliam Museum. The Church Commissioners for England, *Church Commissioners' Research into Historic Links to Transatlantic Chattel Slavery* (2023).
26. South Sea Company, Minutes of the Court of Directors, 5 August 1712–2 February 1715, Add MSS 25495 , BL, fol. 260; Voyages: The Trans-Atlantic Slave Trade Database, https://www.slavevoyages.org/voyages/jJXM8Im4, (accessed 6 May 2023).
27. Joseph Redington (ed.), 'Volume 174: March 15-April 10, 1714', *Calendar of Treasury Papers, Volume 4, 1708–1714* (London, 1974), p. 566. The United Kingdom used the Julian Calendar until 1752, in which 25 March was the first 'legal' or 'civil' day of the new year (in this case, 1714). The *Calendar of Treasury Papers* records the date for the entry as 1713/1714, to clarify that dates between 1 January and 24 March also counted under the 1714 calendar. These correspond to the movements of the four slaving ships noted above.
28. William Stratford to Edward Harley, 9 November 1720, in *Historical Manuscripts Commission. Report on the manuscripts of His Grace the Duke of Portland, K.G., preserved at Welbeck Abbey. Volume 7,* (London, 1901), p. 282.
29. On transatlantic shipments in the period 1733–40, see Voyages: The Trans-Atlantic Slave Trade Database: https://www.slavevoyages.org/voyages/jJXM8Im4 (accessed 6 May 2023). On intra-American shipments to Spanish colonies, see Voyages. The Intra-American Slave Trade Database: https://www.slavevoyages.org/voyages/Lg6fONNG (accessed 30 May 2023); Gregory E. O'Malley, *Final Passages: The Intercolonial Slave Trade of British America, 1619–1807* (Chapel Hill, N.C., 2016), chap. 6.

in the New annuities, flowed to the Fitzwilliam Museum. What follows is the most plausible scenario.

Decker could have dispensed with his SSC stock as early as March 1714, after the Company received the Asiento and had organised its first four slaving voyages. Between November 1713 and February 1714, the slaving ships *Saint Mark*, *Windsor*, *Good Hope Gally* and *Canada* departed for the West African coast.[26] These ships transported an estimated 1,100 people into slavery in the Americas; many died on the crossing. These four completed slaving voyages were part of what made the SSC an attractive stock to hold. On 25 March 1714, the Treasury recorded that a Memorial of Thomas Moore to the Lord High Treasurer was read for 'the payment of 15,555l. 8s. 6d. and 40,241l. 2s. due to Matthew Decker, Esq., on a deposit of 69,435l. South Sea stock, advanced for Her Majesty's forces in the Low Countries' (in other words, £15,555 8s 6d; £40,241 2s; £69,435 respectively).[27] If that was the end of Decker's investment in the SSC, he had effectively made a profit of £20,164 by lending capital in the form of SSC stock to the government for the armed forces. He then received a repayment of this loan in the form of cash, rather than as the return of the stock. The profit would corroborate what Decker later told a correspondent of Robert Harley's son, Edward. In November 1720, as the share price tumbled in the infamous burst of the South Sea Bubble, Decker said that 'he has not for four months past had anything to do in Exchange Alley upon his own account. He had sold out betimes, and had nothing left in any of the stocks but what was pure gains'.[28] Through his subsequent purchase of artworks and his daughter's marriage, Decker's SSC profit flowed into the Fitzwilliam family.

We do not know — yet — whether Decker or somebody else purchased the New annuities that were issued in 1733. Nor do we know how 7th Viscount Fitzwilliam acquired them, though it seems most probable that he inherited them from a family member. In the 1730s, the SSC was still engaged in slave-trading. In the period 1733–40, the Company arranged a further six slaving voyages, mainly from West Central Africa to Buenos Aires and Jamaica. The SSC transported an estimated 2,394 enslaved people on these ships. From 1713–40, the SSC also trans-shipped over 49,000 enslaved people from various colonies in the Americas to Spanish colonies to fulfil the Asiento contract.[29] In 1740, renewed warfare between global empires including Britain and Spain disrupted the Company's slave-trading ventures to Spanish colonies. Although the Asiento contract lasted nominally until 1750, the SSC slave-trading ventures seem to have ceased.

Decker's profit from the SSC and Fitzwilliam's holding of New South Sea annuities cannot by themselves account for the

founding of the Fitzwilliam Museum. Decker also grew wealthy from sources beyond the SSC. Between 1713 and 1743, he was a director of the East India Company. This directorship implicated him in colonial expansion in the Indian sub-continent. By September 1719, Decker held stock in the Royal African Company with a book value of £7,700.[30] He became a director of the RAC the following year. Alongside lending money to the government to fight imperial wars, Decker profited from global imperial expansion and coerced labour. Decker's grandson, 7th Viscount Fitzwilliam, was a major landowner in Ireland. These lands were not part of the Founding Bequest of the Museum but helped to make Fitzwilliam wealthy and pursue his interests in fine art and music. At the same time, the Museum's Dutch connection to enslavement stretched beyond Decker and Fitzwilliam. Daniel Mesman, who was from a family of Dutch silk-weaving merchants, bequeathed around 300 works of art to the Museum in his will. One of his family members — likely to be his father — had lent money to the owners of the Bacolet estate in Grenada in 1772. The borrowers also held enslaved people at Bacolet.[31] Another donor to the Museum, Augustus Arthur Vansittart, descended from a Dutch merchant who invested in the 'East Indies and South Sea trades'.[32] Future researchers may uncover more information about these multiple sources of wealth, which will enhance our collective knowledge about the role of imperialism and enslavement in shaping families and institutions in Britain.

Even accounting for these complexities, two conclusions remain. First, Decker knew that the SSC would engage in slave-trading. He profited from his SSC stocks after slave-trading commenced and before the Bubble burst. Second, the New annuities of 1733, which Fitzwilliam subsequently owned, restructured the Company's existing capital when it was still engaged in slave-trading. These two sources of wealth contributed to the Founding Bequest which comprised Fitzwilliam's collection of art, music and books and the proceeds from the sale of these annuities.

At the height of his power, Decker had his portrait painted by the amateur painter Theodorus Netscher [9]. Netscher worked as paymaster for Dutch troops in England and stayed with Decker. In the portrait, Decker stares directly at the viewer, full faced, with a soft jaw and pursed lips, to display his confidence. He wears the accoutrements of gentlemanly wealth, including a wig and silk stock. He stands with his left arm crocked, now in the full-on Renaissance elbow. In the Netscher portrait, the cloak covering Decker's elbow enables greater play of light on his arm, emphasising the foreshortening effect. Like the smoker's book in Schouman's engraving after Dou [6], Decker's elbow extends towards the picture plane, a masculine assertion of possession. Eighteenth-century

30. Company of Royal Adventurers of England Trading with Africa and successors, Ledger, T 70/197, fol. 351, UK National Archives. I thank William Pettigrew and one of the anonymous reviewers of this essay for their help with this source.
31. Susanne Seymour and Sheryllynne Haggerty, *Slavery Connections of Brodsworth Hall (1600—c.1830)* (University of Nottingham, 2010), p. 46 and table 1, p. 103.
32. Wilson 1988, 'Introduction: The Dutch Connection', p. 8.
33. Marcia R. Pointon, *Hanging the Head: Portraiture and Social Formation in Eighteenth-Century England* (New Haven, CT, 1997).

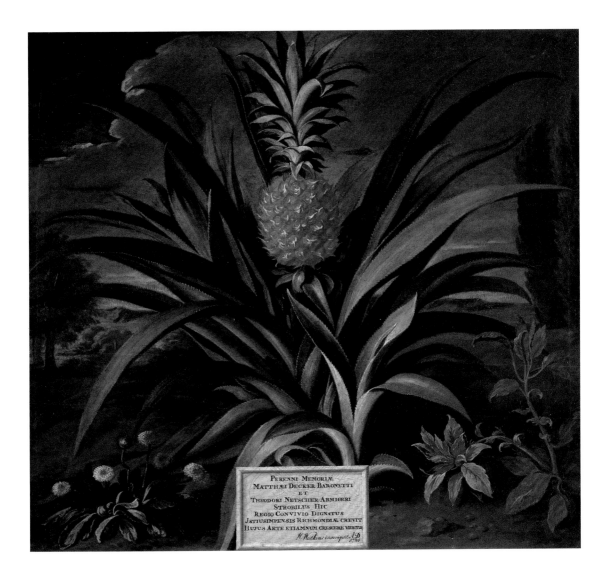

10

Theodorus Netscher
1661–1728
***Pineapple grown in
Sir Matthew Decker's
garden at Richmond, Surrey***
1720 · oil on canvas

portraiture was a competitive field in which many artists competed for commissions.[33] Patrons used this competition to reinforce their position in the social hierarchy. They commissioned paintings not just of family members but also of servants and animals. Unlike many portrait painters, Netscher probably did not need to compete to earn Decker's commission because he had a strong relationship with him based on the painter's role in managing Dutch troops and resources.

Decker used the wealth that he had gained from various sources to purchase an estate in Richmond. On these grounds, he funded his interest in gardening. Decker claimed credit for cultivating the first pineapple grown in England, which was also portrayed by Netscher [10]. The pineapple sits at head height on the canvas, on top of its bush-like body, with a small plaque. Netscher produced a portrait of sharp contrasts. He

created a classical and realist symmetry to the picture whilst portraying the pineapple as bright, fecund and flamboyant. He placed the horticultural order of the landscaped garden beneath a stormy sky. Netscher honoured Decker's botanical genius, just as he had honoured his commercial success. There now remains a richer visual representation of this single pineapple than of the tens of thousands of enslaved people purchased and shipped to, and within, the Americas by the SSC. The same Anglo-Dutch imperial trading nexus that enabled the cultivation of this pineapple displaced millions of African and Indigenous American people and caused environmental destruction throughout the Americas through extractive economic systems of commodity production.

Resistance in the visual culture of Suriname

Anglo-Dutch systems of enslavement shaped visual culture not only within the Fitzwilliam Museum's collections in terms of burgher masculinity and cultures of consumption, but also throughout the Atlantic world. We see this shaping in the representation of the peoples and cultures of an important Dutch colony: Suriname. The Spanish, Dutch, British and French empires vied for control of trading outposts along the rivers between South America's Atlantic coastline and Venezuela to the west of Suriname.[34] In 1667, the Dutch and British agreed to a peace settlement that ended the Second Anglo-Dutch War. During the conflict, the Dutch had seized the colony of Suriname from Britain. The peace terms included Dutch retention of Suriname in exchange for British retention of the city of New Amsterdam (which later became New York City). In 1683, the Society of Suriname, a joint venture between the city of Amsterdam, the Van Aerssen van Sommelsdijck family, and the Dutch WIC, was chartered to govern the colony. Along Suriname's rivers, land proprietors developed plantations where they forced enslaved people to grow cotton, coffee, sugar and cacao.

Dirk Valkenburg's painting known as *The Slave-Dance* (1706—08) is perhaps the most profound portrayal of enslaved people's lives in early Dutch colonial Suriname [11]. Thirty-eight men, women and children gather around an open space outside the slave quarters for a group activity involving drumming and dance. Their bodies glisten with oil, accentuating their muscles and flexible postures. Valkenburg saw these enslaved people as having their own important culture, shaped by music, cuisine and family relationships. But he also focused the viewer's attention on their productive and reproductive labour. From the woman in late pregnancy dressed in red on the far right of the canvas to the elderly woman on the far left, Valkenburg depicted the plantation workforce as apparently self-perpetuating. These people were arranged for the viewer's pleasure: Valkenburg's

34 Bram Hoonhout and Thomas Mareite, 'Freedom at the Fringes? Slave Flight and Empire-Building in the Early Modern Spanish Borderlands of Essequibo-Venezuela and Louisiana-Texas', *Slavery & Abolition*, vol. 40, no. 1 (2019), pp. 61—86.

Dirk Valkenburg · 1675–1721
*Ritual Party of Enslaved
People on a Sugar
Plantation in Surinam*
1706–08 · oil on canvas

SMK, National Gallery of Denmark: KMS376
acquired in 1800 · photo: Statens Museum
for Kunst, open.smk.dk, public domain

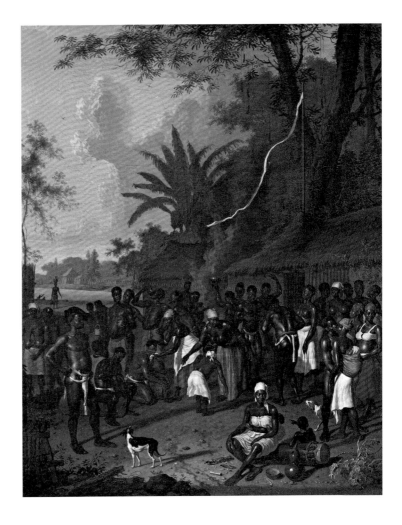

35 Frank Dragtenstein, 'De opstand
op Palmeneribo', *OSO. Tijdschrift voor
Surinaamse taalkunde, letterkunde en
geschiedenis.*, 23 (2004), pp. 214–35.
36 Natalie Zemon Davis, *Women on the
Margins: Three Seventeenth-Century
Lives* (Cambridge, MA, 1995), pp. 190–1;
John E. Crowley, 'Sugar Machines: Picturing
Industrialized Slavery', *The American
Historical Review*, vol. 121 (April 2016), p. 415.
37 Charles Ford, Thomas Cummins and
Rosalie Smith McCrea, 'The Slave Colonies',
in David Bindman and Henry Louis Gates Jr
(eds), *The Image of the Black in Western Art,
Vol. III: From the 'Age of Discovery' to the Age
of Abolition, Part 3: The Eighteenth Century*
(Cambridge, 2011), pp. 241–305.

commission was to depict the Palmeneribo plantation for its
Amsterdam-based owner, Jonasz Witsen. During the period
when Valkenburg made this painting, the enslaved people
revolted against plantation servitude at Palmeneribo. They
objected to the withdrawal of the customary right to grow
their own crops and visit friends and family on other plant-
ations on Saturdays and Sundays.[35] The authorities sentenced
the alleged ringleaders to death by burning. Valkenburg, who
participated in suppressing the rebellion, left Suriname the
following year, before his commission was finished.

Valkenburg's painting has provoked contrasting interpretations
ranging from appreciation to horror. Some scholars have seen
the painting as a rare ethnographic depiction of how people
subjected to slavery developed their own culture. For instance,
the painting is often taken to represent Winti worship, an Afro-
Surinamese syncretic religion.[36] An opposing view contends that
the highly saturated colours and glistening muscles represented
the enslaved people as little more than commodified beings.[37]

12

Captain J.G. Stedman
1744—1797
Plan of a regular Coffee
Plantation · plate from John
Stedman, *Narrative, of a five*
years' expedition, against the
revolted negroes of Surinam,
in Guiana [...] (London, 1796)

Fitzwilliam Museum, University of
Cambridge: PB 17-2020 · bequeathed
by Richard, 7th Viscount Fitzwilliam, 1816
photo: © The Fitzwilliam Museum,
Cambridge

Instead of seeing this painting solely as a representation of an Afro-diasporic culture or racialised commodification, we would be better placing Valkenburg's painting next to Rembrandt's *Two African Men* [5] to see how far Dutch representations of Black people had shifted between 1661 and 1708. Although the Black figures are central to Valkenburg's composition, they are framed by the plantation. Unlike Rembrandt's work, the frame contains the subjects rather than aids their expression. The people seem to fill up, rather than fill in, the space. The difference in artistic practices — Rembrandt's studio-based portraiture compared with Valkenburg's plantation-based observation — might explain the difference in representation. In the Anglo-Dutch world, the rise of professional studios and academies with the commitment to painting portraits of predominantly white sitters from life ran parallel to the narrowing representation of Black people as attendants to these sitters. Rembrandt's superior skill as a painter also mattered: Valkenburg's figures seem stiff and frozen in position, rather than lively and spontaneous. In painting a group scene, such as a militia night watch or the officials in a draper's guild, Rembrandt consistently managed to convey individuals' idiosyncratic expressions and postures within a collective activity. Whatever the difference in practice and skill, Valkenburg did not attempt to portray individuality, whether through focusing on detail or any other chosen method. Instead, he seemed to think it more suitable for Witsen's aggrandisement to produce multiple representations of the same social archetype: the slave. Unlike Rembrandt, who invited us to share in the friendship between the two sitters, Valkenburg placed these composite enslaved people behind a screen, like the cold vitrine of a cabinet of curiosities.

The Palmeneribo revolt was one among many that erupted across Dutch Suriname. One such uprising produced a narrative of counterinsurgency that had important consequences for visual culture in the late eighteenth century. Its author, John Gabriel Stedman, exemplified the connections between the British and Dutch worlds of slavery. Born in the Netherlands to a Scottish military officer and his Dutch wife, he travelled to Suriname as a soldier in the 1770s. Between 1772 and 1777, Stedman served in several military expeditions, primarily against Maroon people who had freed themselves from slavery. Stedman helped to capture the Maroon village of Gado Saby in eastern Suriname. Between periods of armed service, he observed and drew a wide variety of people, places and cultural practices. These included methods of bush fighting, musical instruments, the layout of plantations [12] and objects made by Indigenous people. Stedman had prolonged sexual contact with an enslaved woman, whom he called Joanna. As an enslaved woman who did not own her own body, Joanna had no capacity to consent to his sexual demands. Inadvertently, Stedman's writings about his actions in Suriname revealed

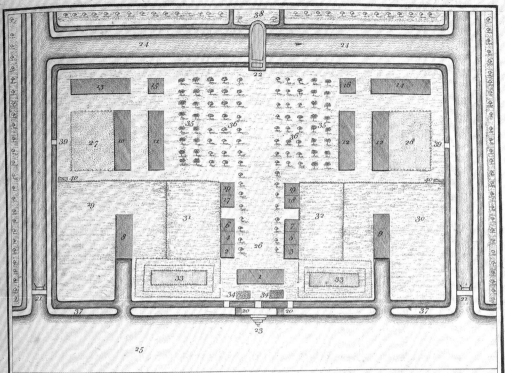

References to the Plan.

1. The Dwelling House
2. The Overseers Dwelling
3. The Book-keepers Office
4. The Kitchen
5. The Storehouse
6. The Poultry-house
7. The Hogs-sty
8. The Boat-house or small Dock
9. The Carpenters & Coopers Lodge
10. The Drying Lodge for the Coffee
11. The Bruising Lodge for do
12. The Negro-houses
13. The Horse Stables
14. The Fold for Sheep & Bullocks
15. The Great Guard house
16. The Hospital
17. The Pigeon-house
18. The Corn-house or Granary
19. The Necessary houses
20. The Sentry Boxes for Watchmen

21. The Floodgates
22. The Great Draw-bridge
23. The Landing Place
24. The Great Canals
25. The River or Creek
26. The Gravel walks
27. The Drying Floor for Coffee
28. The Negro Gardens
29. The Pasture for the Horses
30. The Pasture for the Sheep & Bullocks
31. The Poultry-yard
32. The Hogs-yard
33. The Kitchen Gardens
34. The Flower do
35. The Plantain Trees
36. The Groves of Orange Trees
37. The Dams & Gutters for Draining
38. The Path to enter the Fields
39. The Bridges over the Gutters
40. The Gates, Barriers, &c.

Plan of a regular Coffee Plantation.

T. Conder Sculpsit

London, Published Dec.r 1st 1791, by J. Johnson, St. Pauls Church Yard.
78

13

**Cambridge Expedition
to Langa Tabiki**

cover · student fundraising
brochure (Cambridge, 1965)

Museum of Archaeology and Anthropology,
University of Cambridge: Archives, Annual
Correspondence files, 1965, doc. 525
photo: Museum of Archaeology and
Anthropology, Cambridge · [not in exhibiton]

38. Anne K. Mellor, 'Sex, Violence,
and Slavery: Blake and Wollstonecraft',
Huntington Library Quarterly, vol. 58, no. 3/4
(January 1995), pp. 345—70; David Bindman,
'Blake's Vision of Slavery Revisited',
Huntington Library Quarterly, vol. 58, no. 3/4
(January 1995), pp. 373—82; and Sarah
Thomas, *Witnessing Slavery: Art and Travel
in the Age of Abolition* (New Haven and
London, 2019), chapter 4.
39. 'Cambridge Expedition to Langa Tabiki'
(1965), Museum of Archaeology and
Anthropology, University of Cambridge,
Archives, Annual Correspondence files, 1965.
40. An initial online search of the British
Museum's catalogue and the Royal Botanical
Garden's catalogues for the Archive and
the Economic Botany Collections suggests
that both institutions have historic links to
collecting from Suriname including in colonial
and postcolonial contexts, but not materials
directly associated with the expedition of
1965.
41. Herman Jie Sam Foek, 'Art Making,
Aesthetic Considerations and the Formation
of Social and Cultural Homogeneity with the
Changing Bush Negro Society of Suriname',
Journal of Intercultural Studies, vol. 25,
no. 1 (April 2004), pp. 7—20.

the extensive physical and psychological coercion involved
in every domain of enslavement, ranging from the intimate
to the military.

In 1796, Stedman's account came to widespread attention
in Britain through a published version of his drawings and
narrative. The radical publisher Joseph Johnson issued an ed-
ited *Narrative, of a five years' expedition* with engravings by
William Blake and Francesco Bartolozzi. Blake and Bartolozzi
copied and adapted Stedman's original drawings, which were
subsequently lost. The result of this peculiar partnership was
a series of images that combined the conventions of war imag-
ery, ethnography and pornography.[38] For instance, Stedman
alluded to both military strategy and daily life for enslaved
people in his depiction of a plantation [12]. The bird's-eye view
gives a different perspective from Valkenburg's landscape
work. The rectilinear division of space suggests oppressive
confinement and the spatial organisation of a military offensive
against enslaved insurgents. Seen from above, the violence of
insurgency and counterinsurgency pervades every space.

Stedman's imagery has continued to resurface as scholars and
artists confront how colonial slavery has shaped Surinamese
material and visual culture. One reverberation of Stedman's
imagery in Cambridge comes from the anthropological coll-
ections. In 1965, three Cambridge students together with a
doctoral student at the University of Amsterdam planned an
expedition to the Maroni (or Marowijne) River region. They
planned to go further south than Stedman had done in his
mercenary expedition in the 1770s. The students' destination
was an island called Langa Tabiki. The expedition's patrons
included the Museum of Archaeology and Anthropology in
Cambridge (then known as the Museum of Archaeology and
Ethnology), the Pitt Rivers Museum in Oxford, the Royal
Botanic Gardens in Kew and the British Museum's Natural
History Section. The students produced a fundraising brochure
for their expedition, which featured on the front a Maroon
soldier drawn by Stedman [13].[39] The brochure's imagery was
not simply an illustration of the historic roots of Surinamese
Maroon people, but also shaped the expectations of the
students and the funders regarding how the Maroons lived,
evoking danger and 'primitivism'.

Far from being 'primitive', Maroon people had combined
political resistance to slavery with developing their own
socio-economic and artistic conventions. The first Paramakan
(also known as Pamaka and Paramacca) Maroons had escaped
from multiple plantations in eastern Suriname in around 1830.
According to colonial law, these fugitive people and their
descendants were outlaws who could be captured and re-
enslaved. The Dutch colonial authorities abolished slavery

14

**Unrecorded maker,
Paramaka Maroon people**
Rectangular stool
Suriname, Sipaliwini District
probably mid-twentieth century
(before 1965) · wood, pigment
and metal

Museum of Archaeology and Anthropology,
University of Cambridge: 1966.172
acquired on a student-led Cambridge
expedition to Langa Tabiki, 1965
photo: Museum of Archaeology and
Anthropology, Cambridge

in 1863, when they imposed a ten-year bonded labour regime on formerly enslaved people. Only towards the end of that term, in 1872, did the colonial government agree to a peace treaty with the Paramakans, formally recognising the autonomy that they had claimed over the past 40 years. In 1879, a group of Paramakan people established a settlement on an island in the Marowijne River, which became known as Langa Tabiki (Langatabbetje in Dutch).

The Cambridge expedition acquired dozens of objects, which the Museum of Archaeology and Anthropology and Oxford's Pitt Rivers Museum have accessioned into their collections.[40] It is hard to know the intentions of the Paramaka makers of the various objects including stools [14], a canoe paddle [15], a clothes beater and bowls. Considering the nascent tourism market for such objects, perhaps they made them for sale.[41] Some of the objects, such as the clothes beater, have little wear or water damage, suggesting that the producers did not use them prior to the expedition's acquisition. Alternatively, the producers may have considered some of the items precious and only agreed to hand them over because the expedition offered something desirable in exchange. The terms of exchange, and the power relations behind them, were not recorded when the objects entered the collections of Cambridge's Museum of Archaeology and Anthropology.

The objects enable great insight into how the Paramaka Maroons used an Afro-Atlantic visual culture to enshrine political authority and sociality. For instance, the maker of the stool [14] has incorporated a cross inlaid in darker wood in the

middle of the seated section. It is the Kongo cosmogram. As one scholar has put it, 'To stand [or to sit] upon this sign meant that a person was fully capable of governing people.'[42] As indicated by the blazing and dimming stars, the four points represent the movement of the sun from sunrise to sunset. The cross also represents the realm of the living and the dead separated by water. Accounts from the seventeenth and eighteenth centuries note that people from Central Africa believed that to cross the ocean was to enter the realm of the dead. Around one quarter of all enslaved African people transported to Suriname came from West Central Africa, including from the Kongo Kingdom.[43] In Suriname, they grew sugar and coffee on vast plantations. The stool's unrecorded designer used the Kongo cosmogram to recall African political power, honour the community's ancestors who lived and died in slavery and enact a new social order in the Americas.

On the underside of the stool, and not visible here, is a piece of tinplate, shaped like a fish, and attached using drawing pins. The stool's owner has bound it here, perhaps to evoke the 'nganga', sacred objects which provide the ritual homes of ancestors.[44] Maroon people also attached cowrie shells, a currency used by traders to purchase captives on the West African coast, to amulets on necklaces and bracelets.[45] The makers and wearers of these objects critiqued the systemic inequality upon which commodity production depended. They harnessed the same symbols of this unequal material world for their own projects of healing and establishing political order. Red, green and black paint decorate details on the stool. In the nineteenth and twentieth centuries, another Maroon group of eastern Suriname, the Ndyuka, produced multicoloured striped cloth. The vivid contrast of colours was aesthetically beautiful and warded off evil spirits.[46]

Alongside the stool, a woman's canoe paddle [15] demonstrates how Paramakan people combined African and American visual conventions. The paddle contains similar imagery to the stool, such as the Kongo sun and interlocking bands of colour. On the reverse, it contains several engraved symbols of arrows, circles and triangles in a dispersed geometric arrangement. The engravings recall macumba ground art as practised in Rio de Janeiro. These were drawings made by people versed in both Kongo and Yoruba art. The artists used macumba to 'point' to the gods and remember the people who had disappeared because of slavery.[47] In synthesising various sources of knowledge from the African diaspora between Kongo and the Americas, Maroon people in Suriname made new Black Atlantic tools that resisted enslavement. Stools and paddles enabled them to dismantle and move their possessions along the vast river routes, thereby establishing an alternative social order to the racial domination that the colonial regime had hoped to impose.

42. Fu-Kiau Bunseki quoted in Robert Farris Thompson, *Flash of the Spirit: African and Afro-American Art and Philosophy* (New York, 1984), p. 109.
43. Voyages: The Trans-Atlantic Slave Trade Database, https://www.slavevoyages.org/voyages/RvxCeK7T (accessed 23 May 2023).
44. Stephan Palmié, *Wizards and Scientists: Explorations in Afro-Cuban Modernity and Tradition* (Durham, NC, 2002), p. 167.
45. For examples, see 'Necklace with shells and bells, which also serves as an amulet', TM-H-2407 and 'Armring with white clay and cowrie shells', TM-H-2431a, Wereldculturen Collections, the Netherlands.
46. Thompson 1984, p. 217.
47. Thompson 1984, pp. 112–16.

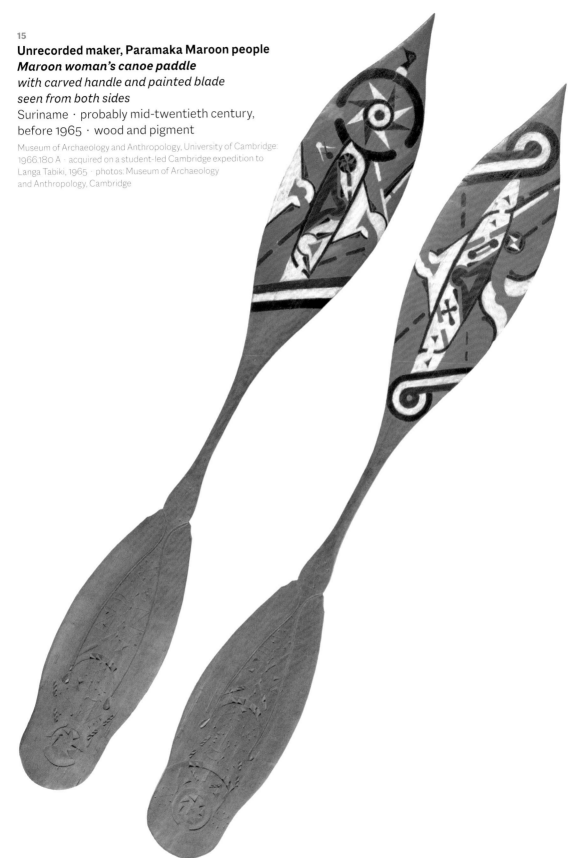

15

Unrecorded maker, Paramaka Maroon people
Maroon woman's canoe paddle
with carved handle and painted blade
seen from both sides
Suriname · probably mid-twentieth century,
before 1965 · wood and pigment

Museum of Archaeology and Anthropology, University of Cambridge:
1966.180 A · acquired on a student-led Cambridge expedition to
Langa Tabiki, 1965 · photos: Museum of Archaeology
and Anthropology, Cambridge

Consequences

As Atlantic slavery and empire shaped the Anglo-Dutch world, so too did it produce a specific visual and material culture in the Fitzwilliam Museum. The consequences of this long-term shaping have been profound. The collections have separated the conditions of the production of goods from the conditions of their consumption. In most of the collections from the sixteenth century onwards, the collections present a world in which people in Europe enjoyed coffee, sugar, tobacco, silver and mahogany in great luxury. Consumers of both fine and applied art needed neither to think about the enslaved people who produced these goods, nor to imagine their work conditions, family lives or aspirations. The consequence of the South Sea Company's slave-trading for the University of Cambridge was a significant contribution to the Founding Bequest for the Fitzwilliam Museum. This Bequest included Decker's art collection and two sources of profit from the SSC; the amount of profit cannot be quantified yet its existence cannot be denied. The consequence for the people of West Africa and the Caribbean has been long-term disadvantage. People suffer from a lack of assets, environmental damage, enervated institutions and a lack of investment in producing the high-quality data required to understand the scale of these problems or provide solutions.[48]

Alongside this visual separation of production from consumption, the Fitzwilliam Museum's hidden connections to Atlantic imperial enslavement have produced stereotyped representations of people of the African diaspora. In the collections, Black people are often represented as threatening or in pain. More accurate ways of thinking about Blackness, such as the intimacy and joy of friendship in Rembrandt's *Two African Men*, or the visual mapping of freedom in the Maroon designs from Suriname, have been lacking.

Atlantic slavery has contributed to long-term trends that have produced large inequalities in the wealth of Black and white households. These include weakening Black people's property rights and discriminating against them in access to education and employment.[49] The monocultures of cash-crop cultivation have left many places in West Africa and the Americas with eroded soil and increased exposure to environmental disaster. It is impossible to heal the harm done to past, present and future generations by these actions. The museum sector, let alone any individual museum, is not singly responsible for the injustices wrought by Atlantic enslavement. But people and institutions, including museums, help to define, maintain and change a society's guiding values. At the founding of the Fitzwilliam Museum, those values included white supremacy and a willed blindness to the lives of people who lived in

48. One report has estimated the median wealth per adult in Jamaica at $5,976, or 4.5% of the median wealth per adult in Britain ($131,522). The authors assess the quality of data for Jamaica as 'poor'. Anthony Shorrocks, James Davies and Rodrigo Lluberas, *Global Wealth Databook 2021* (June 2021). See Table 2-1 for country details including a rating of wealth data quality for Jamaica, p. 22; Table 3-1 for median wealth by country, pp. 116 and 118. Note that there is scant economic literature on the microeconomics of Jamaica, such as assessing trends in household wealth over time. Future research could compare the picture to the United States, where one in three African-American households has no assets. On household wealth in the United States, see Mehrsa Baradaran, *The Color of Money: Black Banks and the Racial Wealth Gap* (Cambridge, MA, 2017), p. 249.
49. See the report by Runnymede: Omar Khan, *The Colour of Money: How Racial Inequalities Obstruct a Fair and Resilient Economy* (London, April 2020); see also Jake Subryan Richards, 'On Black Lives Matter', *HA News* (Autumn 2020), pp. 6–7.

slavery. To confront this past is the first step in determining how to change those values.

To imagine another museum, and another society, is possible.[50] The Fitzwilliam Museum has come a long way from being simply the 'good, substantial and convenient' institution that the founder envisaged. There is still a long path ahead, full of possibility. In the United Kingdom, museums will need to become places where people learn about this painful history. The process may start with rethinking the conventional categories of the galleries, such as the Italian Renaissance or the seventeenth-century Dutch so-called 'Golden Age'. Supporting contemporary artists can help them to imagine the future of the museum. The process must transcend the institution's walls. In West Africa, South America, the Caribbean, North America and Britain, the Fitzwilliam Museum should invest resources within a reparative framework to give people who have been disadvantaged by the global economy a better quality of life. Such a framework requires developing long-term, evidence-based projects in these regions with a commitment to sufficient investment from the University of Cambridge and its museums. In 2022, the Church of England, which also profited from South Sea Company annuities, announced reparations of £100 million in response to research into this history.[51] Cambridge's investment should include a capital commitment but should stretch beyond that to considerations of academic and cultural forms of investment. The terms of such investment should be established in equal partnership with people in each of these key regions. The process succeeds when a more just world is born.

50. Clémentine Deliss, *The Metabolic Museum* (Berlin, 2020).
51. The Church of England, Press release, 10 January 2023, https://www.church ofengland.org/media-and-news/press-releases/church-commissioners-publishes-full-report-historic-links (accessed 23 May 2023).

1

Glimpses of the world before Atlantic enslavement

West Africa, the Caribbean and Europe had independent histories before being connected through violence by transatlantic enslavement. Each had complex social and material cultures.

In sub-Saharan West Africa, people formed political communities with extensive agricultural systems, long-distance trade networks and rich cultural lives. In the Caribbean, the diverse Indigenous peoples developed their own artforms and sophisticated political systems.

Enslavement existed as an alternative to execution for war captives across all these societies, but to different degrees. Importantly, before the transatlantic slave trade, enslavement was neither racial nor necessarily inherited.

We can still glimpse these worlds through the objects these people made and those that collectors have given to Cambridge institutions.

Alternative view of 25

Africa: Akan goldweights

Among the great cultures of sub-Saharan West Africa were the Akan — a linguistic group comprising the Asante, Fante, Brong, Akyem, Akwapim, Akwamu, Kwahu, Aowin, Wassa, Assin, Denkyira, Sehwi and the Adansi ethnic groups of present south-western Ghana and south-eastern Côte d'Ivoire [see map 1, p.180]. Over centuries, the Akan mined gold, and sold it on vast trading routes across the Sahara Desert.

From the 1400s, they developed a system of 'mmbrammɔ', or goldweights, to measure gold dust, the Akan currency.

Goldweights were acquired by both Dutch and British colonial collectors, but in the late nineteenth and early twentieth centuries they were also gathered by Black collectors. Through lifetime gifts and bequests, these goldweights were accessioned into the University of Cambridge Museums.

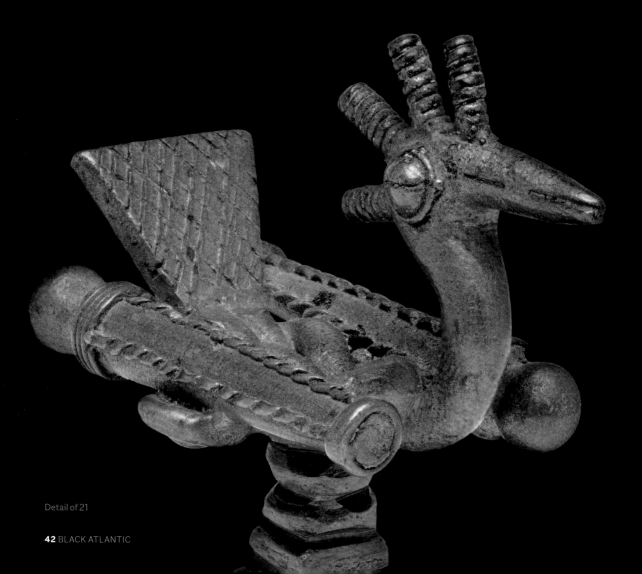

Detail of 21

Narratives of a people

Benjamina Efua Dadzie

'Sikafutuo abrammɔ' (or goldweights) was a system developed by the Akan people to measure on portable scales [16] gold dust, their currency, from the fourteenth century until the colonial period, when its use was discouraged in favour of colonial government-issued currency. Skilled metalworkers cast highly individual weights, mainly in brass but also in copper and silver, to give form to the rich Akan tradition of 'mmbɛ' (proverbs) as well as belief systems, weaponry, animals, birds and the geometric forms of Akan symbology [17—21]. Traders travelled great distances across the Sahara Desert with these weights, along with their scales, blowers, sifters and spoons, to effect their transactions. Far from home, these goldweights acted as material ambassadors for Akan values and culture.

I first learnt of Akan goldweights during an undergraduate class at the University of Manchester in 2014. As an Akan person — Denkyira to be exact — I have always been aware of the importance of language and the use of proverbs; and of how a truly cultured Akan person is recognised by their mastery and skilful use of proverbs in speech. This notion is clearly illustrated in the Akan proverb 'onipanyansafuɔ yebu nɔ bɛ, yennka nɔ asɛm', meaning 'the wise is spoken to in proverbs, not in words.' This means that in Akan culture, only a person who is properly educated in Akan knowledge systems is able to communicate in proverbs, which are regarded as a linguistic device to filter, conceal, or otherwise emphasise one's utterances and statements. What I did not know about was the existence of Akan goldweights as physical embodiments of these proverbs, and their use by Akan people as tools for handing down their worldview for generations.

I became eager to know more as a means to learn about the people I belong to culturally, but whose history I have yet to understand fully, because of both my upbringing and education in Europe. That said, I do not believe that things would have been any different had I been raised in Ghana, where I was born. The work of scholars like Timothy Garrard, Peggy Appiah and Alexander Atta Yaw Kyerematen has greatly aided my study of the making and meaning of Akan goldweights. Garrard produced the most extensive work to date on goldweights, which, misleading though it may be in parts with regard to the origin of the weight standards, remains an indispensable guide to understanding the context from which this system emerges. Appiah's collection of proverbs through-out the Akan territory in Ghana provides a vital reference-work for the meaning of goldweights and is a piece of scholarship whose value cannot be underestimated. Kyerematen, a Ghanaian anthro-pologist who trained at Fourah Bay College, Durham University and Oxford University, and who was the founder and first Director of the Centre for National Culture in Kumasi, Ghana, published on goldweights as part of his work that focused on the preservation of his native Asante culture, in all its forms, for the benefit of Ghanaian people.

16
Unrecorded Akan makers
Small balance scale for weighing gold and scoop
Kingdom of Asante (Ghana) likely late nineteenth or early twentieth century · brass

Cambridge University Library: ORCS.4.05 purchased from a Hausa trader by D.M. Lawson when working as a Gold Coast telegraph engineer between 1926 and 1932, and later donated to the Royal Commonwealth Society, whose collections were acquired by Cambridge University Library in 1993 photo: reproduced by kind permission of the Syndics of Cambridge University Library

17—21

Unrecorded Akan makers
Goldweights

Kingdom of Asante (Ghana)
unknown date, perhaps
nineteenth century · brass

Museum of Archaeology and Anthropology,
University of Cambridge · photos: Museum
of Archaeology and Anthropology, Cambridge

Clockwise from top

17 · *in the shape of a European sword*
2010.254 · presumed collected by Sir Cecil
Hamilton Armitage; purchased by Maurice
Cockin; inherited by Celia Barclay, 1961;
given by Dr Gordon Barclay, 2010

18 · *in the shape of an Akan sword*
1927.173.2 H · bequeathed by Professor
Sir William Ridgeway, 1927

19 · *in the shape of a bird with a body
formed as a 'Nyaconton' or god's knot,
and European cannon for wings*
2015.241 · given by Mrs Sylvia Spooner and
Professor Edward T. Spooner, 2015; acquired
by Arthur C. Spooner between 1926 and 1963

20 · *in the shape of a 'nsin dua'
(carved wood) bowl with four birds
perched on its rim*
1934.1123 I · given by Mrs Bernard Senior,
1934, from her husband's collection

21 · *in the shape of a 'sankofa' (go back
to fetch) bird, which refers to an Akan
proverb on the importance of learning
from the past in order to face the future*
1981.81 B · given by Mrs G.A. Cruise from the
collection of her husband, Mr L. Cruise, 1981

From the late 1400s, skilled metal-
workers cast highly individual brass
weights giving form to the rich Akan
tradition of 'mmɛ' or proverbs, as
well as to its belief systems, weaponry,
animals and the geometric forms of
Akan symbology. Traders travelled
great distances with these weights,
along with scales, blowers, sifters
and spoons, to conduct transactions.
Even far from home, the weights
were ambassadors for Akan values
and culture.

22

Unrecorded Akan maker
Goldweight
in the shape of a warri board
Kingdom of Asante (Ghana)
unknown date, perhaps
nineteenth century · brass

Museum of Archaeology and Anthropology,
University of Cambridge: Z 14833.14
donated in 1951 with unrecorded provenance
photo: Museum of Archaeology and
Anthropology, Cambridge

Many goldweights depict 'oware' or
'warri', a two-player board game that
was popular among the Akan and is
still enjoyed within some communities
today. The game involves 48 nickernut
or seed counters, distributed in four sets
in each pit, except the pits at the ends,
where captured counters are collected.
Through strategic play, the objective is
to outwit the opponent and accumulate
25 or more counters.

23

Unrecorded maker
Warri board
in the shape of a boat,
with playing counters
probably West Africa
likely early-to mid-twentieth
century · wood and seeds

Cambridge University Library: ORCS.4.07
presented by Mrs Marjorie Gibb, 1962, to
the Royal Commonwealth Society, whose
collections were acquired by Cambridge
University Library, 1993 · photo: repro-
duced by kind permission of the Syndics
of Cambridge University Library

Thanks to the ground-breaking work of these scholars, I quickly became aware that Akan goldweights had roles extending far beyond their functional one as tools in weighing gold. These small portable weights embody enormous cultural significance, which is as enduring as the metal from which they are cast. Easily transportable, they allow time travel, so that present and future generations can reach back and gain insights into their ancestral histories. Many goldweights depict objects that directly link past to present.

Some depict 'oware' (warri), a two-player board game popular among the Akan and still enjoyed within some African communities today [22]. The game involves collecting 48 nickernut or seed counters, distributed in four sets in each pit, except the pits at the ends, where captured counters are collected, as seen in this West African warri board, elaborately carved in the shape of a boat, now cared for by the University Library of Cambridge [23].

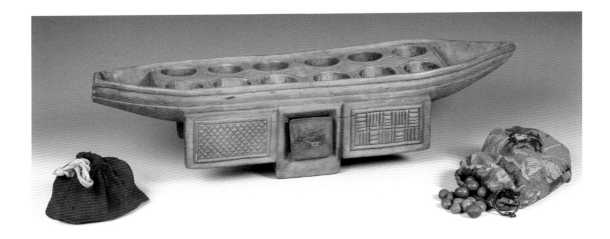

24–26

Unrecorded Akan makers
Goldweights
Kingdom of Asante (Ghana)
unknown date, probably
twentieth century · brass

Museum of Archaeology and Anthropology,
University of Cambridge · photos: Museum
of Archaeology and Anthropology, Cambridge

24 · *in the shape of a piece
of knotted leaf or fibre*
1970.19

25 · *in the shape of a man sacrificing
a bird to Nyame at the Nyame Dua,
which has a bowl containing three
eggs in its fork*
1970.18

26 · *in the shape of a four-sided pyramid*
1970.16

These three weights were collected
by the Ghanaian anthropologist
Dr Alexander Atta Yaw Kyerematen.
He appears to have given them, along
with two others, to Mary Cra'ster, an
assistant at the Museum of Archaeology
and Ethnology in the 1970s, during a
research trip to Cambridge. The Museum
of Archaeology and Anthropology (as
it is now called) owns more than 700
Akan goldweights.

Through strategic play, the objective is to outwit the opponent
and accumulate 25 or more counters. It is regarded by some
as a metaphor for precolonial political power that required the
recruitment of people. The UL's warri board (together with the
portable balance scale for weighing gold [16]) is now part of its
Royal Commonwealth Society (RCS) Library holdings, having
originally been presented to the Royal Commonwealth Society
by Marjorie Gibb in 1962. The RCS Library was acquired by
Cambridge University Library in 1993, and comprises the coll-
ections amassed by the Colonial Society, founded in 1868, and
its successors: the Royal Colonial Institute, Royal Empire Society
and Royal Commonwealth Society. Numbering over 300,000
printed items, over 900 archival collections and over 125,000
photographs, the RCS Library represents an enormous repository
of information on the Commonwealth and Britain's former colonial
territories and is the embodiment of colonial enterprise.

Since that undergraduate class, I have had the opportunity to learn
about the sheer variety of weights that exist and about several
Ghanaian collectors whose prized goldweights made their way to
places like Cambridge. In my former role as Collections Assistant in
Anthropology at the Museum of Archaeology and Anthropology in
Cambridge, I was particularly pleased to encounter William Assah-
Kisseadoo, a student or trader who had been based in Clarendon
Street, Cambridge, in the 1910s. He gifted a 'set of thirty-three
brass weights [...] used for the handling of gold dust, in the reign
of King Prempe [*sic*] [...]' to MAA in 1915.

I was equally delighted to discover that five Akan goldweights from
the collection of Alexander Atta Yaw Kyerematen had also made
their way to MAA but not as a direct gift from him. Kyerematen had
given them to Mary Cra'ster, an Assistant Curator at the Museum
of Archaeology and Ethnology (as MAA was then known), and she

donated them to MAA in the 1970s. Whether she had been asked to do so by Kyerematen is not known, but certainly his family are pleased that his goldweights have ended up in this particular collection. Three of Kyerematen's gifts are shown here: the knotted fibres [24] are the symbol of wisdom, while the other two weights refer to Nyame, the supreme god in Akan cosmology. One takes the form of a figure sacrificing a bird at the 'Nyame Dua', or tree of god [25], the other a geometric structure pointing skywards, possibly to Nyame's dwelling place [26].

While I have been able to glean details about the context from which Kyerematen's collection emerges through his published work, former colleagues and family members, similar provenance research into Assah-Kisseadoo and his collection has proved far more challenging. Like generations before him, might a story of Assah-Kisseadoo be learnt through the iconography of the goldweights he donated?

Further reading
• Albert Ott, 'Akan Gold Weights', *Transactions of the Historical Society of Ghana*, vol. 9 (1968), pp. 17–42: https://www.jstor.org/stable/41674621
• Timothy F. Garrard, *Akan Weights and the Gold Trade* (London, 1980)
• Marion Johnson, 'Gold-Weights', *The Journal of African History*, vol. 24, no. 1 (1983), pp. 112–14 http://www.jstor.org/stable/181866
• Samuel Gyasi Obeng, 'The Proverb as a Mitigating and Politeness Strategy in Akan Discourse', *Anthropological Linguistics*, vol. 38, no. 3 (1996), pp. 521–49: https://www.jstor.org/stable/30028601
• Peggy Appiah, Anthony Appiah and Ivor Agyeman-Duah, *Bu Me Be: Proverbs of the Akans*, 2nd edn (Ayebia Clarke Publishing Ltd, 2007)
• Benjamina Efua Dadzie and Barima Asumadu Sakyi, 'Alexander Atta Yaw Kyerematen and Akan Goldweights at MAA' blog, *University of Cambridge Museums Collections in Action*, posted 10 January 2022. https://www.museums.cam.ac.uk/blog/2022/01/10/alexander-atta-yaw-kyerematen-and-akan-goldweights-at-maa
• https://www.lib.cam.ac.uk/rcs (for the Royal Commonwealth Society Library holdings at the University Library, Cambridge)

Indigenous islands in the Caribbean Sea

From ancient times, Indigenous people in the Caribbean migrated along two sweeping paths between the mainland and the islands. One route ran from Yucatán to Cuba and southwards, the other from the Guianas through Trinidad northwards up the Lesser Antilles [see map 2, p.180].

As people settled on the islands, they built villages, grew crops and expressed themselves through pottery and stone sculptures of human faces and animals.

In the 1800s, almost 400 years after the Spanish conquest of these islands and subsequent suppression of these cultures, Sir Thomas Graham Briggs, a former Cambridge student, whose family owned plantations in Barbados, collected objects originally owned by Indigenous groups. These then entered the collections of the University of Cambridge Museums.

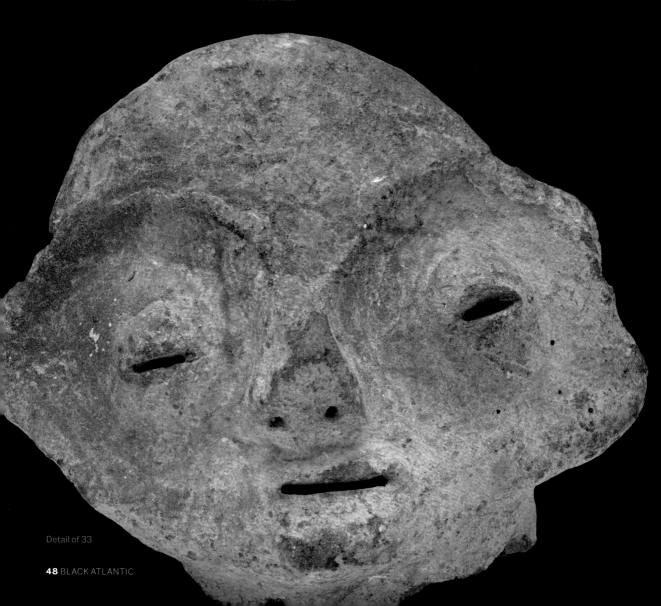

Detail of 33

Tangible legacies: the material culture of Caribbean Indigenous peoples

Jimena Lobo Guerrero Arenas

27
Unrecorded Indigenous Caribbean maker/s
Duho
ceremonial seat for a leader
Taíno chiefdom (Haiti)
fourteenth century
guayac wood (*Guaiacum sp.*)

Musée du Quai Branly — Jacques Chirac: 71.1950.77.1 Am · given by Mr and Mrs David David-Weill, 1951 · photo: Musée du Quai Branly — Jacques Chirac, Dist. RMN-Grand Palais · © image Musée du Quai Branly — Jacques Chirac

This 'duho' or ritual seat was made at the height of Taíno culture (1000s–1500s) on the island now home to Haiti and the Dominican Republic. A creature that is part-human and part-animal stands on all fours. In bold curving lines, the sculptor has dressed the creature in a cotton belt around its middle, an object of great value that chiefs gave each other as gifts. Taíno people gathered around this wooden throne for political and spiritual ceremonies.

The Caribbean has a rich and long history marked by encounters, mobility, change and continuity. In this regard, the Caribbean shares similarities with other regions of the Americas, but also boasts its own distinct characteristics. Notably, the region's inter-action with nature stands out as particularly unique. Approximately 6,000 years ago, from the first migrations coming from the Yucatán region of Mexico and from north-eastern South America, people arrived to pristine environments and found their ways of relating to them.

Magnificent wood sculptures played a key role in society and speak of people's interactions with their habitat. For centuries ceremonial seats known as 'duhos' were crafted out of a single trunk using two main types of wood: *Guaiacum sp.* and *Cordia sp.* The 'cacique' (leader) would sit in a 'duho' to witness the 'batey' (or ball game) and also during the 'cohoba' (*Piptadenia peregrina*) ritual. Highly decorated belts made with shell beadwork and cotton weave were prized possessions among 'caciques'. The carved band on the back of this large (71.5 cm in length, 30.6 cm in width, and 42.5 cm in height) and well-preserved 'duho' [27] depicts a belt wrapped around the figure's waist. The arms would also be adorned with cotton bands. These intricate works of art, symbolising power and authority, were passed down from generation to generation of leaders.

Finely polished green and black stone celts were used to create the so-called 'petaloid' axes, for their resemblance to flower petals, or almond-shaped 'amygdaloids' such as this elongated axe of black polished stone from Santa Cruz (present-day Jamaica) [28] or this smaller adze of polished green stone found in St Vincent [29].

Unrecorded Indigenous Caribbean makers
unknown date, pre-Columbian

Museum of Archaeology and Anthropology, University of Cambridge · photos: Museum of Archaeology and Anthropology, Cambridge

28
Elongated axe
Jamaica, Santa Cruz District
(Yamaye) · black stone
1888.46.3 A · collected and
given by Joseph Jackson Lister,
1888

29
Adze
St Vincent (Hairouna)
green stone
E 1894.47 · collected by
Sir Thomas Graham Briggs
(1833—1887); purchased from
Charles Kenrick Gibbons
(1856—1918), 1894

30
*Long knife with
serrated edges*
St Vincent (Hairouna) · stone
1901.2 · collected by Brown
of Bellair in St Vincent in 1900
and given by Charles Cave in
May 1901

31
*Large axe,
possibly an axe head*
Haiti (Ayiti) · stone,
probably rhyolite
1951.355 · given by Louis
Colville Gray Clarke, 1951

32
Large axe
Antigua (Waladli) · stone
Z 2510 · collected by Sir Thomas Graham
Briggs (1833—1887); purchased from Charles
Kenrick Gibbons (1856—1918), possibly 1890

33
Votive head
St Vincent (Hairouna) · burnt clay
E 1894.50 · collected by Sir Thomas Graham
Briggs (1833—1887); purchased from Charles
Kenrick Gibbons (1856—1918), 1894

34
Amulet in the shape of a fish
St Vincent (Hairouna) · soapstone
Z 39515 (alternatively, 1894.52) · collected
by Sir Thomas Graham Briggs (1833—1887);
purchased from Charles Kenrick Gibbons
(1856—1918), possibly 1894

35
**Unrecorded Indigenous
Caribbean maker**
Walking stick
Dominica (Wai'tukubuli
or Kairi) · late nineteenth
or early twentieth century
wood and basketry

Museum of Archaeology and Anthropology,
University of Cambridge: 1937.1320 B
given by Walter William Skeat, 1937
photo: Museum of Archaeology
and Anthropology, Cambridge

In addition to petaloid axes, Indigenous peoples crafted other work tools, including elongated lithic burins, distinguished by having both ends sharpened. These tools would have been used to carve, in different materials, spiritual deities called 'zemís' (or 'cemís'). Oblong eyes were a distinctive feature of the Taíno depictions of 'zemís'. The elongated eyes of this small clay head [33] bear a resemblance to the zemi called 'Itiba Cahubaba', or the 'Great Bleeding Mother'. The term 'zemí' refers to both a deity or ancestral spirit and to objects such as this one, which were used to house these spirits.

Igneous rocks were also selected to make tools for agricultural work and clearing land, carving canoes, cutting manioc root and food preparation. Some were crafted with in-built handles, such as this large axe with a rounded blade from present-day Antigua [32] and this long knife with serrated edges from St Vincent [30]. Others were carved into a petaloid shape like this celt (or axe-head) from Haiti that would have been hafted into a wooden handle to create a multi-purpose tool [31].

This animal-shaped stone amulet, also from St Vincent, is catalogued as a fish but may also be a bird with a beak [34]. Amulets, usually worn as pendants on necklaces or strapped to the forehead, served as talismans providing protection in battle. Many carvings made by Indigenous peoples living in the Caribbean islands depict the mythical 'inriri', or woodpecker, which supposedly formed the female sex with its beak. Are we looking at a woodpecker on the carved handle of this nineteenth-century walking stick from Dominica [35], whose shaft has been assiduously covered in woven basketry? Throughout history, in Ayiti, Wai'tukubuli or Kairi, Yamaye, Waladlí and Hairouna, the original indigenous names of the islands where all these objects were found, Indigenous peoples had a complex and constant interaction with their environment.

Some of these objects [29, 32–34] were gathered by Sir Thomas Graham Briggs (1833–1887), whose collection was sold in part to the Museum of Archaeology and Ethnology in 1894 by his nephew, Charles Kenrick Gibbons (1856–1918), son of Lt Col William Barton Gibbons (1802–1872), a Justice of the Peace for Barbados, who was compensated in 1836 along with other family members for the Sandfords estate in Barbados following the abolition of slavery.

Further reading
• René Herrera Fritot, *Estudio de las hachas antillanas: creacion de índices axiales para las petaloides* (1964)
• Samuel M. Wilson, *The Archaeology of the Caribbean (Cambridge World Archaeology)* (Cambridge, 2007): https://doi.org/10.1017/CBO9780511816505
• William F. Keegan, Corinne L. Hofman and Reniel Rodríguez Ramos, *The Oxford Handbook of Caribbean Archaeology* (2013)
• Joanna Ostapkowicz, Christopher Bronk Ramsey, Fiona Brock, Caroline Cartwright, Rebecca Stacey and Mike Richards, 'Birdmen, cemís and duhos: Material studies and AMS 14C dating of Pre-Hispanic Caribbean wood sculptures in the British Museum', *Journal of Archaeological Science*, vol. 40 (December 2013), pp. 4675–87: https://doi.org/10.1016/j.jas.2013.07.015

Alberta Whittle's 'Hindsight is a luxury you cannot afford'

Sandra De Rycker

With this work [36] Barbadian-Scottish multimedia artist Alberta Whittle urges us to pause and reconsider the present and damaging legacies of colonialism. Using collaborative creation and proposing that we join her in actions of 'collective care', Whittle carefully subverts accepted 'histories' of the European colonisation of a so-called 'New World', reimagining alternate possibilities as a means to resist injustice.

Hindsight is a luxury you cannot afford (the Conjuror) incorporates imagery adapted from the sixteenth-century engravings of Theodor de Bry (1528–1598). Originally published to accompany travel narratives of the early years of European colonisation, De Bry's works illustrated the arrival of Columbus in the Americas. Produced in the medium of print, some illustrations offered characterised depictions of the people and landscapes, while others portrayed the colonists' brutal violation and suppression of Indigenous peoples. These disturbing images became a widely distributed and accepted visualisation of European historical constructs of colonists' so-called 'new world discovery'.

36a
Alberta Whittle · born 1980
The Conjuror — looking back and looking forward
2021 · photo-etched copper plate with ink residue diptych, each mounted on a hand-carved music stand

photo: Patrick Jameson · © Alberta Whittle, all rights reserved, DACS/Artimage 2023 courtesy of the artist and The Modern Institute/Toby Webster Ltd, Glasgow

36b

Alberta Whittle · born 1980
Hindsight is a luxury you cannot afford (the Conjuror) · 2021
photo etching on copper plate printed on Somerset Velvet 250gsm

edition of five plus two artist's proofs · photo: Patrick Jameson · © Alberta Whittle,
all rights reserved, DACS/Artimage 2023 · courtesy of the artist and The Modern Institute/
Toby Webster Ltd, Glasgow

On two copper plates, and one resultant print, Whittle has reimagined a sixteenth-
century illustration to a text of Christopher Columbus's exploits in the 'New World'
in which an Indigenous 'Conjuror' is described as being 'very familiar with devils'.
Whittle has removed the print's original text and reworked the surrounding land-
scape to re-contextualise the Indigenous man. The wooden music stands are carved
with ears, supporting the printers' plates like a musical score, suggesting we listen
out for, as well as look at, the many ways long-lasting colonial words and images
affect our present.

During the making of this edition, Whittle appropriated and reimagined a De Bry engraving titled *The Conjuror* (a highly stylised depiction of an Indigenous figure) to create new work using methods of print. Removing the historic text and transposing the imagery, Whittle reworked the landscape, by hand, using her own fluid drawings, creating deliberately hard-to-read areas and bringing the Indigenous figure to the foreground. This imagery was then transferred and photo-etched into a copper printing plate ready to receive the vividly coloured ink reflecting Whittle's memories of Barbados.

Whittle's traditional choice of copper to develop these prints interrogates historic publishing, the authority of the printed document and its role in shaping ideologies. For Whittle, copper also evokes the 'copper-bottomed' wooden ships that carried migrating invaders: copper lining was used to protect against shipworms,[1] a similarly non-indigenous 'invasive' marine species that gradually consumed the wood of voyaging boats — a reminder of the ever-present migration, extraction and power at the core of such invasions.

Prints are artworks that sustain present traces of past actions, in this case the inky imprints and deep emboss of the textured copper plate upon the paper. Once removed from the print, such plates are usually discarded or remain hidden inside the studio. For *The Conjuror — looking back and looking forward*, Whittle instead chose to display the unseen mechanisms of print, retaining the inky copper plates and incorporating them into a sculpture.

Exhibited here alongside the print, with the copper plates replicated and inverted (prompting us to look both forward and back), this work reopens a dialogue between past and present, seen and unseen; an opportunity to reconsider what is missing, to highlight how past actions shape present representations — what has been removed from such narratives?

The wooden music stands support and elevate the usually unseen printers' plates, like a musical score, resonating with unwritten narratives — asking us to listen. Whittle co-opts the reversals that are part of the printing process to offer alternate ways of seeing, to show the stories covered (rather than discovered) by the repressive and inflexible language of colonial histories. Using the inversions of print to infuse this work with markers of human presence, Whittle breathes life and warmth back into these narratives, offering up the unseen, that we may listen to the wider story.

1. Whittle has also cited shipworms as collaborators and 'co-conspirators' in her other works that incorporate wooden printing blocks eaten into and shaped by shipworms prior to their use in the studio.

Europe: slavery before racism, Blackness before slavery

From the ancient world to the present day, many societies have enslaved people under different circumstances.

Enslavement meant many things within different cultures, but generally the enslaved were designated as powerless outsiders whom others could buy and sell. In ancient European cultures, the victors in battle often punished the vanquished with enslavement.

Before the era of Atlantic enslavement, European artists rarely portrayed Black people. When they did, they usually depicted them as honourable individuals. From the 1600s onwards, as the enslavement and trafficking of African people gathered momentum, the modes of depiction changed, and became increasingly racist.

The work by contemporary artist Barbara Walker imagines an alternative to the historic marginalisation and secondary status that African people have been accorded in European art for centuries.

Detail of 38

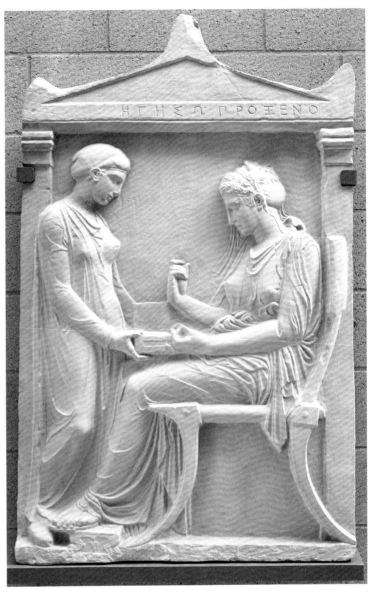

37

Unrecorded ancient Greek maker
Grave stele of Hegeso, daughter of Proxenos
plaster cast · *c.*1884 · made by Martinelli, Athens
after a Pentelic marble original, Athens · *c.*400 BCE

Museum of Classical Archaeology, University of Cambridge: 206 · purchased from
Martinelli, 1884 · photo: Museum of Classical Archaeology, Cambridge

In this nineteenth-century plaster cast of a 400 BCE original, a Greek woman
named Hegeso sits in a rippling dress as she chooses jewellery from a box presented
by an unnamed young woman. Rather than racialised characteristics, the adolescent's
shapeless dress, smaller stature and lack of name mark her out as enslaved. Like most
stelai, or tombstones, the image and inscription commemorate only the elite person's
status and ignore that of the enslaved person.

38

Unrecorded Ancient Roman maker
Relief of soldiers leading enslaved chained men with a wild animal fight below
Smyrna (Izmir, Turkey)
200 CE · marble

The Ashmolean Museum, University of Oxford: AN Michaelis 137 · bequeathed by John Selden, 1654 · photo: © Ashmolean Museum

As with the tombstone of Hegeso [37], clothing — or lack of it — is the chief marker of captivity in this marble relief from the Roman city of Smyrna. The top two rows feature clothed, helmeted soldiers leading chained, almost naked men. They are likely war captives or social outcasts. In the bottom row, a lion kills a bull whilst an ibex fights a second lion. A fight with the animals may await the captives.

39

Jan Jansz Mostaert · *c.*1474—1552/53
Portrait of an African Man · *c.*1525—30 · oil on oak panel

Rijksmuseum, Amsterdam: SK-A-4986 · purchased in 2005 from the art dealer R. Noortman, Maastricht, with support from the Vereniging Rembrandt and additional funding from the Prins Bernhard Cultuurfonds, the Mondriaan Stichting, the VSBfonds, the BankGiro Lottery and the Rijksmuseum Fonds · photo: Rijksmuseum, Amsterdam

The Dutch artist Jan Mostaert draws attention to this man's gloved hands and what he holds: a sword and a luxurious bag — both signs of wealth and high status. This portrait suggests the wide-ranging roles that Black people played in Europe before the era of transatlantic enslavement. The man's identity is uncertain but he may be Christophle le More, an archer and bodyguard to the Holy Roman Emperor Charles V.

40
Barbara Walker · born 1964
Vanishing Point 17 (Veronese)
2020 · graphite on embossed Somerset Satin paper

Barbara Walker reimagined the National Gallery's *Adoration of the Kings* by the sixteenth-century painter Paolo Veronese using pencil and white embossed paper. She shifts our gaze to the lines of sight of three Black figures, the king (left) and two anonymous Black attendants. Rather than the angels above or the kneeling kings, these three people's view of the Christ Child now captures our attention.

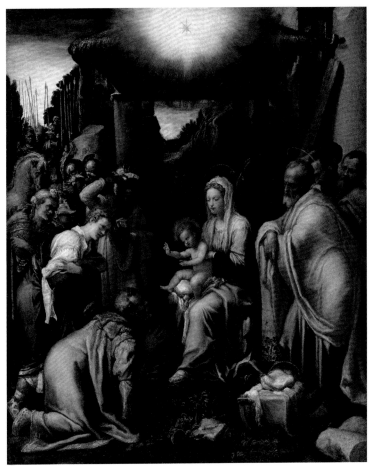

41
Taddeo Zuccari · 1529—1566
Adoration of the Kings · 1555—60 · oil on panel

Although the Bible only speaks of 'wise men from the East' bringing gifts to honour the new-born Christ, the Italian painter Zuccari followed European artistic conventions by depicting three kings — one of whom is a Black African named Balthazar. Zuccari painted this king as equal to his peers in terms of richness of costume and closeness to Christ. Over time, interconnections of religion, racism, enslavement and colonial power influenced the image of the Black king.

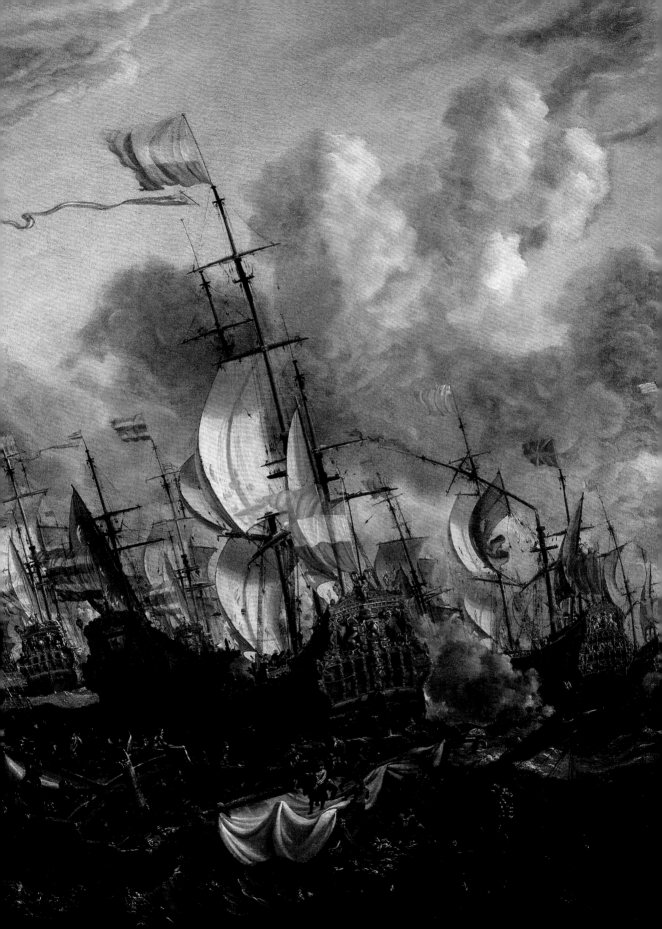

2

Cambridge wealth from Atlantic enslavement

Trading companies in seventeenth-century Europe were crucial to slave-trading and colonial expansion. Inspired by Dutch models, slave-trading companies, including the Royal African Company (RAC) and South Sea Company (SSC), were founded in Britain with state support.

Operating from the coastal forts, merchants employed by these companies lent guns and traded goods to enslavers within sub-Saharan Africa. Repayment took the form of war captives. This cycle of guns for captives expanded into systematic and ruthless methods of trafficking. Profits from this trade flowed into the family of the Fitzwilliam Museum's founder. Over time, they also shaped the collections across the Cambridge University Museums.

In the 1600s and 1700s, enslavement also permeated daily life in Britain: scientists created hierarchies of skin colour and coins celebrated the royal patronage of slave-trading. To make the defence of trading routes and slaving voyages more successful, Parliament offered a prize to any person able to invent an instrument to calculate a ship's position at sea accurately.

The wealth and prestige generated by enslavement, allowed the University of Cambridge to gather objects, art and materials from across the globe. These collections both reinforced and celebrated Britain's position as the leading Atlantic slave-trading power of eighteenth-century Europe.

Detail of 8

Royal patronage

From the fifteenth century, ruling monarchs in Europe gave crucial financial and political support to establish overseas empires. In Britain, the crown sponsored expeditions to acquire colonies in North America and the Caribbean.

White colonisers attacked and committed a genocide of Indigenous peoples through firepower and the spread of European diseases. They claimed land rights and used forced labourers to grow crops.

Initially, white people, including servants and people convicted of crimes, worked for a fixed period on plantations alongside captive African people. By 1700, British colonies passed laws that created racial categories and stipulated that white people were free whereas Black people were enslaved. This colour bar disregarded the truth that there is a single human race.

Discrimination was reinforced by historical racist science, promoted by The Royal Society, Britain's leading scientific institution.

Detail of 46

The Royal Society and the Royal African Company: scientific enquiry and enslavement

Eleanor Stephenson

42

The History of the Royal Society of London, for the Improving of Natural Knowledge
frontispiece (London, 1667)

The Royal Society, London: 7769 · once owned by Jeanne Antoinette Poisson, Marquise de Pompadour (1721—1764)
photo: © The Royal Society

The newly restored King Charles II, depicted here as a classical sculpture, sponsored the Royal Society, Britain's chief scientific body, and the Company of Royal Adventurers of England Trading into Africa in the same year. In this illustration for a book promoting the Society, navigational instruments, books and a gun appear in the foreground. In the background a long telescope is visible. The text describes these institutions of science and enslavement as twin sisters.

In his *History of the Royal Society* of 1667 [42], Thomas Sprat describes the Royal Society as the 'Twin-Sister' of the Royal African Company, a genealogical analogy stemming from their shared royal patron, Charles II, shown proudly on the frontispiece. Seven years earlier, on 28 November 1660, a group of 12 men gathered at Gresham College, London, and decided to set up a 'Colledge for the promoting of Phyisco-Mathematicall Experimentall Learning'. The following week, Sir Robert Moray, the first president of this society, 'brought in word from ye Court that The King [...] did well approve of it and would be ready to give an encouragement'. It was also in December 1660 that Charles II appointed the Councils of Trade and Foreign Plantations, chose to retain Jamaica, a Caribbean island captured from the Spanish under Oliver Cromwell, and granted a charter to the Company of Royal Adventurers of England Trading into Africa. The Company operated with a monopoly on English trade of gold and ivory along the west coast of Africa, and from 1663, the trade of enslaved African people. In the charters that Charles granted the 'Royal Society of London' in 1662, 1663 and 1669, the king was named Founder and Patron, and the

43

Frobisher's Gold (fool's gold)

Polar Museum, Scott Polar Research
Institute, University of Cambridge: N759a
given by A Hutchinson, 1927; originally
collected on the third expedition led by
Sir Martin Frobisher to Meta Incognita
(Baffin Island, Canadian Arctic), 1578;
later deposited at Dartford Priory
photo: Scott Polar Research Institute,
University of Cambridge

Many transatlantic expeditions began
as attempts to find a faster passage
to India than circumnavigating the
African continent. Martin Frobisher,
a late sixteenth-century slave-trader,
tried three times to find a northwest
passage above Canada. When he
brought home dark earth that seemed
to glimmer with gold, he won Queen
Elizabeth I's patronage. But the glimmer
was a mirage. Frobisher's 'gold' turned
out to be a worthless aggregate of
common minerals: fool's gold.

institution agreed to extend both the 'very arts and sciences'
and the 'boundaries of Empire' — a clear response to the Crown's
ambition to use science to expand empire.

In his text, Sprat compared Charles II to King Solomon, the Old
Testament ruler renowned for his wisdom, whose servants had set
sail for Ophir and returned with 'four hundred and twenty talents
of gold'. It was also Solomon who, in Francis Bacon's vision, had
established the institution of knowledge, Solomon's House, which
scholars have argued inspired the Society. Sprat commented that
'In both these Institutions begun together, our King has imitated
the two most famous Works of the wisest of antient Kings: who
at the same time sent to Ophir for Gold, and compos'd a Natural
History, from the Cedar to the Shrub.'

The geography of Ophir had been a topic of debate and interest
for centuries, especially from the mid-fifteenth century when
European explorers began to associate Ophir's riches of 'gold,
silver, ivory, apes and peacocks' with the 'New World'. In his 1578
publication, *A true discourse of the late voyages of discouerie*,
George Best compared the 'gold' discovered in the Canadian Arctic
Circle by the English privateer and slave-trader, Martin Frobisher,
with Solomon's 'pretious mettall of Ophir'. Though this 'gold' was
later found to be worthless — such as this sample [43] taken during
Frobisher's third and final expedition in 1578, which was sponsored
by Queen Elizabeth I — this rock symbolises the birth of the Crown's
imperial interests. To the late seventeenth-century reader, Sprat's
metaphorical comparisons would have been obvious: the Royal
African Company returned gold to their royal patron, and the Royal
Society returned the wisdom necessary to increase such riches.

In the first 40 years of the Society, at least 60 Fellows were share-
holders of the Royal African Company, and in 1682, one of these,
Abraham Hill, purchased shares on behalf of the Royal Society.
At Society meetings, Fellows sought to improve navigation and
various trades, including that of 'Fortifications' and 'Sugar-Makers',
and they also discussed the causes of skin colour, 'particularly of
the Negroes'. During the Presidency of Lord John Vaughan, the
former Governor of Jamaica, the Society discussed and published
Richard Waller's 'Table of coloures' [44], which he imagined would
be useful for describing 'the Colours of Natural Bodies'. The various
hues of black are named, 'Niger', and 'AEthiopicus' or 'Negro-Black'.
By connecting skin colour with artificial concepts of race, this table
illustrated contemporary acceptance of hereditary enslavement
based on skin colour, an idea central to the legal codes enforced in
English colonies by governors such as Lord Vaughan. To conclude,
these objects show that philosophical and material interests over-
lapped at the early Royal Society, and thus mark the beginnings
of institutionalised science as a tool of empire.

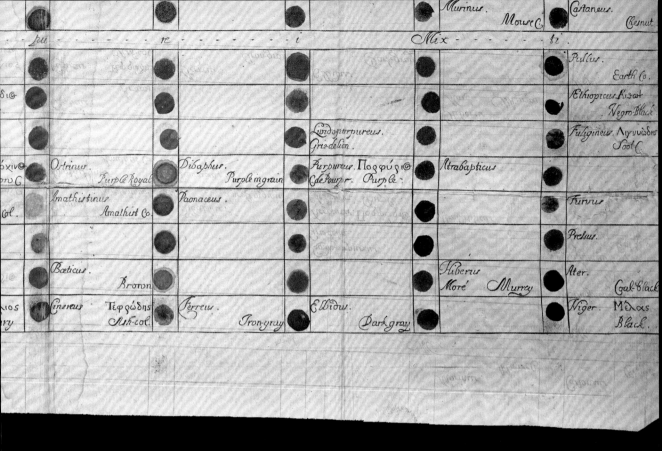

The colour chart contains handwritten colour names including:

Murinus. / Mouse C.
Cataneus. / Chesnut
Pullus. / Earth Co.
Æthiopicus Kiswot / Negro-Black
Fuliginus. Λιγνυωδης / Soot C.
Livido-purpureus. / Griz-delion.
Ostrinus. / Purple Royal
Dibaphus. / Purple in grain
Purpureus. Πορφύρ[eos] / Cde Pourpr. Purp. Co.
Atrabapticus
Amathistinus / Amathist Co.
Paonaceus.
Furvus
Prelius.
Bæticus. / Brown
Hiberus / More' Murrey
Ater. / Gal-Black
Cinereus Τεφρώδης / Ash-col.
Ferreus. / Iron-gray
Elbidus. / Dark gray
Niger Μέλας / Black

Enslavement, anti-Black racism and colour prejudice

There is only one human race: Homo Sapiens. And the origins of humanity lie in continental Africa. Yet white supremacists developed ideas that some people were from different racial groups than others. They used these ideas to claim that Black people were inferior to white people.

Richard Waller's 'Table of coloures' is one example of historical racist science. The only part of his colour chart that uses racialised language is among the darker tones. European traders, scholars and statesmen used this claim of Black inferiority to justify purchasing captive people in Africa and transporting them to the Americas as slaves.

In the Americas, colonial governments passed laws that meant that white people were free, and Black people were enslaved. It was almost impossible for an enslaved African person, or their descendants, to get freedom. Colonial societies developed arbitrary categories to classify anybody with Black ancestry as enslaved.

Keith Piper's *The Coloureds' Codex (Enlightenment Edition)* critiques how plantation managers used these made-up categories to identify and control enslaved people. The work challenges 'colourism': the assumption that lighter skin is somehow better. This colour prejudice continues to afflict many societies today.

Detail of 44

'The Coloureds' Codex (Enlightenment Edition)'

Keith Piper

The Coloureds' Codex [45] exists as an ironic and parodic commentary upon what evolved as an imposed hierarchy of social privilege within the brutal spaces of the slave plantations of the eighteenth and nineteenth centuries. They are a set of imposed hierarchies that still resonate into the present day, re-echoing through systems of 'colourism' and implied social and aesthetic value.

Historically, the use of skin colour — or 'complexion' — as a marker of one's position within the hierarchy of any given society has a history deeply entangled with the development of notions of class and the division of labour, especially within agrarian societies. Exposure to the elements and a resultant darker or 'ruddier' complexion would often differentiate those who worked the soil from social elites who could avoid physical labour, remain shaded and therefore pale. These hierarchies would be exported from Europe to the plantations of the 'New World'. Here they would differentiate not only the non-labouring plantation owner from the bonded European peasantry (who were often transported and pressed into agricultural labour on the plantations) but also, and more visibly, from the legions of enslaved workers from West Africa who had been imported to the Americas once the supply of Indigenous labour had been exhausted. The finely gradated hierarchical system that evolved in this context, with 'White' gentry at its pinnacle and newly imported 'Black' Africans at its base, would be further complicated by the results of sexual access that empowered men had to enslaved women. This resulted in the births of an array of individuals of 'mixed race' and intermediate skin tone who, in the twisted logic of the plantation, would often occupy intermediate spaces in its hierarchy.

The Coloureds' Codex imagines a 'toolbox' enabling a plantation overseer to locate the position of individuals within this hierarchy using the social divisions of 'White', 'House Negro' and 'Field Negro' as 'rational' guides.

44

Richard Waller · died 1715
'Table of coloures'
ink and watercolour on paper
from *Philosophical Transactions*,
vol. 16, issue 179 (1686—7),
pp. 24—5

Trinity College, Cambridge: 310 b 6A 8 · once owned by former Trinity student Thomas Kirke (1650—1706) · photo: reproduced by kind permission of the Master and Fellows of Trinity College Cambridge

Richard Waller published this table after years of discussing colour, including skin colour, at the Royal Society. To describe colours accurately users should compare an object with the 'nearest' colour on the chart, and then use the 'word affixt to that Colour'. The seventh colour from the bottom on the right is 'Æthiopicus' or 'Negro-Black'. This is one example of the enormous role European scientists played in the justification of enslavement and anti-Black racism.

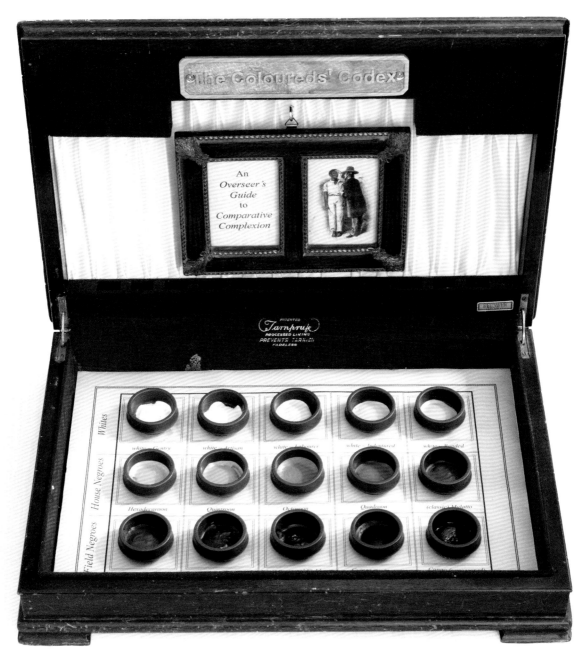

45

Keith Piper · born 1960
The Coloureds' Codex (Enlightenment Edition)
2023 · wood, paper, pigment

collection of the artist · photo: © Keith Piper

In May 2023, Keith Piper constructed this box with 15 pots of pigment arranged according to an invented system of skin tones. Slave-owning societies used arbitrary racial categories such as these to discriminate against people of Black heritage. Not every person in the Americas with Black heritage was enslaved, but they all suffered racial discrimination regardless of whether they were enslaved or free. Piper subverts how museums display historical material and highlights how racist ideologies continue to impact the present day.

The Royal African Company

William Pettigrew

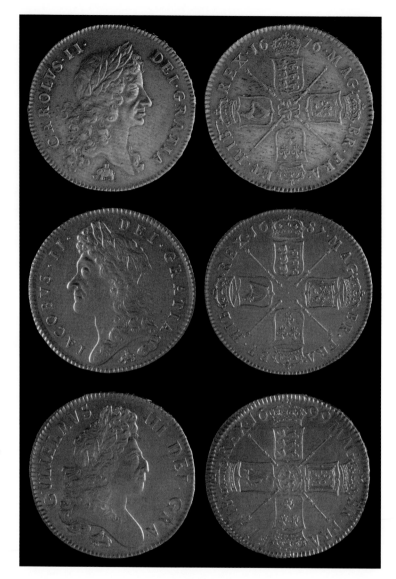

46—48

The Royal Mint, London
Five guinea coins
gold

Fitzwilliam Museum, University of Cambridge
originally made for the Royal African Company
photos: © The Fitzwilliam Museum,
Cambridge

46 · with head of Charles II
and Royal African Company logo
(under the monarch's head) · 1676
CM.YG.3606-R · bequeathed by
Arthur W. Young, 1936

47 · with head of James II
and Royal African Company logo
(under the monarch's head) · 1687
CM.YG.3629-R · bequeathed by
Arthur W. Young, 1936

48 · with head of William III
and Royal African Company logo
(under the monarch's head) · 1699
CM.5.1359-1933 · bequeathed by
James Stewart Henderson, 1933

Beneath the looming heads of three
British monarchs, a tiny elephant with
a castle on its back can be glimpsed. This
symbol indicates that the gold used in
these coins — mined by enslaved people
in West Africa — came to the Royal Mint
via the Royal African Company (RAC),
which Charles II helped to establish.
The RAC's elephant and castle logo
was last used on gold coins made in
1726, during the reign of George I.

The Royal African Company (RAC) was the single largest contributor to the transatlantic trade in enslaved African people, shipping
in the region of 150,000—160,000 captives between 1672 and
1731. The Company boasted a royal charter granting it a monopoly
over all English trade from modern day Morocco to the Cape of Good
Hope for a thousand years. Like its predecessor, the Company of
Royal Adventurers of England Trading into Africa, the RAC enjoyed
the right to coin African gold into what would become the largest
denomination in the English coinage, the guinea, named after
the seventeenth-century word for Africa.

Here we see guineas from three different reigns: a five guinea
coin of 1676 with the head of Charles II [46]; another of 1687
with James II's head [47]; and one of 1699 with William III [48].

All were struck at the Royal Mint in the Tower of London and include under the monarch's head a small elephant-and-castle, which was the RAC's logo (also shown on Seller's map of Africa [see 59]). The RAC logo indicates that the gold used in making the coin came to the Mint via the RAC.

The RAC proved to be a highly successful commercial organisation, sending out more than 500 ships between 1673 and 1713, minting 548,327 gold guineas, and importing 30,000 tons of sugar and large quantities of redwood dyestuffs and ivory into England. Based at Leadenhall Street in the heart of the City of London, the RAC maintained a network of fortified trading posts in West Africa where enslaved people were incarcerated prior to being shipped to the Americas. These included Fort William, Fort James, Fort Sekondi, Fort Winneba, Fort Apollonia, Fort Tantumquery, Fort Metal Cross, Fort Komenda and Cape Coast Castle, the last of which was the administrative centre.

The Company had especially intimate connections with the monarchy. Founded by King Charles II, and assiduously supported by his brother, James, Duke of York, even after he became James II, the RAC lost its monopoly after James went into exile in 1688. With James gone, hundreds of independent traders in enslaved African people entered the market, expanding the scale of England's slave trade still further, and shifting the trade's centre of gravity away from London to the provinces. The Company's connection to the state and the monarchy endured but King William of Orange and his successors took less direct interest in its operation than their predecessors. The Company was finally dissolved in 1750. Members of the company received £26,689 as compensation for their shares.

Detail of 46

Making money: Dutch connections

A significant part of Richard Fitzwilliam's wealth, and many of the artworks in the Fitzwilliam Museum's Founder's Collection, came from his maternal grandfather, Matthew Decker. Growing up in Amsterdam, Decker witnessed the success of companies using private investor money to colonise overseas territories. Captives were shipped from sub-Saharan West Africa to plantations in the Americas and forced to work as enslaved labourers in complex and lucrative systems of trade.

In 1700, Decker brought this knowledge to England. In 1711, he helped to establish the South Sea Company (SSC). People who had previously lent money to the state received SSC shares instead of repayment of the loan. The SSC also obtained the monopoly to traffic African people to the Spanish Americas. The prospect of profit from slave-trading, and the conversion of more government debt into company stock, made the SSC shares an attractive investment to many. The SSC helped put enslavement at the heart of early British capitalism.

Detail of 57

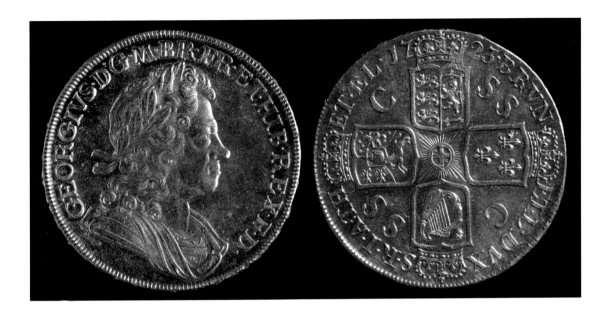

South Sea Company

William Pettigrew

49—50

The Royal Mint, London
Two silver crowns
with head of George I and
royal arms interspersed
with 'SSC', the South Sea
Company initials
1723 · silver

Fitzwilliam Museum, University of Cambridge:
CM.5.1498-1933 and CM.5.1499·1933
bequeathed by James Stewart Henderson,
1933 · photo: © The Fitzwilliam Museum,
Cambridge

The letters 'SSC' (for the South Sea
Company) encircle royal symbols on
these silver coins, each worth a crown.
In 1722, two years after the crash in
share price, the SSC found a hoard of
silver in present-day Indonesia. It sold
the silver to the Royal Mint, which
turned it into crowns, half crowns,
shillings and sixpences: a currency
of colonial capitalism.

The South Sea Company (SSC) was formed in 1711, during the reign
of Queen Anne, to allow the cash-strapped British state to convert
its debt into company stock. The costs of 25 years of warfare with
France placed huge financial pressure on the British state. From
1713, the SSC was given the opportunity to benefit from a contract
— The Asiento — that the British Crown secured under the terms
of the Treaty of Utrecht with Philip V of Spain, following the War of
Spanish Succession. This gave the South Sea Company a monopoly
over the supply of enslaved African people to the Spanish Empire
in the Americas. Robert Harley, the government minister, proposed
to refinance the state with a new company whose commercial
focus would be the transatlantic trade in enslaved African people.

Between 1714 and 1740, the Company transported at least 36,000
enslaved African people from West Africa to South America and the
Caribbean. In the early 1720s, the SSC discovered a hoard of silver
in Indonesia, which it shipped to London and sold to the Royal Mint.
This silver was used to make coinage including silver crowns, such
as these examples from 1723 where the front bears the head of
George I [49] and the back the royal arms interspersed with the
initials of the South Sea Company, to indicate the origin of the
silver [50].

In 1718, the British government expanded the financial role of
the South Sea Company by converting the entire national debt
(excepting that owed to the Bank of England and the East India
Company) into South Sea Company stock. Government ministers
hoped this would reduce the rate of interest the state had to pay
on its existing debt and finalised legislation to support this scheme
in April 1720. As a result, demand for South Sea Company stock
soared and prices increased before crashing in the summer of that

year in what is known as the South Sea Bubble, famously satirised in a political cartoon by William Hogarth, published in 1721 [51].

Despite the harm this event caused some investors, the scheme helped the British state to consolidate its debt and reduce the rate of interest it had to pay its creditors. This notorious episode has often distracted attention from the important role that the South Sea Company played in the transatlantic trade in enslaved African people between 1714 and 1740. From the 1740s until its dissolution in 1855, the South Sea Company was — for the most part — a holding company for government annuities.

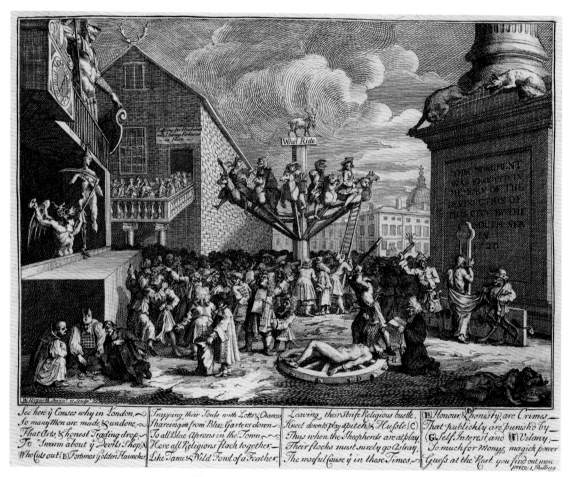

51

William Hogarth · 1697–1764

The South Sea Scheme · 1721 · etching and engraving on paper

Fitzwilliam Museum, University of Cambridge: 22.K.3-100 · bequeathed by Richard, 7th Viscount Fitzwilliam, 1816 · photo: © The Fitzwilliam Museum, Cambridge

William Hogarth mocked South Sea Company investors for the wild speculation that helped to create the South Sea Bubble, a major financial crisis in which the share price rose out of control and then crashed. Isaac Newton, the eminent Cambridge scientist, lost huge sums as a result. The Bubble led him allegedly to declare, 'I can calculate the motion of heavenly bodies, but not the madness of people'. Might he have seen his own madness reflected in Hogarth's biting satire?

Manillas

Alissandra Cummins

Manillas are an ancient form of general-purpose currency or barter coinage and were used for centuries across Africa by Africans as a means of exchange [52]. The earliest manillas took the form of metal bracelets, armlets and leg-bands, but later developed into penannular rings (a ring with a small break in the circumference). Referred to as 'okpoho' or 'okpoko', the Calabar, Efik, Annang and Ibibio term for 'money' or 'brass', the European term 'manilla' is believed to derive from Spanish and Portuguese words for bracelet, hand-ring and necklace. Manillas were made from copper, bronze or brass, which were metals traditionally considered by Africans to be far more useful than gold and thus reserved for internal exchange and value judgements, while gold — used primarily for adornment — was permitted to be exported as a barter commodity with foreigner traders. Manillas were long enmeshed within the traditional gift exchange economies and signifying practices of Western Africa, representing puberty, courtship, marriage, funerary and divination rites, and worn by women to show the wealth and status of their families.

Historians used to maintain that this exclusive production and use of manillas only changed during the eighteenth century when contests among regional polities escalated, creating demand for European firearms, which could be exchanged for African commodities, including captive people. Yet recent research into shipping, banking, insurance and industrial company records, as well as geochemical analysis of manillas recovered from shipwrecks in African, American and European waters, has definitively demonstrated that the expanding slave-sugar economy was a major factor in the development of copper mining and associated processes across central and western Europe. In turn, this facilitated the European production of manillas, and associated trading practices, on a colossal scale. From the fifteenth to eighteenth centuries, the Holy Roman Empire (present-day southern Germany, Austria, Flanders and Hungary) was the principal source of the manillas used in the West Africa Trade, since this is where most of Europe's copper mines, largely controlled by the Fugger family of Augsburg, were established. France and the Netherlands also had their own metal ore industries that developed and flourished alongside the Africa Trade. From the late eighteenth century, Britain became Europe's leading brass manufacturer.

Hundreds of thousands of European-produced utilitarian copper and brass manillas have been discovered in early modern European shipwrecks, together with guns, English and East Indian textiles, Venetian beads and alcohol. These European-produced commodities were handed over by thousands of European traders (firstly, Portuguese and then Dutch, Spanish, French, English and Danish) in West Africa between c.1500 and c.1800 to their African counterparts, in exchange for African gold, wood, ivory, spices such as pepper — and increasingly, enslaved people. The direct connection between manillas and the purchase of African captives is made

Unrecorded makers
Ten small manillas
and a large king manilla
with a 'British Bank of West
Africa Ltd' linen money bag
probably Birmingham · late
nineteenth/early twentieth
century · likely copper alloy

Fitzwilliam Museum, University of Cambridge:
CM.525-2008—CM.534-2008 and
CM.W.12-R · gift of J.C.B. Jean Austin,
acquired by the donor's father, Col J.B.J.
Austin, during service in the Colonial Police
of British West Africa, 1926—53 · photo:
© The Fitzwilliam Museum, Cambridge

Millions of bracelet-shaped metal
bands (manillas) were used as a com-
mon currency in West Africa. They
were manufactured cheaply across
Europe and used by Portuguese, Dutch,
Spanish, French, British and Danish
traders to buy captive people, gold,
wood and ivory. This set, made for the
British Bank of West Africa in the late
1800s/early 1900s, proves that British
colonial exploitation continued long
after the abolition of the slave trade.
King manillas served as a store of
value rather than a medium of every-
day exchange and some may have been
used in large slave-trading transactions.
Manillas were finally outlawed as legal
tender in British-ruled Nigeria in March
1949 when more than 30 million of
them were withdrawn.

clear in the 1773 *Encyclopaedia Britannica* entry that defined
'manilles' as '[...] the principal commodities which the Europeans
carry to the coast of Africa, and exchange with the natives for
slaves'. This also explains why manillas became known as 'slave
trade money' or 'slave bracelets'.

Ironically, this increased access to European brass in the form
of imported manillas led to an explosion of creativity by African
artists, especially in the Kingdom of Benin. Artists working at the
court of the Oba (Benin's ruler) would smelt them down and re-
cycle the metal into bronze works of art for his palace. Generically
referred to nowadays as 'the Benin bronzes', these powerful bronze
sculptures range from ancestral portraits, positioned on royal altars,
to decorative plaques depicting the Oba, his courtiers and foreign
interlocutors. Directly following the British 'punitive expedition'
to Benin in 1897, which saw the looting of an estimated 10,000
bronzes, some 200 Benin bronzes were given to the British
Museum by the Secretary of State for Foreign Affairs, while others
were sold on the international art market, primarily to newly est-
ablished ethnographic museums in the West. Other examples were
purchased by private collectors, who often then sold, lent or gave
them to these or similar museums. As a result, the majority of Benin
bronzes are currently found in public collections across Europe,
including in the Museum of Archaeology and Anthropology at the
University of Cambridge, which currently holds the second-largest
collection of Benin bronzes in Britain after the British Museum. It
is therefore highly likely that many of the Benin bronzes in British
collections, including those in Cambridge, were cast from melted-
down European manillas. Discussions are currently underway to
return ownership of 116 of these Benin bronzes from the University
of Cambridge to the Government of Nigeria.

In the later eighteenth century, demand for copper in the Africa Trade reached new heights. On the one hand, this 'red gold' was demanded in vast quantities by African traders as a barter commodity against enslaved fellow Africans and, on the other, it was demanded by European plantation owners in the Caribbean who needed it for equipment used in the sugar and rum production processes. This led to specialised centres of industrialised copper production developing across Europe, but above all in England, first in Bristol and then in Birmingham. By the last quarter of the eighteenth century, Birmingham was the most important centre in Europe for finished brass wares, with numerous factories specialising in the production of manillas, such as the Cheadle Brass Wire Company that opened its Manilla House and Assay Office in 1790.

The direct link between the trade in copper, the brass industry and the Atlantic slave trade is made clear by a petition to the House of Lords dated 9 July 1788 — exactly when the first moves to regulate the Slave Trade were afoot — by Thomas Williams, the so-called 'Copper King' of Anglesey. Williams and his partners declared that 'the slave trade in particular had led them to invest heavily in the copper industry' and claimed that it had been 'the demand for copper in Africa that had induced him to lay out £70,000 on facilities at Holywell, Penclawdd and Temple Mills'. The articles they manufactured were 'entirely for the African market and not saleable for any other'. Most of the different types of manilla demanded by African traders were made in Birmingham, including a new form, known as the Birmingham manilla, which was crescent-shaped with flared finial terminations.

By the end of the nineteenth century, imperial powers were replacing copper and brass manillas with western currencies. Yet, this group of ten small copper manillas, probably made in Birmingham in the late nineteenth or early twentieth centuries, and their linen bag marked for the British Bank of West Africa [52], remind us that manillas remained entrenched as legal tender in British-ruled Nigeria until the middle of the twentieth century. It was not until March 1949 that they were finally outlawed after the British Government had purchased and withdrawn over 30 million of them. The present group of manillas was acquired in Nigeria by Colonel J.B.J. Austin at some point during 1926 and 1953, when employed by the Colonial Police of British West Africa. The manillas were given by his son, J.C.B. Jean Austin, to the Fitzwilliam Museum in 2008.

Further reading
• Rolf Denk, *The West African Manilla Currency. Research and Securing of Evidence from 1439–2019* (Hamburg 2020)
• Tobias B. Skowronek et al., 'German brass for Benin Bronzes: Geochemical analysis insights into the early Atlantic trade', PLOS ONE, vol. 18, no. 4 (April 2023): https://doi.org/10.1371/journal.pone.0283415

Gibbes's plantation tokens: making, meaning and legacy

Alissandra Cummins

Until 1825 Britain did not supply any of its own currency to its colonies. For the preceding two centuries, British colonies had been pretty much left to fend for themselves numismatically and used whatever non-British money they could lay their hands on [53—55]. The Government's expectation was that the colonies would contribute revenue and stimulate industrial growth by providing both raw materials and markets for British mercantile expansion. In return, the colonies would be protected by British arms and civilised by British rule. Parliament went so far, in fact, as to enact legislation prohibiting the export of British silver coinage since it was felt that the colonies should be providing Britain with precious metals rather than draining them away. As a direct result of this policy, British silver coins were extremely scarce in the colonies. With barter as the mainstay of commerce, British colonies thus remained reliant for over 200 years on a long and colourful list of coins, ranging through the alphabet from 'anchor money', 'black doggs' and 'hog money' to 'quatties' (or 'Christian quatties'), 'Venetians' and 'zequeens' (the Venetian 'zecchini', from where the English word 'sequins' derives).

It is repeatedly asserted that, due to chronic shortages of British coinage in its colonies, copper tokens were used and informally accepted by settlers in the West Indies and elsewhere in the 'New World', as a form of legal tender in denominations of pennies and half-pennies precisely when some of the newly formed American states were coining coppers for commercial use. In this context, however, it is important first to understand the general status of 'small change' at this time, even in England. By his own account, writing in 1757, the king's Assay Master, Joseph Harris affirmed that 'Copper coins with us are properly not money, but a kind of tokens [sic] passing by way of exchange instead of parts of the smallest pieces of silver coin; and as such, very useful in small home traffic [...] A silver penny is too small for common use; and yet pence, and their halfs, and quarters enter daily into accounts. To supply the want of very small silver coins, a kind of TOKENS or substitutes have been instituted; these are now with us, all made of copper, and of two species only, called half-pence, and farthings; and these are a legal tender in all sums below sixpence [...].'

So, copper money — whether officially minted coins or privately executed tokens — was already perceived in a particular way by the time that wealthy enslaver and plantation owner Sir Philip Gibbes (1731—1815) decided to create his own Barbados issues. The Fitz-william Museum owns several copper tokens commissioned and issued by Gibbes between 1788 and 1792, by which time he owned 166 enslaved people. The first dies for these copper tokens, known as 'Pine Pennies', were engraved by John Milton (1759—1805) of London, and were executed in 1788 as a private parcel struck by that engraver, the year before he officially joined the Royal Mint [53—54]. A second state was struck by John G. Hancock of Birmingham in 1792 [55]. Gibbes's initial run of the 'Pine Penny'

John Milton · 1759—1805
Two 'Barbados pennies'
London · 1788 · copper

Fitzwilliam Museum, University of Cambridge:
CM.W.154-R and CM.BI.2918-R
unprovenanced · photos © The Fitzwilliam
Museum, Cambridge

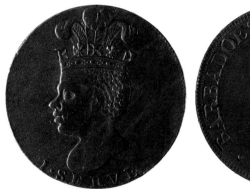
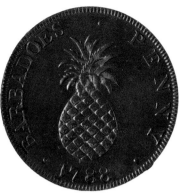

has traditionally been regarded as the first non-Spanish coin to be made for, or used on, Barbados. However, as numismatist Fred Pridmore observed in his seminal 1962 and 1966 articles on colonial coins used in the Caribbean, 'The Library of the Royal Mint contains no file, book, or record which furnishes any information on these Barbados pieces', and also that no 'record of them appears in either the local Barbadian newspapers or in the minutes of the Barbados Council or Assembly'. Furthermore, Pridmore's observation about 'the inclusion [of the] Barbados pieces in the Virtuoso's Companion and Coin Collector's Guide (1795) [...] normally devoted to non-legal issues or special collector's pieces' clearly suggests that Gibbes's tokens were not made as legal tender.

So, what was the reason for their production? To answer this, we have to understand more about the commissioner of these tokens, Sir Philip Gibbes, and his business operations that centred on the extensive Spring Head and Taitts sugar plantations at St James's, Barbados, which had come down from his mother's side. Born on Barbados in March 1731 to English parents from a line of Barbados plantation owners stretching back to the 1630s, Gibbes was educated in England. He entered the Middle Temple in July 1755 and was called to the English Bar in February 1758. It is not known whether he ever practised as a lawyer in either England or Barbados, but when the dispute between England and the 13 American colonies arose (following the imposition of the Townshend Acts [1767—70] that aimed to raise revenue from North America by taxing glass, lead, paper, paint and tea), this posed a 'very alarming situation in which the West India Islands are now placed by the late American proceedings'. Gibbes, by then already an experienced negotiator and navigator of the legal shoals of the planters' pro-slavery lobby, was one of the 23 'gentlemen of the West India Islands residing in London' who took appropriate defensive action. In January 1775, he was a signatory to the request to the Society of West India Merchants for joint action 'on the present important crisis', which was quickly formalised in 1778 with the creation of the Standing Committee of the Society of West India Planters and Merchants, the forerunner of the West India Committee, which continues to operate today.

In the following decade, Gibbes became an active member of the Barbados Council, at a time when, as Pridmore reminds us, 'the state of the island's currency was deplorable, and its correction and regulation was constantly before the Council and Assembly'. Gibbes was also an active member of both the Barbadian Society for the Improvement of Plantership and the Society for the Propagation of the Gospel in Foreign Parts. Reliant on his enslaved African workforce to operate his plantations, Gibbes used his spheres of influence in Barbados, Bristol and London to make explicit the case for the regulation of slavery rather than its total abolition. To further help his cause, Gibbes published several works on 'responsible' plantation ownership. In 1786, he co-authored *Instructions for the Management of a Plantation in Barbadoes and for the Treatment of Negroes* and also published anonymously *Instructions for the Treatment of Negroes*, making his position in the debate clear when he wrote:

Although I sincerely lament the existence of the slave trade, I feel no repugnance in availing myself of the means it affords me of supplying by purchase the number of Negroes requisite for the management of my plantations. The practice and the principle are not irreconcilable.

Herein, Gibbes enjoined plantation managers to take great care of their enslaved workers with detailed descriptions for the feeding, housing, education, regulation of working hours and, most particularly, looking after mothers and children — who, after all, would become the mainstay of his workforce once the slave trade had been abolished. It was no doubt this publication and Gibbes's involvement with the Society for the Propagation of the Gospel in Foreign Parts, that allowed the abolitionist and activist Olaudah Equiano to describe Gibbes as 'the most worthy and humane gentleman' in his 1789 autobiography [see 64], even though by then Gibbes 'owned' more than 100 enslaved people. In 1791, no doubt keen to keep on friendly terms with key abolitionists and make his pro-slavery stance appear as moderate and acceptable as possible, Gibbes published a second, enlarged edition of his *Instructions* in which he now included additional material such as special songs to support the Christianising education of the enslaved.

Yet, nowhere in either edition of Gibbes's detailed *Instructions* is there any mention of using special coppers to facilitate the domestic and working lives of the enslaved, which strongly suggests that this was not his original intention in producing them. So, if not for use by the enslaved workers on his plantations, what was their purpose and why now? A close look at their satirical and highly politicised iconography — chosen by Gibbes — is revealing. The first issues of 1788 have imagery that asserts both British sovereignty and Barbadian identity at the same time. The obverse

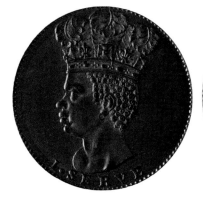
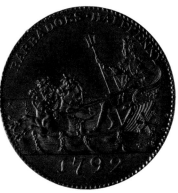

55
John G. Hancock
'Barbados half-penny'
Birmingham · 1792 · copper

Fitzwilliam Museum, University of Cambridge:
CM.W.155-R · unprovenanced · photos
© The Fitzwilliam Museum, Cambridge

Due to a shortage of legal coinage,
unofficial copper tokens were made
in the UK and shipped out for use
by settlers in British colonies in the
Caribbean. These tokens, designed by
an owner of large sugar plantations in
Barbados, Sir Philip Gibbes, combine
imagery that references British
monarchy and Barbados.

(front) of the 1788 penny token, for example, shows an African man's head in profile, wearing the heraldic Prince of Wales' feathers (three ostrich feathers encircled by a coronet) and his motto, 'I serve', symbolising both the subservience of Black people to their white counterparts, and Barbadian subservience to the English crown [53], while its reverse is filled with the image of a pineapple [54], which by this time was well established as an identifying symbol of Barbados, and understood as such. Gibbes was no doubt aware of the fact that, although satire as a political and propagandistic tool had witnessed massive growth in the final decades of the eighteenth century, the British courts had developed sophisticated procedures for delimiting verbal ambiguity in trials for libel to such an extent that publication of written satire was a dangerous endeavour. However, he would also have known that these same procedures could not yet be applied effectively to either the interpretation of, or the prosecution of, visual images.

Prince William Henry's 'royal frolics' as a naval officer visiting Barbados in 1786 were well documented in the British press and had provided fuel for raunchy imagery which pushed the boundaries of decency and decorum. But while Joshua Reynolds' 1787 portrait of the Prince of Wales with a Black page was meant to engender a hugely important image of royal authority and power, his reputation was already tarnished by the scandal of an illicit marriage and financial extravagance which reached unimaginable heights by the time of the Regency crisis of 1788. The combination of the profligate activities of these two royal princes proved to be an irresistible target. So, through his clever deployment and juxtaposition of English and Barbadian images, Gibbes had found an eloquent non-verbal (i.e. safe) way to make clear his personal perspective on the utility of both royal authority and the abolition lobby, and their complex interrelations. The ambiguous perspective offered on the English Crown, which could equally have been regarded as a satirical commentary on the Prince of Wales himself, was politically perilous and this may be part of the reason for their very limited issue: John Milton's personal workshop records indicate, for example, that only 5,376 pennies were struck for Gibbes in 1788.

In 1792, Gibbes commissioned and issued a second series of penny and half-penny copper tokens, presumably because his experiment had been deemed a success and more tokens were likely needed for transactions in Barbados and elsewhere in the Black Atlantic economy [55]. This 1792 issue was of much wider circulation than the earlier 1788 issue, with 39,000 pence and 46,800 half-pence coins made. Significantly, these later tokens have different imagery on their obverses: the so-called 'Neptune car' motif. In these coins, George III — dressed in British royal regalia but in the traditional guise of Neptune, god of the seas — sits in a commanding but relaxed position on his throne-chariot being driven through the waves by two powerful hippocamps, which he controls with effortless ease with just his left hand, so he can hold aloft a great trident (like a baton of command) in his right [55]. This image was a replica of the Great Seal of Barbados. The reason for this change of imagery appears to have been driven by pragmatism and Gibbes's desire to 'make money', literally and metaphorically. His ability to generate profits from his investment in these copper tokens had clearly taken priority where these coins gained traction enabling commodity trade and barter exchange principally between and among the merchant and the non-enslaved working classes in Barbados. Gibbes's copper tokens were therefore almost certainly issued to function as legal tender for use within the Caribbean economy, even if technically they were not that. Interestingly, replicas of varying quality of the original 1788 tokens, much lighter in weight, with a smaller African man's head, and several inconsistencies in spelling have also been identified by Pridmore as 'specimens struck upon English half-penny token blanks that had their origin in Birmingham, which might be dated variously as 1791 and 1793, and were probably a repeat order also struck by John Hancock of Birmingham'.

In the present context of Cambridge and the Black Atlantic, it is important to make clear Gibbes's links with the University, where he sent both of his sons to complete their educations. According to Matriculation Registers, Philip Gibbes Junior and his younger brother, Samuel Osborne, were both admitted as Fellow Commoners at St John's College on 26 January 1774, only shortly before the arrival of two great future abolitionists: William Wilberforce (who went up to St John's in October 1776) and Thomas Clarkson (who started there in June 1779). Philip Gibbes Junior pursued a successful legal career in Barbados, becoming first a judge on the Barbados bench and then Chief Justice of Barbados. He was removed from that position by Governor Ricketts in 1797, in a controversy over the murder trial of Joseph Denny, a man of mixed race. Samuel Osborne Gibbes went on to become Receiver-General of Grenada.

Both sons predeceased their father, so Sir Philip Gibbes bequeathed both Spring Head and Taitts to his 13-year-old grandson, Samuel Osborne Gibbes Junior (1803—1874) in his

1815 will. In 1817, the Gibbes' estate was recorded as 'owning' a total of 313 enslaved people: 168 individuals were enslaved on Spring Head and another 145 men and women are recorded at Taitts. In December 1820, following family tradition, Samuel Osborne Gibbes Junior matriculated as a Fellow Commoner at St John's College, Cambridge, but his residency there was extremely brief given that he was already in Barbados running his two plantations at an unrecorded date in 1821. He stayed there until 1833, returning to England around the time of the Abolition Act. On 9 May 1836, Samuel Osborne Gibbes Junior received two enormous compensation awards totalling £6,536 11s and 4d. One was £3,062 8s and 10d for the 'loss' of 132 enslaved people from Spring Head; the other award, £3,474 2s 6d for the 'loss' of 156 enslaved people from Taitts. This was in addition to the £117 11s 1d he had been awarded on 18 January 1836 for the 'loss' of four enslaved people on St Vincent, making his total award £6,654 2s 5d. According to the Bank of England inflation calculator, this is roughly equivalent to just over £613,000 today, or £666,400 according to the 'real wage or real wealth' comparator value for the United Kingdom on the MeasuringWorth.com website. However, these measure only price inflation (meaning that compensation payouts are multiplied by 100 times or so) and do not take into account the fact that Britain is much richer as a society today than it was in the 1830s. Thus, according to Nick Draper (Director of the Centre for the Study of the Legacies of British Slave-ownership from 2016 to 2019), an even more accurate price converter is one that includes wages as well as prices, for example, using the Measuring Worth 'labour earnings' method. Using this approach, compensation payments are multiplied by closer to 1,000 times. According to this LBS-approved methodology, Samuel Osborne Gibbes Junior's 1836 slave compensation awards would actually be equivalent to the staggering sum of £6,076,000 today. For the 292 men, women and children in question, they would spend another two years in servitude under the apprenticeship system for which they would never be compensated, even upon gaining their freedom.

Further reading
• Neville Connell, 'Barbadian Coppers of the 18th Century', *Journal of the Barbados Museum and Historical Society*, vol. XXVII, no. 3 (1960), pp. 107—9
• F. Pridmore, 'Notes on colonial coins — The Barbados Issues of 1788 & 1792. Are They Coins or Private Tokens', *Journal of the Barbados Museum and Historical Society*, vol. XXX, no. 1 (1962), pp. 14--19
• F. Pridmore, 'Notes on colonial coins — The Barbados Penny 1788. Second Issue', *Journal of the Barbados Museum and Historical Society*, vol. XXXII, no. 1 (1966), pp. 19—23
• Biographical Profile and Legacies Summary of 'Sir Philip Gibbes Bart.' on the Centre for the Study of the Legacies of British Slavery: https://www.ucl.ac.uk/lbs/person/view/2146643193
• Biographical Profile and Legacies Summary of 'Sir Samuel Osborne Gibbes 2nd Bart.' on the Centre for the Study of the Legacies of British Slavery: https://www.ucl.ac.uk/lbs/person/view/6802

African Company of Merchants tokens

Alissandra Cummins

From the seventeenth century, European demand for plantation labour caused an escalation in slave raiding and warfare on the west coast of Africa, processes which accelerated from roughly 1750 to 1850 as the trade in enslaved people and slave-produced commodities (such as palm oil and peanuts) reached its peak. Malachy Postlethwayt, Director of the Royal African Company in the 1740s, was convinced of the importance and profitability of the slave trade, declaring in 1746:

What renders the Negroe-Trade still more estimable and important, is, that near Nine-tenths of those Negroes are paid for in Africa with British Produce and Manufactures only [...] We send no Specie or Bullion to pay for the Products of Africa, but, 'tis certain, we bring from thence very large Quantities of Gold [...] From which Facts, the Trade to Africa may very truly be said to be, as it were, all Profit to the Nation.

In 1750, the Royal African Company was dissolved by the African Company Act, and its properties and assets were transferred to the African Company of Merchants (also known as the Company of Merchants Trading to Africa). This British-chartered company operated in the Gold Coast area of modern Ghana from 1752 to 1821 and was engaged directly in the Atlantic slave trade. Historian Immanuel Wallerstein has described this as the 'incorporation' of West Africa into the capitalist world-system where the new Company governed and maintained the infrastructure of nine fortifications and 'factories' along the west coast of Africa, including Cape Coast Castle, and facilitated African trade by other companies and individuals.

The right to transact and do business using gold and silver coined in England had been specifically incorporated in the charters of the two preceding companies trading with Africa: The Company of Royal Adventurers of England Trading into Africa incorporated in 1662, and its successor called The Royal Africa Company, which was formed in 1672. The reasons why were obvious. African societies and kingdoms traditionally used Indigenous currencies (such as cowry shells, gold nuggets and dust, iron rods, manillas [52] and cloth) to execute official and commercial trade transactions. These were monetary systems which neither Britain nor its representatives or agents could effectively either control or indirectly influence. Unlike its predecessor, the African Company of Merchants was a regulated company, not a joint stock company. Clause IV of the African Company Act 1750 stated:

That it shall not be lawful for the Company, established by this Act, to trade to or from Africa in their corporate or joint Capacity, or to have any joint or transferable Stock, or to borrow, or take up, any Sum or Sums of Money, on their Common Seal.

56

Soho Mint, Birmingham
Quarter Ackey

1796 (first issue) · silver

Fitzwilliam Museum, University of Cambridge:
CM.W.156-R · unprovenanced · photos:
© The Fitzwilliam Museum, Cambridge

This small token known as an Ackey coin tells a big story. Around its edge reads 'FREE TRADE TO AFRICA BY ACT OF PARLIMENT [sic] 1750'. This act transferred the assets of the Royal African Company, such as its coastal slave-trading forts, to the Company of Merchants Trading to Africa. Private merchants paid the new company to use the forts for their slave-trading ventures and these coins as currency. The shift contributed to a huge increase in British slave-trading.

While officials in London and their colonial counterparts in West Africa sought to protect the political and monetary interests of the British Government, independent expatriate merchants worked to protect their own private commercial interests and profit-base. The latter lobbied heavily for a new monetary system in the colonies mainly because it represented direct control of the machinery of money-making to augment their personal coffers. However, these ambitions to ensure the supply of adequate coinage to do business in the colonies competed with the British Government's need to eliminate competing foreign and native currencies in its West African territories. The process of moving through monetisation to more formal rule to enable the collection of taxes, was inexorable.

The first token coins made for the African Company of Merchants were thus to assist trading along the Gold Coast through the provision of a restricted but necessary supplement to the denominations needed, acting as a replacement for low value royal coinage. These tokens were struck in silver by the Soho Mint in Handsworth, Birmingham, in 1796. This first issue consisted of four denominations: One Ackey, Half Ackey, Quarter Ackey and One Tackoe (the eighth of the value of the One Ackey coin) with the terms 'Ackey' and 'Tackoe' deriving from the gold trade. The One Ackey was made with the same specifications (size and weight) as the British half crown.

All four 1796 denominations have the same decoration on their obverses (or front sides): the royal cypher or monogram of George III (the letters 'G R', being an abbreviation of the Latin 'Georgius Rex', or 'King George' in English) surmounted by a crown and the date '1796' (recording the year of issue) and circumscribed by a laurel wreath, as can be seen in this Quarter Ackey example [56].

Their reverses carry an identical and emphatic inscription written in bold capital letters: 'FREE TRADE TO AFRICA BY ACT OF PARLIAMENT 1750' (with the last word in many examples curiously misspelled 'parliment'). But their decoration differs between denominations. The reverse of the Quarter Ackey, for

57

Probably Soho Mint, Birmingham
Half Ackey
1818 (third issue) · silver

Fitzwilliam Museum, University of Cambridge: CM.1698.1963 · given by the late Miss Jean Ritchie, 1963 · photos: © The Fitzwilliam Museum, Cambridge

As well as celebrating the 1750 Act for Free Trade to Africa, this token made for the Company of Merchants Trading to Africa depicts two Indigenous men as heraldic supporters with the symbols of slave-trading: the sailing ship and the old logo of the Royal African Company, the African elephant with a castle on its back.

example, bears just the African Company of Merchants' badge, comprising a shield decorated (amongst other motifs) with a merchant ship in full sail and a cornucopia spilling forth coins, crowned by the Royal African Company logo of elephant-and-castle [56]. The larger denominations are physically larger in size and this permits inclusion of the pair of heraldic supporters, again taken from the original Royal African Company coat of arms: in reality, racist representations of two different types of Indigenous people, the supporter on the left with a feathered headdress, feathered skirt and bow and quiver of arrows; the right-hand supporter with an elephant-head cap, loin cloth and snake. Proof coins and patterns were also made.

A second issue of token coins was produced in 1801, and the third and final issue in 1818, which consisted of One Ackey and Half Ackey pieces. In these later issues, the head of George III appeared instead of the crowned cypher on the obverse with the Latin inscription, 'GEORGIUS III D[EI]. G[RATIA]. BRITANNIAR[UM]. REX. F[IDEI]. D[EFENSOR].' ('George III, by the grace of God, King of Britain, Defender of the Faith'). The reverse used the same Company arms and inscription as the earlier issues, as can be seen in this Half Ackey example [57].

While these tokens might have been designed to be tied into the monetary economy, these mintages were initially very small and it appears likely that the coinage was intended as more experimental or symbolic than a serious introduction of a local trade currency. On the other hand, the Indigenous users found other uses for these objects and often melted them down and repurposed the silver for jewellery-making rather than investing it in the bank.

Further reading
• Malachy Postlethwayt, *The National and Private Advantages of the African Trade Considered*, 2nd edn (London, 1746)
• Immanuel Wallerstein, 'The Great Expansion: The Incorporation of Vast New Zones into the Capitalist World Economy (c.1750—1850)', *Studies in History*, vol. 4, issue 1—2 (1988), pp. 85—156
• Immanuel Wallerstein, *The Modern World-System III: The Second Era of Expansion of the Capitalist World-Economy, 1730—1840s* (San Diego, 1989), pp. 129—89
• H. Fuller, 'From Cowries to Coins: Money and Colonialism in the Gold Coast and British West Africa in the Early 20th Century', in Catherine Eagleton, Harcourt Fuller and John Perkins (eds), *Money in Africa* (London, 2009), pp. 54—61

Technology for the transatlantic trade

Do advances in technology always mean progress?

In the era of transatlantic enslavement, crossing oceans was a dangerous business. Before the 1760s, ship crews had no reliable way to calculate how far east or west they were — the longitude problem. This hampered merchant and naval seafaring so much that Parliament offered a substantial reward for a solution to the problem.

New navigational instruments, often made of materials gathered by enslaved people, fuelled the boom in colonial expansion and slave-trading — to the intense suffering of millions of people.

Detail of 58

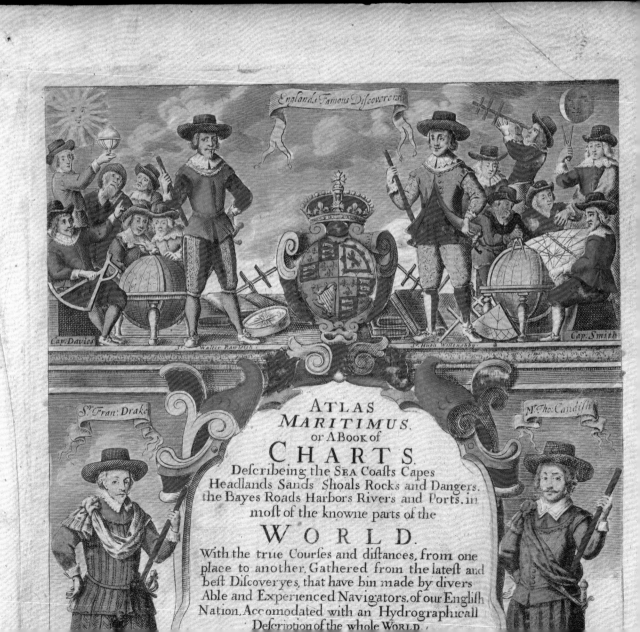

England's Famous Discoverers

Cap: Davies

S.r Walter Rawleigh

S.r Hugh Willoughby

Cap: Smith

S.r Fran: Drake

M.r Tho: Candish

ATLAS MARITIMUS.
or A BOOK of
CHARTS.
Describeing the SEA Coasts Capes
Headlands Sands Shoals Rocks and Dangers.
the Bayes Roads Harbors Rivers and Ports, in
most of the knowne parts of the
WORLD.
With the true Courses and distances, from one
place to another. Gathered from the latest and
best Discoveryes, that have bin made by divers
Able and Experienced Navigators, of our English
Nation, Accomodated with an Hydrographicall
Description of the whole WORLD.

Maps, instruments and maritime power

Eleanor Stephenson

Late seventeenth-century maps and terrestrial globes played a significant role in promoting English imperialism. These objects conveyed knowledge and control of places and people, which — even when unfounded — were powerful expressions of colonial ambition and reinforced ideas of racialised hierarchy. In this period, maps and globes often included elaborate cartouche designs, which were used to signal the interests of the cartographer and his patron. Following the popularisation of allegories of 'parts' of the world by Italian artist Cesare Ripa in his *Iconologia* of 1593, Dutch and later English mapmakers began to include people, dressed and accessorised with products of their homes, as geographic representations.

In the chart by John Seller [59], which was dedicated to James Stuart, Duke of York, in his capacity as the 'Governor of the Most Honorable [Royal African] Company', there are four allegories of African people. Two are shown holding arrows on either side of a shield, part of the Royal African Company's (RAC) coat of arms, though missing the 'exotic' feathered headdresses usually seen in the Company's crest [see 57], and two more in the lower cartouche are portrayed wearing pearl earrings and loin cloths, and holding a bird. Although the enslavement of African people is not mentioned, the allegorical scheme would have been understood within the context of the Company's activities. The connection between representations of African people and enslavement is evident throughout Seller's atlases, and most blatantly in maps of Caribbean islands, thus supporting ideas of race-based slavery in specific colonial territories.

John Seller began his career as an instrument maker, and in 1667, became a brother of the Worshipful Company of Clockmakers in the City of London. In 1671, as he turned his focus to mapmaking, Seller was appointed Royal Hydrographer to King Charles II. But navigational instruments remained central to the iconography he employed to illustrate his atlases, as seen in the frontispiece to *Atlas Maritimus* [58], which includes compasses, quadrants, globes and backstaffs. Instruments were crucial to English maritime power and expansionism, and thus in the visual form, represented such goals. In the frontispiece to Sprat's *History of The Royal Society*, John Evelyn included instruments designed by early Fellows, such as the pendulum clock seen above the bookshelf on the left [see 42]. In 1664, this clock was tested by Captain Robert Holmes on a voyage to West Africa, sponsored by the RAC to attack Dutch slave-trade ships and forts, which led to the Second Anglo-Dutch War (1665—7). By including the clock in his design, Evelyn illustrated the inter-imperial significance of nautical technology.

Seller was determined to challenge the Dutch Republic's dominance of cartography and instrument making by 'making a Sea Waggoner for the Whole World' which would rival 'our neighbours

58
John Seller · 1630—1697
Frontispiece · from *Atlas Maritimus or the Sea-Atlas Being A Book of Maritime Charts* (London, 1675)

59

John Seller · 1630—1697
A Chart of the Seacoasts from the Landsend of England to Cape Bona Esperanca
from *The English Pilot, the Third Book, Describing ... the Oriental Navigation* (London, 1677)

Cambridge University Library: Hanson.bb.46
photo: reproduced by kind permission of the Syndics of Cambridge University Library

John Seller's navigational chart of Europe (top left), West Africa (centre) and the east coast of Brazil (bottom right), illustrates the Royal African Company's 1672 charter. These were all places involved in the transatlantic slave trade. The company's crest and cartouche below were strategically placed on Africa to suggest proprietary rights and geographic knowledge. But, beyond owning a handful of forts on the 'Gold Coast', the company knew nothing of the continent.

the Hollanders'. To achieve this, Seller, and subsequent English cartographers, bought old Dutch copper plates, some even made 50 years prior, and repurposed them. Nicolaes Visscher's map of the Americas from 1658 [60], for example, which included a cartouche design by the Dutch artist, Nicolaes Berchem, was copied numerous times, including by Seller, and in 1690, by London-based globe-makers Robert Morden, William Berry and Philip Lea, in their 'New Terrestrial Globe' [61]. Visscher's map and the terrestrial globe both show the same vignette of Indigenous people fighting, covering the hinterland of Brazil, a strategic position to cover the Republic's recent failure to conquer, and therefore, survey the country. Maps and instruments were practical tools for imperial expansion but also offered the Metropole iconography to propagate colonial trades, slavery and settlement.

60

Nicolaes Visscher I
1618—1679
Novissima et Accuratissima Totius Americae Descriptio
1658

photo: courtesy of Geographicus Rare Antique Maps · [not in exhibition]

61

Robert Morden · *c.1650—1703*
William Berry · *c.1639—1718*
and Philip Lea · *c.1660—1700*
14-inch terrestrial globe
with 12 hand-coloured gores (tapered shapes to fit the spherical surface) printed from copper engravings, marking circumnavigation routes of Sir Francis Drake and Sir Thomas Cavendish
London · 1690 · mahogany, paper, brass, iron, pigment

on loan to the Whipple Museum of the History of Science, University of Cambridge: 2691, from the Provost and Scholars of King's College, Cambridge · photo: reproduced by kind permission of the Provost and Fellows of King's College, Cambridge

This globe promoted English maritime trade and colonial expansion, with trade routes marked in black and depictions of Indigenous peoples. South America was covered with a scene of 'tribal' conflict, using racist stereotypes first designed by Nicolaes Berchem. This expensive object aimed to convey the owner's wealth and underscores their racist world view, as well as England's attempts to colonise people and places.

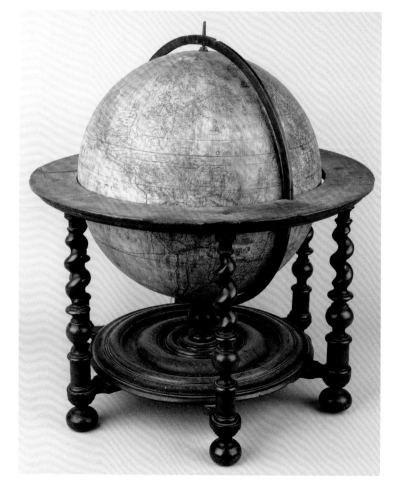

Seafaring, enslavement and the longitude problem

Joshua Nall

Without slavery, there is no Longitude Act of 1714. The British Government's interest in improving the navigation of ships at sea was inextricable from Britain's firm commitment to an economy built on the backs of enslaved people. By the early 1700s, significant portions of the country's finances depended on colonial trade spread across India, North America and the Caribbean. Shipwrecks threatened the bottom line of the ascendant planter-merchant classes, as well as imperilling the navy vessels charged with upholding the nation's claims to territories and trade routes. The early 1710s saw the establishment of both the slave-trading South Sea Company and a Parliamentary committee tasked with reducing naval and merchant shipping losses. Tellingly, we find the same men involved in both concerns. William Clayton, a slave-trader and MP for Liverpool, chaired the committee; it included members such as Thomas Onslow, who owed his fortune to slavery; and it heard evidence from investors in the South Sea Company, among them Cambridge-educated Sir Isaac Newton.

The committee's recommendation, approved by an Act of Parliament in July 1714, was to offer a stupendous reward — up to £20,000 — to anyone who could find a practicable means of determining a ship's longitude at sea to within half a degree (giving its East-West position to an accuracy of about 50 km at the equator). Reading the act now, it is quite clear why Parliament offered such an extravagant sum of money. Any claim to the prize, the act stipulated, must be tested on a voyage that shall 'Sail over the Ocean, from Great Britain to any such Port in the West-Indies, as those Commissioners […] shall Choose or Nominate for the Experiment.' As the historian B. W. Higman notes, 'reasons for this limitation to the West Indies are hard to find in terms of the pure science of the problem.' More compelling explanations are found in the implication of Britain's ruling classes within the Caribbean sugar economy and the consequent expansion of the so-called 'Triangular Trade' between Britain, West Africa and the West Indies. Above all, it was the treacherous Middle Passage from Africa into the Caribbean that motivated Britain's pursuit of a solution to the longitude problem.

The instruments discussed here represent the two solutions that ultimately won the lion's share of the prize. The easiest means of determining longitude at sea is to know the difference between local time (found relatively easily from observations of the sun's position) and the time at a fixed reference site (with Greenwich Observatory soon chosen as this zero point). So, a clock that could keep Greenwich time aboard ship would solve the problem. But clocks are complex and fickle machines, prone to run fast or slow in unpredictable ways and hugely vulnerable to temperature changes and the motion of the sea. The clockmaker John Harrison argued that he could overcome these problems, securing many thousands of pounds from the Board of Longitude to undertake years of painstaking research developing a reliable marine timekeeper.

62

Robert Molyneux · operated 1811—54
Two-day marine chronometer
in gimbal and fitted box
London · 1828 · metal (brass, steel, silver),
glass, wood (mahogany) and ivory

Whipple Museum of the History of Science, University of Cambridge:
2581 · transferred from Institute of Astronomy, University of
Cambridge, June 1980 · photo: © The Whipple Museum of
the History of Science, University of Cambridge

In 1714, Parliament offered enormous cash prizes for a solution
to calculating longitude at sea — a vital aid to navigation.Its
British Longitude Act proposed that the instrument be tested
'from Great Britain to any such Port in the West-Indies'
(Caribbean) — the chief destination of slaving vessels. The
chronometer, which could measure time, even when moving,
became the ultimate solution. This one, manufactured in
London in 1828, was encased with enslaved-produced mahogany.

63

Edward Nairne · 1726—1806
Sextant · *with frame of reinforced brass plates*
and index mirror with three coloured filters
London · c.1770 · brass, wood and glass

on loan to the Whipple Museum of the History of Science, University
of Cambridge: 1081, from the Master and Fellows of St John's College,
Cambridge, since August 1951 · photo: by permission of the Master
and Fellows of St John's College, Cambridge

In 1765, St John's College, Cambridge, opened an observatory
to support astronomical research and used instruments,
including this sextant, to measure the angle between the
horizon and the sun, moon or a star. Sextants were more
practical and affordable than chronometers for calculating
longitude and helped make sea-trading far more efficient and
lucrative. This included allowing ships carrying enslaved
African people to navigate across the Atlantic.

The Board's financial commitment paid off: by the 1760s, Harrison's design had proven its viability on sea trials to Jamaica and Barbados, and from this a commercial trade in the 'chronometer' gradually developed, such as this fine example manufactured by Robert Molyneux of London in 1828 [62]. This is the Whipple Museum's oldest chronometer, dating from a period when most sizable ships would have carried them.

The sextant is every bit as important as the chronometer in the story of 'solving' the problem of longitude, although it is less famous. Sextants formed a key part of a rival method that eschewed expensive clockwork in favour of finding Greenwich time via a series of astronomical calculations. In effect, the moon served as a clock, with navigators using a sextant to measure its position relative to certain prominent stars. Greenwich time was then computed using tables of astronomical data provided in that year's *Nautical Almanac*. By the end of the eighteenth century, sextants and their cheaper wooden variant, the octant, would have been a common sight on slave ships plying the Atlantic Ocean from Africa to the colonies in North America, South America and the Caribbean — a sea crossing known commonly as the 'Middle Passage'. Chronometers, by contrast, remained the preserve of only the grandest ships in the British fleets. This sextant from about 1770 by Edward Nairne is therefore very early [63]. Its provenance links it to the observatory at St John's College, Cambridge, which was founded in 1765 to support astronomical research, the backbone of the 'lunar distance' method of navigating by sextant and almanac.

Further reading
• R.F. Higgitt and R. Dunn, *Finding Longitude: How Ships, Clocks and Stars Helped Solve the Longitude Problem* (Collins, 2014)
• B.W. Higman, 'Locating the Caribbean: The Role of Slavery and the Slave Trade in the Search for Longitude', *Journal of Caribbean History*, vol. 54, no. 2 (2020), pp. 296—317

Equiano and his account of the transatlantic sea voyage

Isaac Ayamba

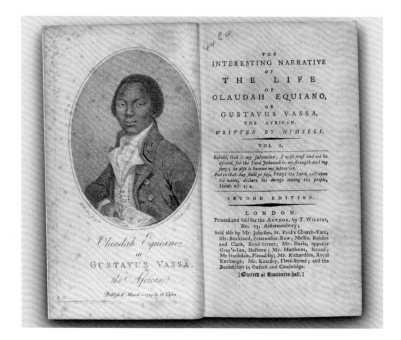

64

Olaudah Equiano
c.1745—1797
The Interesting Narrative of the Life of Olaudah Equiano, or Gustavus Vassa, The African, Written by Himself
second edition (London, December 1789)

In March 1789, Olaudah Equiano published his life story, *The Interesting Narrative*, to promote and raise funds for the campaign to abolish the slave trade. In the book, and on speaking tours that likely began in Cambridge, he recalled being enslaved as a boy in West Africa and forced onto a slaving ship destined for Barbados.

Written nearly a quarter of a century after his manumission, and first published in March 1789, *The Interesting Narrative of the Life of Olaudah Equiano, or Gustavus Vassa, The African, Written by Himself* [64] is a vivid chronicle of Olaudah Equiano's experiences as an enslaved man from his capture as an 11-year-old child from his native village in Eboe (Igbo) land in the kingdom of Benin to his release from bondage and subsequent life as an economically successful free man. The purchase of his freedom in 1766, about ten years after his capture, was an extraordinary accomplishment for a slave of his age. In comparison to other enslaved people, Olaudah (from his own account) escaped the worst brutality of his enslavers, arguably, because of his assiduousness and abilities as a sailor which endeared him to them.

Olaudah never set out to extol the virtues of his able seamanship and astuteness as a trader in order to draw admiration, or to expose his personal ordeal to elicit sympathy, as was common of other 'slave biographies' at the time. Rather, he bore testimony to the atrocities, injustices and humiliation suffered by some humans who were treated by other humans as though they were not human, and to inform the wider population about the evils of enslavement and the slave trade.

Advances in navigation [see 58—63], which led to greater intercontinental trade, undoubtedly fuelled the slave trade, with Equiano as one among its millions of victims. It is undeniable that the course of Equiano's life was shaped by navigation, his able seamanship and business acumen. The curators of *Black Atlantic* chose to place Equiano's autobiography under the subsection 'Technology for the transatlantic trade' to allow contemporary audiences to hear first-hand from a victim of enslavement about the horrors of the

transatlantic sea voyage from Africa to the colonies in North America, South America and the Caribbean — known as the 'Middle Passage'.

The curators selected passages from Equiano's account in which he speaks plainly about the inhumane treatment of the African captives by the white enslavers and slave ship's crew. Equiano's descriptions are still appalling to read today, over 200 years after they were first written, but like the curators, I feel that a short passage is worth reprinting here, to make readers of this book equally aware of the sheer brutality and violence of the Atlantic slave trade from a first-hand account:

The stench of the hold while we were on the coast was so intolerably loathsome, that it was dangerous to remain there for any time, and some of us had been permitted to stay on the deck for the fresh air; but now that the whole ship's cargo were confined together, it became absolutely pestilential. The closeness of the place, and the heat of the climate, added to the number in the ship, which was so crowded that each had scarcely room to turn himself, almost suffocated us. This produced copious perspirations, so that the air soon became unfit for respiration, from a variety of loathsome smells, and brought on a sickness among the slaves, of which many died, thus falling victims to the improvident avarice, as I may call it, of their purchasers.

This wretched situation was again aggravated by the galling of the chains, now become insupportable; and the filth of the necessary tubs, into which the children often fell, and were almost suffocated. The shrieks of the women, and the groans of the dying, rendered the whole a scene of horror almost inconceivable.

Happily perhaps for myself I was soon reduced so low here that it was thought necessary to keep me almost always on deck; and from my extreme youth I was not put in fetters. In this situation I expected every hour to share the fate of my companions, some of whom were almost daily brought upon deck at the point of death, which I began to hope would soon put an end to my miseries. Often did I think many of the inhabitants of the deep much more happy than myself. I envied them the freedom they enjoyed, and as often wished I could change my condition for theirs. Every circumstance I met with served only to render my state more painful, and heighten my apprehensions, and my opinion of the cruelty of the whites.[1]

Equiano's graphic eyewitness text of the horrors of the Atlantic sea crossing for the African captives was placed in the exhibition in proximity to an almost contemporary image of a slave ship. This was published by Equiano's great friend and supporter Thomas Clarkson in his 1808 book, *The History of the Rise, Progress, and Accomplishment of the Abolition of the African Slave-trade by the British Parliament* [65], which represents a unique contemporary account of the abolition movement and the Parliamentary debates leading to the Slave Trade Act of 1807. In it, Clarkson, a Cambridge graduate and

1. First edition of Equiano's *Interesting Narrative* (London, 1789), pp. 79—80

65

Thomas Clarkson
1760—1846
Fold-out diagram
from volume 2 of *The History
of the Rise, Progress, and
Accomplishment of the
Abolition of the African Slave-
trade by the British Parliament,*
2 volumes (London, 1808)

Trinity College, Cambridge: S.15.131
photo: reproduced by kind permission of
the Master and Fellows of Trinity College
Cambridge

Thomas Clarkson, one of the most
famous Cambridge-educated abolition-
ists, used this image of the stowage
plan of the Liverpool-registered slave
ship *Brooks* to illustrate the appalling
conditions for enslaved people. The
cross-sections and bird's-eye view of
each deck were adapted from a diagram
produced by the Plymouth Committee
for Effecting the Abolition of the Slave
Trade. Here, without the original's
descriptive text, the engraving
becomes an iconic image.

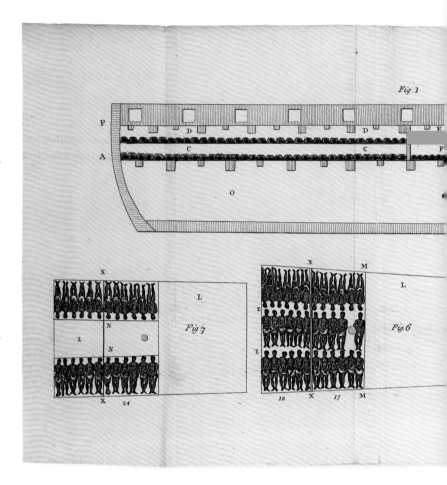

leading abolitionist, recounted how concerted campaigns by Black
and white abolitionists had helped to sway public opinion in Britain
against the slave trade, leading to its eventual abolition in 1807 by
an act of parliament.

Clarkson's diagram showing the plan and section of a slave ship,
though shocking in its graphic details and disempowering in rep-
resenting the enslaved as passive victims with no agency, was an
extremely effective piece of visual propaganda in making the case
for abolition clear. As Clarkson's text states, the diagram was:

*designed to give the spectator an idea of the sufferings of the
Africans in the Middle Passage, and this so familiarly, that he might
instantly pronounce upon the miseries experienced there [...] As this
print seemed to make an instantaneous impression of horror upon all
who saw it, and as it was therefore very instrumental, in consequence
of the wide circulation given it, in serving the cause of the injured
Africans, I have given the reader a copy of it in the annexed plate.*

It was thanks to Equiano and Clarkson's shared dream of ending
the slave trade that they became firm allies and worked together

The work was called An Essay on the comparative Efficiency of Regulation or Abolition as applied to the Slave-trade.

The committee also in this interval brought out their famous print of the plan and section of a slave-ship; which was designed to give the spectator an idea of the sufferings of the Africans in the Middle Passage, and this so familiarly, that he might instantly pronounce upon the miseries experienced there. The committee at Plymouth had been the first to suggest the idea; but that in London had now improved it. As this print seemed to make an instantaneous impression of horror upon all who saw it, and as it was therefore very instrumental, in consequence of the wide circulation given it, in serving the cause of the injured Africans, I have given the reader a copy of it in the annexed plate, and I will now state the ground or basis, upon which it was formed.

It must be obvious that it became the committee to select some one ship, which had been engaged in the Slave-trade, with her real dimensions, if they meant to make a fair representation of the manner of the transportation.

towards their shared goal. It was Clarkson's links with the University of Cambridge and its active anti-slavery lobby in the late 1780s that led Equiano to come to Cambridge at the start of his nationwide book tour to sell his autobiography and speak in public about the need to outlaw the slave trade. It was in Cambridge that Equiano met people who became firm friends, including Susannah Cullen whom he married in 1792, and John Audley and Edward Ind whom he nominated as his executors in 1797.

Given the fact that Cambridge and the surrounding area meant so much to Equiano personally and professionally, and he spent much of his final years here when not on his book tours, it is fitting that Cambridge has finally recognised its own Black freedom-fighter by renaming a bridge, located in the vicinity of the resting place of his beloved eldest daughter, in his honour. By this recognition, credit has been given where credit is due. Equiano Bridge has become a symbol of hope, integration and diversity, and a source of inspiration for the African and Black heritage community in the city and beyond. It is also appropriate that Equiano will be such a key focus of the next legacies-related exhibition that the Fitzwilliam Museum will be mounting in spring 2025.

Further reading
- Olaudah Equiano, *The Interesting Narrative of the Life of Olaudah Equiano, or Gustavus Vassa, The African, Written by Himself* (2nd edn, 1789)
- Thomas Clarkson, *The History of the Rise, Progress, and Accomplishment of the Abolition of the African Slave-trade by the British Parliament*, 2 vols (London, 1808)
- J. Luebering, 'Olaudah Equiano', in *Encyclopedia Britannica*; available at https://www.britannica.com/biography/Olaudah-Equiano (accessed 16 February 2023)

Warfare between the British, Dutch and Spanish empires

Detail of 66

Between 1652 and 1784, the British and Dutch empires fought four huge wars over trade and colonial possessions. Both sides celebrated their naval power through the arts, although by the mid-eighteenth century, Britain achieved maritime pre-eminence.

Conflicts also arose over slave trading. In 1713, Britain gained the right to the Spanish Asiento, or contract, the monopoly to traffic enslaved African people to the Spanish Americas. Previous holders of this contract included the Portuguese and Dutch. But by the 1730s war broke out between Spain and Britain, in part over the Asiento's terms.

As both abolitionists and artists revealed, British naval supremacy facilitated a huge rise in slave trading.

Delftware, punch, Liverpool 'shipwares' and visual propaganda

Victoria Avery[*]

Made from tin-glazed earthenware, Delftware was a cheaper alternative to the blue-and-white porcelain exported from China by the Dutch East India Company (VOC), a business empire synonymous with enslavement and ruthless exploitation. It was made across the Dutch Republic from the 1630s, especially in the town of Delft, and hence its name, both for the internal and external market. Hard-wearing and long lasting, it was used in a huge variety of functional wares, from wall- and fireplace-tiles [68] to tobacco jars [see 91], plates, dishes and ornaments, often decorated with patriotic motifs. Manufacturers in England and Ireland wanted a share in this lucrative pottery market and so started producing similar blue-and-white china, known as English Delftware or Irish Delftware. It was equally popular with the merchant classes and again often decorated with nationalistic imagery and jingoist slogans celebrating British maritime supremacy especially on large chargers meant for display and large punch bowls meant for communal drinking sessions [66—67, 69]. What this decoration avoided was making explicit the fact that Britain's power, wealth and prestige were derived in large part from the transatlantic slave trade and the commodities produced by enslaved African people on European-owned plantations.

Introduced into England by employees of the East India Company — England's answer to the VOC — from the 1650s, punch quickly became a popular drink in Britain, especially at the gatherings of male-only clubs and societies, usually held in taverns, coffee houses or special punch houses. It was also the tipple of choice for the British Navy and the merchant marine. Derived from the Hindi word 'paantsch', meaning 'five', punch is made from five key ingredients: spirit (rum or brandy), sugar, citrus fruits, spices (usually grated nutmeg) and hot water. With the sugar produced by enslaved people on British-owned Caribbean plantations, and the rum distilled from molasses (a by-product of sugar production), punch could not have been made without the transatlantic slave trade. Large communal serving bowls were produced in silver and ceramic, and decorated with the names of guilds or societies, hunting scenes and maritime themes, including naval heroes, sea battles [67] and ship portraits.

From the 1760s until the early 1800s, many expensive hand-painted commemorative Delftware 'shipwares' were made in Liverpool, then the most prolific slaving port in the world. In addition to accurate portraits of particular merchant ships, most record the ship's name and wishes for a successful voyage, and sometimes also the captain's name and year a voyage commenced. Some depict Liverpool-registered slave ships ('slavers') and were made specifically to commemorate slaving voyages to West African ports, where captive African people were forcibly transported under appalling conditions to Jamaica, Barbados and other British colonies in the Caribbean [see 64—65]. These slaving voyages were funded either by wealthy individuals or syndicates of Liverpool merchants, who

*I am grateful to Miranda Goodby and Ben Miller, respectively former Senior Curator of Ceramics and Ceramics Curator at The Potteries Museum & Art Gallery, Stoke-on-Trent, for assistance with my research.

66

Unrecorded makers
Dish

Bristol · after August 1740
tin-glazed earthenware (English
Delftware) · decorated by
Joseph Flower · c.1728—1785
after a print published by
Henry Overton · 1676—1751

In March 1740, following his Portobelo
victory [67], Vice-Admiral Vernon
led his fleet up the River Chagres to
bombard the Spanish fort and town of
San Lorenzo el Real, a key stronghold
controlling trade to Panama and Peru.
Based on a widely circulated print, this
plate depicts explosions over the fort,
the Spanish customs house on fire,
and many British naval flags, all in
the fashionable blue and white
Delftware style.

as 'part-owners' jointly covered the enormous cost of putting a slaver to sea (buying/building the vessel, fitting it out, supplying the crew, buying foodstuffs and a cargo of trade goods, often textiles, iron, copper, guns and alcohol) in return for a share of the profits. Slave-traders wished to shape public opinion in favour of their business interests. In eighteenth-century Britain, opposition to the trade and to slavery grew. By the end of the century, abolitionists had organised into societies and Parliament launched an investigation into the trade.

At half a metre wide, the Potteries Museum 'ship bowl' [69] is probably one of the largest Delftware punch bowls ever made in Liverpool. It is also unique in its explicit visual and textual references to the Atlantic slave trade. Most slaving ceramics show (materialise) the slave ship but hide (dematerialise) its primary purpose: the transportation of human cargo. This bowl celebrates the slave trade in its toast, 'Success to the Africa Trade', and its detailed maritime scene of a convoy of four large slave ships at anchor in deep water, each flying the Red Ensign indicating British nationality. In the foreground, a yawl or longboat is being rowed by eight men, with another man navigating at the front, and five seated in the back. It seems likely that the artist intended to depict African captives being ferried from the shore to the slave ships anchored in the deeper water. This was standard practice along most of the West African coastline, given the lack of deep-water harbours in which slavers could dock — but such an explicit visualisation of this part of the enslavement process is very rare indeed. If captive African people are indeed intended, then the artist's error in showing them wearing clothes and headgear, proves his lack of first-hand knowledge of the trade, as enslaved people were normally embarked naked and chained. Traditional military trophies with flags (one with the monogram of George III), drums, spears, quivers of arrows, cannon and so on decorate the interior rim, and are interspersed with carefully portrayed marine ammunition including bomb-, bar-, grape-, chain- and star- or spider-shot. In stark contrast — and incongruous, at least to modern eyes — the exterior of the bowl is decorated with generic stylised landscape views, one European in feel, the other more Asian, showing men engaged in pleasant pastimes such as fishing and strolling in the countryside.

The punch bowl also bears the name of George Dickinson (1732—1806), a Liverpool slave-ship master and slave-trader. According to the Trans-Atlantic Slave Trade Database, Dickinson joined a venture syndicate (with seven other merchants led by Peter Hunt) to acquire a 30-tonnage 'brigantine' called the *John*, built and registered in 1763. As ship's captain, he left Liverpool with a nine-man crew on 31 May 1763 and sailed to Sierra Leone, intending to purchase 120 captives. In fact, he purchased 106 enslaved people and arrived in Barbados on 3 January 1764 with 103 captives still living. We do not know to whom he sold these African people but it is perfectly possible that a few of them may have been purchased

67

Unrecorded makers
Punch bowl
Liverpool · after March 1740 ·
tin-glazed earthenware
(English Delftware)

Fitzwilliam Museum, University of Cambridge:
C.1669-1928 · bequeathed by Dr J.W.L.
Glaisher, 1928 · photo: © The Fitzwilliam
Museum, Cambridge

In November 1739, with 'six ships only',
Vice-Admiral Vernon captured Portobelo
in Panama, a key Spanish trading post.
This war was fought because the British
had been supplementing their profits
from trafficking African people with
smuggled goods, thereby avoiding duties
to the Spanish crown. To celebrate this
'victory', the song *Rule Britannia* was
composed (including the line 'Britons
never, never, never shall be slaves')
and punch made from enslaved-
produced sugar and rum was drunk
from commemorative bowls like this.

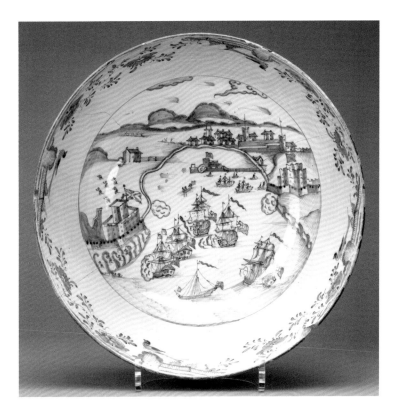

to work on either the Spring Head sugar plantation at St James's,
or the adjacent Taitts sugar plantation, which were owned by Sir
Philip Gibbes [see 53–55]. The *John* departed on 25 February and
arrived back in Liverpool on 3 April. On 23 May, the boat set sail
again, captained once more by Dickinson but now with a 13-man
crew and six guns, and headed for the Iles de Los (an island group
off Conakry in Guinea) where Dickinson purchased 148 enslaved
African people (28 more than intended) and transported them to
St Kitts. We do not know the date of arrival, but we do know that
17 captives died en route. Dickinson and his crew likely threw their
dead bodies overboard. The *John* departed St Kitts on 10 January
1765 and docked back in Liverpool on 25 February.

Presumably as a direct result of the profits from these two back-
to-back voyages, all but one of the original syndicate partners re-
combined to purchase a much larger slave ship: a newly built 80-
tonnage 'snauw' called the *Robert*, mounted with four guns and
with a crew of 20. Again captained by Dickinson, the *Robert* left
Liverpool on 1 July 1765 for the Windward Coast with the mission
to buy 200 captives. Of the 204 enslaved African people purchased,
only 175 disembarked at Barbados on 23 January 1766. Again, it is
conceivable that some of these captives may have been purchased
by Sir Philip Gibbes to boost his workforce at either Spring Head
or Taitts. The *Robert* arrived back at Liverpool on 1 July 1766, was
immediately refitted and set sail again before the end of the year,

68

Unrecorded makers
Two tiles

Netherlands, probably Delft
eighteenth century · tin-glazed
earthenware (Dutch Delftware)

Kettle's Yard, University of Cambridge:
014 a–b 1985 c · gift of Jan Heyligers to
Jim Ede · photo: Kettle's Yard, University
of Cambridge

Made in Delft and across the Dutch
Republic from the 1630s, Delftware
was a cheaper alternative to the blue-
and-white porcelain exported from
China. Likely made for a Dutch fireplace,
these tiles ended up at Kettle's Yard,
Cambridge, the home of the British
curator and collector, Jim Ede. Ede
displayed them on an imposing dining
table, which he recorded as being 'one
block of American elm shipped back as
ballast in the eighteenth century when
our empty slave-ships were returning
to England.'

again with Dickinson at the helm, and a crew of 30. At the River
Kissey (Sierra Leone), Dickinson purchased 184 captives and
transported them to Grenada, where the ship docked on 27 May
1767. The Middle Passage voyage was particularly fatal with 30
captives and 16 crew dying during the crossing. Dickinson set
sail for home on 26 June, arriving in Liverpool on 12 August 1767.

At this point, wealthy from his human trafficking, Dickinson
decided to 'go it alone' and purchased as sole owner the *Nanny*,
a new Liverpool-built 30-tonnage 'sloop' with six guns and nine
crew. Under his command, Dickinson set sail for Sierra Leone
on 23 November 1767, intending to buy 100 captives but only
acquired 83. By the time he docked at St Vincent at an unrecorded
date in 1768, only 65 enslaved people had survived to disembark.
The fate of the *Nanny* after this is rather unclear, with the Slave
Trade Database recording its voyage ending in St Croix, and other
accounts claiming it was lost at sea off the West Indies in 1769.
It used to be thought that Dickinson went down with his ship, but
thanks to surviving archival records, we know that he survived
and retired to his native Pilling (Lancashire). He used his fortune
to purchase Hooles Farm and, in 1782, to construct the Ship Inn,
which he owned until his death in 1806. His death records him
as 'George Dickinson Yeoman Late Captain in the Africa Trade'.

The history of the punchbowl is equally curious. The pottery
manufacturer and collector Enoch Wood (1759—1840) recorded
in his unpublished memoir that he obtained it directly from John
Robinson, who decorated the bowl, after the latter had moved
from Liverpool to Staffordshire in 1770. Wood kept it until about
1828, when he presented it to the Hanley Mechanics Institute,
the precursor of the present Potteries Museum & Art Gallery,
Stoke-on-Trent. Many questions remain unanswered about the
bowl's origins: was it commissioned by George Dickinson himself,
or more likely by one of the two syndicates with which he was in-
volved, and had they intended to present it to him on completion
of a profitable slaving voyage? Why did Dickinson never take
possession of it, and why did it remain with John Robinson, who
painted it? Why did Wood purchase it, and why did he present
it to the Hanley Mechanics Institute when so many potters were
ardent abolitionists? While the punch bowl records George
Dickinson and his career in shipping human cargoes, it does not
record the names of the 725 enslaved African people he bought,
transported and resold as chattel slaves, or the fact that he was
directly responsible for the death of 97 of them on board his ships.

Succefs to the Africa Trade.
George Dickinfon.

Further reading
• Jane Webster, 'The material culture
of slave shipping', in J. Walvin, D. Hamilton
and R.J. Blyth (eds), *Representing Slavery:
Art, Artefacts and Archives in the
Collections of the National Maritime
Museum* (Singapore, 2007), pp. 102–17
• Jane Webster, '"Success to the Dobson":
Commemorative artefacts depicting 18th-
century British slave ships', *Post-Medieval
Archaeology*, vol. 49, no. 1 (2015), pp. 72–98
• The Trans-Atlantic Slave Trade Database
that collates archival data concerning
35,000 slaving voyages, including a full
record of British voyages between 1780
and 1807: http://www.slavevoyages.org/
(accessed 22 April 2023)

69

Unrecorded makers · *Punch bowl*

James Pennington's Manufactory, Liverpool · *c*.1763–8
tin-glazed earthenware (English Delftware)

The Potteries Museum & Art Gallery, Stoke-on-Trent. STKMG:536 · acquired by
Enoch Wood (1759–1840) c.1770, who presented it to Hanley Mechanics Institute,
c.1828 · photo: courtesy of The Potteries Museum & Art Gallery, Stoke-on-Trent

Proclaiming 'Success to the Africa Trade', this huge punch bowl was made in the
mid-1760s in Liverpool, then Britain's chief slaving port, from which ships departed
for West Africa to transport enslaved African people to British possessions in the
Caribbean. George Dickinson, named on the bowl, was a Liverpool slave-ship owner
and captain. He is recorded as having made five voyages on three ships, between
1763 and 1768, transporting a total of 725 captives across the Atlantic: 97 died.
The decorations on the inner rim show military trophies and nautical missiles
underscoring the violence of transatlantic enslavement.

'Go West
Young Man'

Keith Piper

In my art practice, I have often looked for devices through which to organise and articulate historical narratives and to look for points of generational continuity. This series of monochrome photomontages completed in 1987 [70] evolved from a small single work on paper produced initially in 1979. In this early work, I juxtaposed a reproduction of the stowage plan of the English slave ship, *The Brooks*, which was first published in 1788 by the Plymouth chapter of the Society for Effecting the Abolition of the Slave Trade [see 65 for a later version], with a famous line evoked by New York newspaper editor Horace Greeley in 1865 to inspire white male settlement of the American Prairie; 'Go West Young Man'.

It was in the juxtaposing of the slave ship, mechanism of the forced transfer of West Africans into the Americas with a slogan extolling the mythic possibilities of the 'West' for young European men that my work derives its initial ironic charge. Returning to the work in 1987, I responded to the irony of this line with the reply, 'I first heard that Joke 400 years ago [...] I died laughing [...] been dying with monotonous regularity ever since.' Within this, the work adopts a narrational device rooted in the Pan-Africanist position of conceptually claiming collective 'Black experiences' as being experienced in the 'first person', articulated through an autobiographical mode of address.

However, this photomontage series opens with another device, an intergenerational conversation with a father figure who issues a series of observations about the status of young Black men in Britain of the 1980s, perceptions that have changed little over subsequent decades. This 'Father' voice echoes through the work, returning at the end as both commentator and receiver of a series of letters exploring extremes of the Black male experience in the UK, before issuing a final response in the final panel of the work.

70

Keith Piper · born 1960
Go West Young Man · 1987 · 14 monochrome photomontages,
gelatin silver print on paper mounted on board

Tate, purchased 2008: T12575 · photo: © Keith Piper/image: Tate

In the first of a series of photomontages, Keith Piper paired one of the iconic stowage plans of the English slave ship *Brooks* with an 1865 US catchphrase 'go west young man', which encouraged white Americans to expand westward. What follows is a modern-day conversation between a Black father and son that reveals and resists the structural racism that continues to distort perceptions of Black masculinity and the Black male body.

3

Fashion, consumption, racism and resistance

As transatlantic enslavement continued to rise during the seventeenth and eighteenth centuries, the products of enslaved labour caused profound changes to European culture, and the racism at its heart.

This directly impacted how the wealthy chose to have their portraits painted and the furniture they commissioned for their homes. The products of transatlantic enslavement — including indigo, mahogany, ivory and turtle shell (known as tortoiseshell) — became fashionable materials for European luxury goods. New pastimes and cultures of taste grew up around plantation imports grown and harvested by enslaved people: coffee and rum drinking, sugar consumption and tobacco smoking.

But there was resistance. On plantations it was not uncommon for the captive workforce to risk death to defy the violence and degradation of the system, and in Europe, enslaved people escaped their oppressors to set up new lives of freedom. Some enslaved people killed themselves in acts of ultimate defiance. On both sides of the Atlantic objections to the slave trade and slavery itself gained traction.

Black artists continue to challenge the history of racist stereotyping and its enduring legacies by depicting Black people in ways that emphasise their humanity and equality with any white sitter.

Detail of 94

Blackness in European art

The way artists in Europe depicted Black people changed as European empires developed systems of Atlantic enslavement through trade and colonisation. At the start of this period, on the rare occasions when artists depicted real Black people, they were more likely to show them as individuals, and in a variety of roles.

But as mass enslavement and support for the idea of the racial inferiority of Black people took hold, new forms of depiction emerged and became acceptable. From the late sixteenth century onwards, Black people were commonly shown in servitude to white people, or as an object of possession, and even as furniture. The range of pigments used by artists to depict people of colour narrowed in the later seventeenth and eighteenth centuries as painters resorted to racist visual stereotype rather than careful observation. Less complex colour mixing resulted in visually less nuanced images of Black people. Both enslavement and anti-Black representations continued in the nineteenth century.

Present-day artists challenge the ongoing consequences of these damaging stereotypes to envisage new modes of representation.

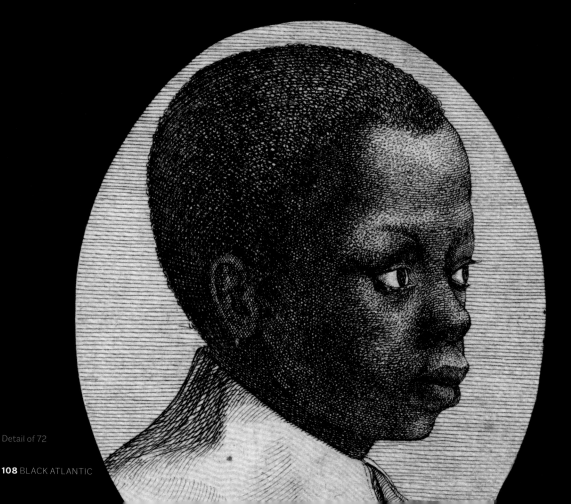

Detail of 72

Between image and reality: the Black presence in European art, 1500–1800

Esther Chadwick

71

Wenceslaus Hollar
1607–1677
after J Felix Biler
active 1630s
Head of a Young Man Wearing a Cap
1635 · etching on paper

Fitzwilliam Museum, University of Cambridge: 31.I.4-578 · bequeathed by Richard, 7th Viscount Fitzwilliam, 1816 · photo· © The Fitzwilliam Museum, Cambridge

In 1635 the Swiss-born artist Wenceslaus Hollar etched this portrait of a Black youth. Although the sitter's identity was not recorded, his features are so specific that it must be the portrait of a real person. The youth's luxuriant hair and fashionable hat-with-badge suggest he was a free man with money to spend on his appearance. Small prints like this were valued for their skill and widely collected.

The presence of people of African heritage in European art from the sixteenth to the eighteenth centuries is irreducible to the tragedy of transatlantic enslavement. Art, as a complex mediation between the real and the symbolic or imaginary worlds, can bear the burden of both oppression and liberation. Although frequently complicit in processes of dehumanisation continuous with (and necessary for) racialised enslavement, European artworks of this period sometimes held out the possibility of resistance to the enslaver's gaze, whether as artefacts of the deeper histories of African people in Europe prior to the rise of the transatlantic trade or as traces of individual agency even at its height. In the selection of historical works discussed in this book, we see this range of possibilities in action.

Jan Jansz Mostaert's *Portrait of an African Man,* painted in Flanders *c.*1525–30 [see 39], shows its bearded subject gazing thoughtfully beyond the frame, chin attentively raised, with a gloved hand poised on the finely wrought hilt of his sword, which in turn emerges from behind a splendid bag embroidered with pearls, gold and fleurs-de-lys. On his scarlet hat is a badge of Our Lady of Halle, suggesting that this well-to-do man was a Christian and had made a pilgrimage there. It is likely he formed part of the circle of Margaret of Austria at the Habsburg court in Brussels or Mechelen. Another possibility is that we are looking at a portrait of Christophle le More, a member of Charles V's bodyguard. This portrait is exceptional: it has been described as the only European portrait of an autonomous individual of African descent to survive from the late medieval and early modern period.

As rare as such an image may be, it was made in a period when the movement of a wide range of African people throughout Europe was well established, whether for trade, diplomacy and pilgrimage, or (but by no means only) as a result of enslavement. It may be tempting to contrast such a carefully individuated representation, whose realism insists so powerfully on the painting as a document of a man's life, with the 'stock' appearance of the biblical Black Magus in devotional paintings such as Taddeo Zuccari's *Adoration of the Kings,* made around three decades later in Rome [see 41]. But even this by-now conventional rendering of one of the three royal visitors to Christ's nativity as Black — in part to signify the global compass of Christianity as a whole — had emerged in the medieval period from the close contact of Europeans and Africans, in other words, from real encounters between actual human beings long before the rise of the transatlantic trade and when several kingdoms flourished on the African continent.

By the seventeenth century, it is possible to speak of Black communities, however precarious, in European cities and towns. This fact helps account for Wenceslaus Hollar's carefully observed etchings of young men and women of African heritage [71 and 72], produced in the Low Countries in the 1630s and 1640s with the

Wenceslaus Hollar
1607—1677
Six Portrait Heads
1635—45 · etchings on paper

Fitzwilliam Museum, University of Cambridge:
31.I.4-579 — 31.I.4-584 · bequeathed by
Richard, 7th Viscount Fitzwilliam, 1816
photo: © The Fitzwilliam Museum,
Cambridge

Whilst on his travels around Cologne
and Antwerp, Hollar etched these
portrait heads of six unrecorded
individuals. His prints were later
collected by connoisseurs such as
Richard Fitzwilliam, who compiled
six albums of the artist's work. This
album contains Hollar's head and
figure studies, arranged by Fitzwilliam
according to date or size, except for this
page where the rationale is racialised.

same delicacy and visual acuity that the artist applied to the rec-
ording of items of clothing, insects and shells, and to the white
people he encountered and portrayed.

With the rapid growth of the transatlantic slavery system from the
sixteenth century and its full establishment by about 1600, how-
ever, European artworks were increasingly called upon to assert
the idea of European superiority and African inferiority. Portraits
of the British aristocracy, such as William Dobson's *John Byron*
and Sir Peter Lely's *Elizabeth Murray* [73 and 74], both depicting
principal sitters with Royalist connections, make their white
supremacist arguments in no uncertain terms. Black servants are
placed at the service of white masters, literally on a lower level or
at the margins of the composition, while their sumptuous dress
effaces any trace of the brutality of the trade which Britain was
now coming to dominate. Sculptures and decorative furniture
such as this pair of stands, or torchères, for the home of Elizabeth
Murray [75] or John Nost the Elder's *Bust of an Enslaved Man*
likely commissioned by George III and on display in Kensington

73

William Dobson · 1611—1646
Portrait of John Byron, 1st Lord Byron
1599—1652 and an Unidentified Attendant
1643 · oil on canvas

University of Manchester, The Tabley House Collection Trust: 221.2
photo: © Tabley House Collection/Bridgeman Images

In 1643, likely after the successful Battle of Roundway
Down, Cambridge graduate John Byron commissioned this
self-assured and life-size portrait. Shown centre-stage as
a Royalist army commander and fashion-conscious dandy,
Byron's wealth and status are made clear by the grandiose
setting, his well-groomed grey horse and Black page in
sumptuous livery. The child's upturned gaze towards his
owner and marginal position (common devices in pictures
including Black attendants) suggests a deference he may
well not have felt.

74

Sir Peter Lely · 1618—1680
Portrait of Elizabeth Murray, Lady Tollemache,
later Countess of Dysart and Duchess of
Lauderdale 1626—1698 and an Unidentified
Servant
*c.*1651 · oil on canvas

National Trust, Ham House: 1139940 · photo: © National Trust Images

In *c.*1651, Lely portrayed noblewoman Elizabeth Murray pluck-
ing an unblemished pink rose from a golden bowl proffered by
her unnamed Black attendant. Through the manipulation of
light and dark, in which the artist shows great technical skill,
Lely deliberately contrasted the skin tones of mistress and
servant. The child blends into the background shadows,
rendered visible only by the whites of his eyes and the
luminous pearl earring, the pair of which hangs from
Murray's jewelled belt.

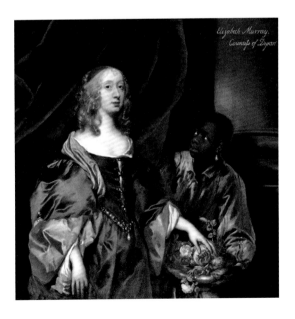

Unrecorded makers
A pair of torchères-on-stands
probably England; possibly Italy
*c.*1675 · softwood, pigment
and gold leaf

National Trust, Ham House: NT 1140088
and 1140088.1 · photo: © National Trust/
Christopher Warleigh-Lack

Elizabeth Murray lived with this pair
of stands at her stately home, Ham
House. They take the form of young
Black men wearing a racist fantasy of
African dress that includes feathered
skirts, bells and turbans. To serve as
stands for candelabra or ornaments,
they carry tambourine-shaped trays
on their heads. Invented in Italy, this
stereotypical representation of Black
people as permanent servants became
fashionable in England. Similar figures
continue to be produced today.

Palace by 1710 [76] are complicit in the objectification of Black
bodies and in the aesthetic sublimation of enslavement that
came to underpin Britain's emergent 'culture of taste'.

Such dehumanising representations find a riposte in the mid-
eighteenth-century *Portrait of a Man in a Red Suit* [see 1]. Look-
ing out across nearly three centuries from an encounter with an
unknown artist in the 1750s — a decade in which over 240,000
African men, women and children were forcibly transported across
the Atlantic Ocean in British ships (more than any other European
slave-trading nation in the same period) — the shining dark-brown
eyes of the man in the red coat and high linen necktie fix us with a
penetrating stare. His name, like that of the Mechelen courtier [see
39], has been lost (for now), but his portrait hints at considerable
social mobility and self-confidence. Its authoritative and fleshy
declaration of presence works against both the dehumanising logic
of the torchères and Nost's bust, and the statistical abstraction
of what became the most widely circulated eighteenth-century
image of enslavement, the *Description of a Slave Ship,* with
its crammed-in cargo of identical, motionless bodies [see 65].
Between Mostaert's *Portrait of an African Man* and this anony-
mous *Portrait of a Man in a Red Suit,* there lie countless lives
lost to the transatlantic trade, but these works speak of flesh
and blood and liveliness, and of stories of defiance.

Further reading
• Marcus Wood, *Blind Memory: Visual Representations of Slavery in England and America, 1780—1865* (Manchester, 2000)
• David Northrup, *Africa's Discovery of Europe, 1450—1850* (New York and Oxford, 2002)
• T.F. Earle and K.J.P. Lowe (eds), *Black Africans in Renaissance Europe* (Cambridge, 2005)
• Imitaz Habib, *Black Lives in the English Archives, 1500—1677: Imprints of the Invisible* (Ashgate, 2008)
• David Bindman, 'The European Scene' in David Bindman and Henry Louis Gates Jr, *The Image of the Black in Western Art, Vol. III, Part 2: From the 'Age of Discovery' to the Age of Abolition. Europe and the World Beyond* (Cambridge, 2011)
• Simon Gikandi, *Slavery and the Culture of Taste* (Princeton and Oxford, 2011)
• Miranda Kaufmann, 'Africans in Britain: 1500—1640', unpublished D. Phil, University of Oxford, 2011 (NB pp. 17—18 critiques Habib 2008)
• Cheryl Finley, *Committed to Memory: The Art of the Slave Ship Icon* (Princeton, 2018)
• Elmer Kolfin and Epco Runia (eds), *Black in Rembrandt's Time* (Zwolle, 2020)
• J.P. Filedt Kok, 'Jan Jansz Mostaert, *Portrait of an African Man*, Mechelen, c.1525—30', in J.P. Filedt Kok (ed.), *Early Netherlandish Paintings,* online coll. cat. Amsterdam: hdl. handle.net/10934/RM0001.COLLECT. 431086 (accessed 21 March 2023)
• Kristen Collins and Bryan C. Keene (eds), *Balthazar: A Black African King in Medieval and Renaissance Art* (Los Angeles, 2023)
• *Slave Voyages:* https://www.slavevoyages. org/assessment/estimates

76
John Nost the Elder · 1686—1710
Bust of an Enslaved Man · *c.*1700 · coloured marbles

The Royal Collection/H.M. King Charles III: RCIN 1396 · photo: Royal Collection Trust/
© His Majesty King Charles III 2023

In 1710 an eyewitness described seeing this 'bust of a Moor very well done from life — made, indeed, of nothing but coloured stones, with great skill' at Kensington Palace. While the costly materials and life-size bust format signify authority, this anonymous, objectified man is shown wearing a collar, identical in design to those made for dogs. Who was this man, and why was his image carved?

Escaping enslavement in eighteenth-century Britain

Mathelinda Nabugodi

Eighteenth-century Britain had a growing Black population, which spanned the social hierarchy: from the sons of African slave merchants who came to Britain to study and build links with their British counterparts to formerly enslaved people who had gained their freedom either by earning enough money to buy themselves formal manumission, or by running away. Britain's Black population also included enslaved people. Many of them worked as domestic servants and were regarded by their 'owners' as 'exotic' attendants whom they dressed up in luxurious liveries [see, for example, 73 and 74]. But their status was unclear. National identity was constructed around pride in the notion of 'freeborn Englishmen' and many believed that merely breathing the air of England was enough to turn a slave into a free person. Some of the enslaved Black servants brought to Britain from overseas colonies took the opportunity this offered to escape from their masters.

As the number of enslaved people in Britain increased, it became necessary to clarify their legal status. It was the fate of James Somerset to set the precedent. Somerset was a Black man who had been 'purchased' in Virginia by Charles Stewart, a British customs officer, in 1749. Stewart brought him to Britain where Somerset served him as a personal servant for two years before running away. Stewart then tracked him down and forced him onto a ship, the *Ann and Mary*, bound for Jamaica where he planned to punish Somerset by selling him into hard labour on a plantation. At this juncture, Somerset's abolitionist allies intervened. They made an application at the Court of King's Bench for a writ of *habeas corpus*, that is, unlawful detainment. Lord Mansfield presided over the case, which was brought to trial in 1772. After months of deliberation, Mansfield ruled that so long as Somerset was on English soil, it would not be lawful to force him onboard a ship that would carry him into enslavement in the Caribbean. While the ruling only stated that no enslaved person could be forcibly removed from England against their will (Lord Mansfield carefully worded his decision to avoid addressing the legality of slavery itself), it was widely interpreted as having decreed that slavery was unlawful in England.

The publicity around the Somerset ruling shored up the belief that any enslaved person would automatically become free the moment they set foot on English soil. Yet, at the same time, British newspapers were full of advertisements for runaway slaves, promising generous rewards to whoever would apprehend them and bring them back to their masters. The fact that these were printed in newspapers across the kingdom and throughout the entirety of the eighteenth century suggests how normalised and accepted the notion of slavery was. But runaway slave adverts are also vital evidence as documents of Black agency and resistance: they show people actively taking control of their own destiny. The following advertisement, published in the *Public Advertiser* on 14 November 1758, is typical:

RUN away on Saturday the 4th inst. from on board the Ship Northesk, Alex. Mac Millan, Master, a Negro Man, named Cambridge, the Property of the said Mac Millan. Whoever will apprehend the said Negro, and bring him to the Bar of Lloyd's Coffee-house in Lombard-street, or to the said Alexander Mac Millan, shall have two Guineas Reward. He had on a red Sailors Jacket and a Cap, and a Sore on the back Part of his Leg, occasioned by the Fall of a Log of Wood; he pretended he is free; he is a stout Man, and speaks but bad English. Whoever entertains him will be prosecuted as the Law directs. ALEXANDER MAC MILLAN

Readers are alerted to the fact that the Master of the *Northesk*, Alexander MacMillan, is on the lookout for an escapee named Cambridge. According to the printed text, the 'stout' Black man pretended to be free — in other words, this man refused to identify himself as anyone's slave. He may well also have refused to listen to the name 'Cambridge' as it is likely that the name was foisted on him by his enslaver.

Ironically, the need to provide an accurate physical description for the purposes of identification and apprehension means that 'runaway slave' adverts offer rare glimpses into how enslaved people looked, dressed and spoke. This kind of individualising information is often purposefully excluded from other kinds of written documents, such as merchant ledgers or plantation inventories. On 12 January 1705, Captain Jonas Hanway, Commander of HMS *Tilbury*, placed an advertisement in the *Daily Courant* about an enslaved child who had run away from him at Deptford Docks four days earlier, describing the escapee as:

A Negro Boy about 12 Years old, call'd James Pancridge, in a Green Livery lined with Red, had on a Wastcoat, Breeches and Stockins Red, a well-proportioned hansom Boy; had on a broad silver-lac'd Hat and a red Shoulder-knot, as Liveries usually have [...]

James's young age and luxurious clothes suggest that he was a servant in a wealthy household. In contrast, 31-year-old Peter had been made to labour as a sailor prior to escaping from the sloop called *The New Content of Jamaica*. His escape was advertised in the *London Post* on 29 August 1701:

Ran away on Wednesday last, the 27th Inst. a Negro Man-servant nam'd Peter, aged about 31 Years, a lusty well-set man, of a stern Countenance, he had on a Woolen wastcoat, white Woolen Stockings, and a pair of Sea Breeches; belonging to the Sloop, The New Content of Jamaica, Francis Morgan Commander, lying at Lime-House-Hole: Whoever brings him to his abovesaid Master, at Lime House Hole, on board the said Vessel, or to Mr. Charles Kent in Old Change, shall have 2 Guineas Reward and reasonable Charges.

The details included in 'runaway slave' adverts often indicate the physical violence and hardship that enslaved people were subjected to as a matter of routine. Cambridge, mentioned above, had 'a Sore on the back Part of his Leg, occasioned by the Fall of a Log of Wood' while Bess, a 16-year-old girl who ran away on 8 December 1702, is described in two related adverts, the first on 12 December [77] and the second on 2 January, as having 'a piece of her left Ear bit off by a Dog' and as 'much pitted with the Small Pox':

A Negro Maid aged about 16 years, named Bess, having on a stript stuff Wastcoat and Peticoat, is much pitted with the Small Pox, and hath lost a piece of her Left Ear, speaks English well, ran away from her Master, Captain Benj. Quelch, on Tuesday the 8th of December. If any persons secure the said Negro, and delivereth her to Mr Lloyd, at his Coffee House in Lombardstreet, shall receive a Guinea reward and reasonable charges.

Post Man and the Historical Account, 2 January 1703

Added to this is the psychological violence suffered by many enslaved people. As the two advertisements below reveal, a young Black Londoner known as Jack was made to wear a collar engraved with the words 'Mr Moses Goodyeare of Chelsea his Negro' while 18-year-old Ann, living in Glasgow, was made to wear a brass collar engraved 'Gustavus Brown in Dalkieth his Negro, 1726.'

A Tall Negro young fellow commonly known by the name of Jack Chelsea, having a Collar about his Neck (unless it be lately filed off) with these Words; Mr Moses Goodyeare of Chelsea his Negro, run away from his Master last Tuesday evening. Whoever secures him and gives notice to Mr Salter at his Coffee-house in Chelsea, shall have 10 s. Reward, he is supposed to be loytering about London.

Post Man and the Historical Account, 24 June 1704

RUN away on the 7th Instant from Dr. Gustavus Brown's Lodgings in Glasgow, a Negro Woman, named Ann, being about 18 Years of Age, with a green Gown and a Brass Collar about her Neck, on which are engraved these Words ["Gustavus Brown in Dalkieth his Negro, 1726."] Whoever apprehends her, so as she may be recovered, shall have two Guineas Reward, and necessary Charges allowed by Laurance Dinwiddie Junior Merchant in Glasgow, or by James Mitchelson, Jeweller in Edinburgh.

Edinburgh Evening Courant, 13 February 1727

These would have been similar to the collar placed around the neck of the Black man in Nost's sculpted bust [76], which originally also had a padlock (no longer present). To complete the dehumanisation of the wearer, these collars were made to resemble dog collars. The fact that the advertisement states that Jack may have had his filed off points to how hated these collars must have been. Filing it off is another act of resistance.

On 12 December 1702, an advert was
placed in a London paper offering a
reward for the capture of a 16-year-old
who had escaped the man who viewed
her as his property. She was only
referred to by her smallpox scars, her
good command of English, her dress
worn at the time of her disappearance
and by her partly missing ear from a
dog bite. A second advert placed in
a different paper a month later, which
named her as Bess, makes it clear that
she was still eluding capture. It is not
known what happened to Bess.

A Negro Maid, aged about 16 Years, much pitted with the Small-Pox, speaks English well, having a piece of her left Ear bit off by a Dog: She hath on a strip'd Stuff Wastcoat and Petticoat, absented her self from her Master Capt. Benjamin Quelch, on Tuesday the eight instant at Night, If any one brings her to Mr. Lloyd's Coffee-House in Lombard-street, they shall have a Guinea Reward and reasonable Charges.

Against such heartless brutality, there are glimpses of solidarity.
A 1753 advert makes mention of an accomplice who helped a young
Black man escape by taking him to Newmarket and exchanging
clothes with him:

*RAN away on Tuesday Se'nnight last, a Black Boy with long black
Hair, about 14 Years old; had on when he went away a brown Livery
Frock, which he has since chang'd with the Boy who deluded him
away, and took him to Newmarket, from whence he set out alone on
Tuesday last with the above Boy's Coat, which is brown, with white
metal Buttons; but 'tis supposed has not chang'd Breeches, which
are green Plush. Whoever will stop him, and give Notice to the Star
and Garter Tavern, in Pall-mall, shall receive Half a Guinea Reward,
or one Guinea on delivering him, at the above Place. Whoever
harbours or employs him shall be prosecuted according to Law.*

London Evening Post, 18 August 1753

We may also wonder whether the pregnant Sylvia and the young
man Lothario colluded with one another when they ran away from
the Jamaican planter Samuel Gregory during a 1763 visit to London:

*RUN away on the 11th instant, from Bishopsgate-street, a Negro
Woman, named Sylvia, the Property of Mr. Samuel Gregory, of the
Island of Jamaica: She is of middle Stature, about 25 Years old,
speaks tolerable good English, and supposed to be with Child; had
on when she went away, a red and yellow Stuff Gown, red Cloak, a
chipped Hat with a blue Ribbon; she also carried with her a blue and
white changeable Taffaty Night Gown, a blue and white Linen ditto,
and a red Copper plate ditto with broad Stripes and large Flowers:
Also went off from the Ship St. Elizabeth, Captain Blaw, on the 17th
instant, a Negro Boy, named Lothario, the Property of the said Mr.
Gregory, had on a Suit of Livery brown Cloth, trimmed with red and
worsted Lace, had a Gold-laced Hat: He is about 18 Years of Age,
and of a slim Make, and speaks bad English; he generally carried a
Fife in his Pocket, on which he was learning to play. Whoever can
give Information of these Negroes, so that the Owner may have
them again, shall receive a Reward of Five Guineas for each, by
applying to Mr. Godwin, opposite to the Church in Bishopsgate-
street. No greater Reward will be offered.*

Public Advertiser, 19 November 1763

As most of the runaway slave adverts make clear, anyone assisting or harbouring escapees was threatened with prosecution. While some were captured and brought back to their enslavers, many others must have managed to build a new life in freedom. Yet anti-Black racial prejudice in Britain and the traumatic displacement they had already suffered must have made it difficult to settle and grow fresh roots. With limited options for securing an income, many Black women were forced into domestic service or prostitution. Many of the young men who ran away did not even try to start a life in Britain; instead, they attempted to sign on to a ship and become part of the global community of sailors, as can be seen in these two advertisements:

Run away from Dormer Sheppard, Esq; at Mile-end Green, on Sunday the 7th instant, a Black Boy, named Lewis, about 16 years old, with a Hat on, in a darkish fine Cloath Coat lin'd with Red, without a Wastcoat, Leather Breeches and Blue Stockings: He speaks English very well. He has been already advertis'd of in this Paper of the 27th and 29th of November, and the Gazette of the 4th instant; and on the 5th was brought home from Her Majesties Ship the Roebuck at Sheerness, aboard of which he had continued several Days, attempting to enter himself, having changed his Name to Scipio. He is now suppos'd to be aboard some Man of Warr. Whoever secures him and gives notice of, or sends him to the said Dormer Sheppards, shall have their Charges paid, and a Guinea reward. Masters of Ships, and all other Persons are forbid to harbour him at their peril.
Post Man and the Historical Account, 13 December 1707

Whereas a lusty young Negro Man about the age of 20, known about York-Buildings by the Name of Kingston, Ran away from his Master on Christmas Day and enter'd himself on Board her Majesty's Ship Essex at Chatham, was upon due Application discharg'd the said Ship and brought to London on Friday the 20th Instant, but went away agen the same Night, whoever gives notice of him to Mr. Morris at Will's Coffee-house in Covent-Garden, so as he may be apprehended, shall have a Guineas Reward, or if brought thither shall be paid 2 Guineas with Charges by the said Mr. Morris. He went away in an old Sad-colour'd Stuff Coat with Black Wastcoat Breeches and Stockins, and carrys about him a Certificate of being Baptiz'd by Mr. Yates Reader of St. Martin's in the Fields. Or if he'll Return to his Service in Ten Days he shall be kindly receiv'd.
Daily Courant, 23 January 1710

These adverts were published to apprehend escaped people and force them back into enslavement. Yet as we read them today they are testament to the bravery of those men, women and children who refused to submit to their enslavers and had the strength and courage to emancipate themselves against all odds.

Further reading
• Charles Johnson, *Middle Passage* (London, 1990)
• Caryl Philips, *Cambridge* (London, 1991)
• Saidiya V. Hartman, 'Venus in Two Acts', *Small Axe*, no. 26, vol. 12, no. 2 (2008), pp. 1—14
• Hazel Carby, *Imperial Intimacies: A Tale of Two Islands* (London, 2019)
• Saidiya V. Hartman, *Lose Your Mother: A Journey Along the Atlantic Slave Route* (London, 2021)

Barbara Walker's 'Vanishing Point' and 'Marking the Moment' series

Habda Rashid

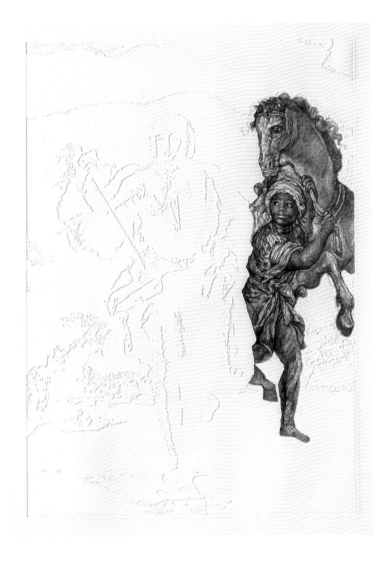

78
Barbara Walker
born 1964
Vanishing Point 25
(Costanzi) · 2021
graphite on embossed
Somerset Satin paper

UK Government Art Collection: GAC 19046
purchased by Government Art Collection
from Cristea Roberts Gallery, 25 March 2022
photo: courtesy Barbara Walker and Cristea
Roberts Gallery, London/Chris Keenan
© Barbara Walker, 2023

In reworking an early eighteenth-century portrait of George Keith, the Scottish nobleman and 10th Earl Marischal, Barbara Walker draws our attention to Keith's Black footman. He is possibly Ibrahim, one of the earl's servants. The original portrait suggests that Ibrahim, the horse, and the estate that stretches to the horizon are all part of Keith's possessions. In Walker's reimagining, Ibrahim's skill in handling the horse takes centre stage.

In Renaissance Europe, there were lots of Black people who were generally either enslaved people, servants or both. With that in mind, I looked at Old Master paintings and prints to see how the Black subject is represented within the Western canon. A lot of viewers don't even see the Black figures in the original paintings. The conversations are about perspective, composition, colour, but the Black figure is rarely discussed. I find that problematic. The Vanishing Point *and* Marking the Moment *series ask how do we move on from this? I'm very interested in visibility and non-visibility in terms of marginalised communities. I use erasure as a metaphor for how the Black community is overlooked, ignored, and even dehumanised by society. In previous works you see me wash away, cut out, isolate or diminish certain aspects of an image and bring others to the forefront. In the* Vanishing Point *drawings, embossing achieves that erasure.*

Barbara Walker

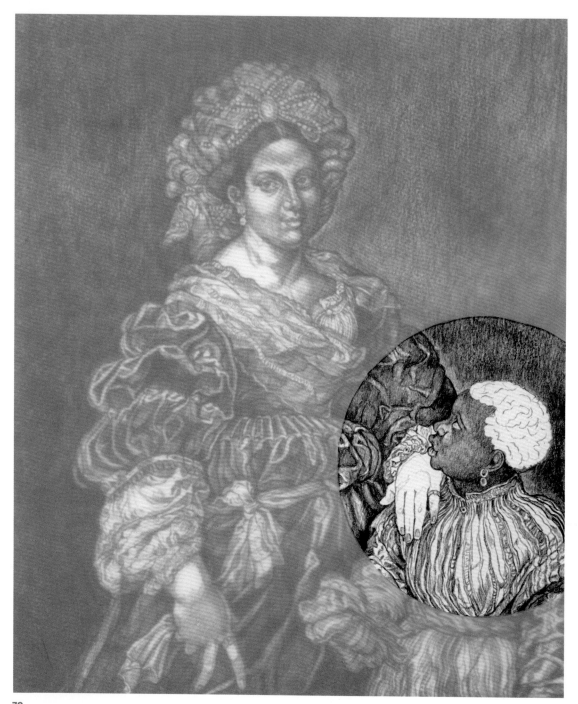

79

Barbara Walker · born 1964
Marking the Moment 3
2022 · graphite on paper overlaid with mylar

Fitzwilliam Museum, University of Cambridge: PD.76-2022
purchased with the Joan Anne Simms Fund, 2021 · photo: courtesy
Barbara Walker and Cristea Roberts Gallery, London/Chris Keenan
© Barbara Walker, 2023

Barbara Walker brings our attention to the people on the margin by reworking the portrait of Italian noblewoman Laura dei Dianti with an anonymous boy attendant by the sixteenth-century artist Titian. Walker's detailed graphite drawing overlaid with tracing paper focuses our attention on the child and on his expression, which seems more guarded than in the original. This challenges the repeated erasure of Black people from European visual culture.

How do you represent erasure? Barbara Walker's experience of growing up in a Jamaican family in Birmingham has directly shaped her practice, which is informed by the social, political and cultural realities that affect her life and the lived experience of diverse immigrant communities across the UK. Utilising a range of media and formats, she primarily works in the space of painting and drawing to make highly detailed figurative works that essentially link historical and contemporary questions concerning race, class, power and representation.

Walker often develops series, as if chapters of a book, that unfold a visual manifestation of her thinking, with a lengthy and intense period of artmaking, preceded by critical time spent on research and discussion. In both the *Vanishing Point* series [40, 78 and 80] and the *Marking the Moment* series [79], Walker's source material is venerated historical Western European paintings and prints, housed in iconic public museums. Walker uses these projects to examine how historical portraiture was traditionally commissioned by the wealthy white elite, and why a particular vision of Black subjects as depicted by white European, mainly male, artists is principally represented in our public archives and collections and dominates traditional narratives in art history.

Barbara Walker's *Vanishing Point* series derives, in part, from her childhood encounters with art in public museums and galleries, which were notable for the absence of Black people in the portraits and narrative scenes that she was viewing. Walker wanted to confront and address the under-representation of Black figures in Western art history, and to offer an alternative depiction of the traditional European artistic canon in which African people are typically racialised and marginalised. Started in 2017 (when Walker won the Evelyn Williams Drawing Award as part of the Jerwood Drawing Prize) and first exhibited at the Jerwood, Hastings, in 2018, this inaugural '*Vanishing Point*' project consists of a suite of 11 works that reinterpret traditional European paintings. The Award enabled Walker to undertake sustained research into well-known paintings made by European artists in the 1500s to 1700s, initially within the collection of the National Gallery, London. Here, Walker was first drawn to Venetian paintings and, specifically, *The Adoration of the Kings* as a subject. Paintings were identified through Walker's conversations with museum staff and her own research. Following this lengthy initial research stage, the selection of the paintings for reinterpretation became an intuitive process for Walker, with the compositional structure and the position of the Black subject a key consideration.

Through blind embossing, Walker in effect erases the dominant white figures present in the original compositions and emphasises the Black subjects by drawing them in fine detail using graphite onto the now blank sheet of white paper. The resulting artworks thus focus exclusively on the Black figures, making them the subjects

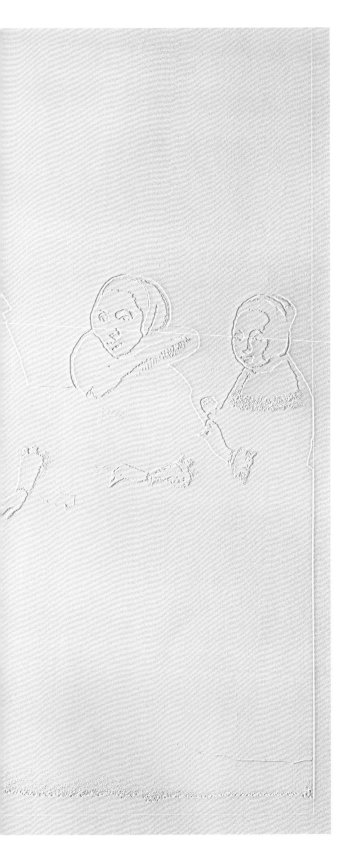

Barbara Walker · born 1964
Vanishing Point 29 (Duyster) · 2021
graphite on embossed Somerset Satin paper

Fitzwilliam Museum, University of Cambridge: PD.75-2022
purchased with the Joan Anne Simms Fund, 2021 · photo: courtesy
Barbara Walker and Cristea Roberts Gallery, London/Chris Keenan
© Barbara Walker, 2023

By embossing the outlines of a wealthy white family,
Walker accentuates the contrast with the graphite drawing
of the anonymous Black man in their midst. Using a Dutch
seventeenth-century painting as her starting point, her
reversal allows us to see him as an individual. The Black man
may have been an attendant, but his clothing, position in the
scene, and posture suggest that he could have been a business
acquaintance instead.

81

Willem Cornelisz Duyster · 1599—1635
and later unrecorded artist/s
Family Group with a Black Man
*c.*1631—*c.*1650 · oil on panel

Rijksmuseum, Amsterdam: SK-A-203 · photo: Rijksmuseum,
Amsterdam · [not in exhibition]

Standing in the centre of the composition between the white
pater familias and his heir apparent is a richly-attired yet
unidentified Black man who stares out to meet the viewer's
eyes with as equal force as the picture's white protagonists.
Despite his penetrating gaze, this man's inferior social status
is implied by his placement behind the table decked in a
sumptuous red cloth. His marginalisation from the group
of figures who occupy the foreground of the composition is
further emphasised by the gesture of the master's pointing
hand which, deliberately positioned in the middle of the
Black man's body, acts not only to designate the line of family
succession but seems to serve as a stamp of white ownership.

rather than the objects and appendages to the white figures of the original. This is clearly seen in Walker's reinterpretation of the Black magus and his two servants in Paolo Veronese's 1573 *Adoration of the Kings* in *Vanishing Point 17 (Veronese)* as well as in her reworkings of Willem Cornelisz Duyster's *Family Group with a Black Man* of *c.*1631–*c.*1650 [see 81] in *Vanishing Point 29 (Duyster)* [80] and Placido Costanzi's *c.*1733 *Portrait of George Keith, 10th Earl Marischal and his groom, possibly Ibrahim* in *Vanishing Point 25 (Costanzi)* [78].

This is also the case for Walker's newer ongoing series, *Marking the Moment*, started in 2022, in which Walker uses historic engravings and etchings as her sources. She intricately redraws the complete scene of the original print and then obscures the majority with a layer of mylar, purposely leaving only the Black figure revealed, as if in a theatrical spotlight. The Fitzwilliam Museum recently bought Walker's *Marking the Moment 3* [79], which reworks Titian's famous *Portrait of Laura dei Dianti* of *c.*1523–5.

The inversion created by Walker that compels the viewer to see and focus on the Black subject is most clearly represented in *Vanishing Point 29 (Duyster)*, where our gaze is elegantly held by the young Black figure [80]. This inscribing of presence, which is accentuated through an addition of materiality via Walker's use of mylar and embossing, serves to highlight an invisibility, historic and actual. We are left to accept that many narratives are unaccounted, untold, silenced or erased.

Through her visual dialogue with Old Master paintings in both the *Vanishing Point* series and the *Marking the Moment* series, Walker examines power, visibility and presence. She represents the act of erasure to highlight historical inequities, inviting the viewer to consider how history is made and how such strategies might reorient our understanding of Black identity. Walker's works offer an alternative and rebalanced depiction of the traditional European artistic canon, and importantly question the role that art has played in history as well as in wider contemporary socio-political contexts. Walker's ability to create a thought-provoking and visually compelling dialogue with highly established and instantly recognisable historical works reflects the strength of her abilities as an artist and thinker.

Enslavement and fashion

Is drinking tea, coffee and hot chocolate, and smoking tobacco, became commonplace, the wealthy in Britain began to buy fashionable items to store and consume these products. Many of these items are beautifully designed and made. But they are not just collectors' pieces.

The consumables they contained, and the materials from which they were made, such as mahogany, silver and turtle shell (known as tortoiseshell), are the products of enslaved people's work. These objects sanitised the transatlantic slave trade so successfully that they blinded their owners to its abject violence. They continued to be valued, collected and often admired uncritically.

If we recognise enslaved and Indigenous producers as being as important as the designers, makers and owners of these fashionable pieces, how do we see these objects differently?

Detail of 83

82

*A cased set of two tea caddies
and a sugar caddy*

box: unrecorded maker, England · caddies:
probably Henry Nutting (active 1790s—after 1815)
*c.*1812—13 · silver and mahogany

Fitzwilliam Museum, University of Cambridge: M.7-1965 · given by
The Friends of the Fitzwilliam, 1965 · photo: © The Fitzwilliam
Museum, Cambridge

In 1813 Viscount Fitzwilliam started using his expensive new
caddies, marked G, B and S on their lids to indicate their respect-
ive contents: green tea (unfermented), bohea tea (fermented)
and sugar. Their fronts are engraved with his coat of arms,
which reappears on the carry-case. The height of elegance and
fashion, this tea-ware set is made from mahogany and silver,
materials produced by enslaved people, and filled with Chinese
tea and Caribbean sugar.

83

Unrecorded makers
Snuffbox · *with gold piqué point work
and interior vignette under glass*
possibly France or England · *c.*1730—60
tortoiseshell, gold points, bodycolour on card, glass

Fitzwilliam Museum, University of Cambridge: M.58-1984
given by Dr & Mrs J.C. Burkill, 1984 · photo: © The Fitzwilliam
Museum, Cambridge

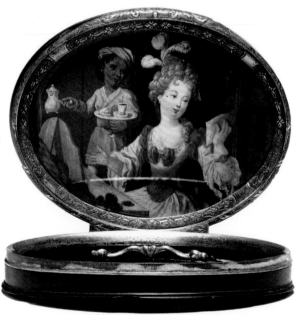

Crafted from luxury tortoiseshell likely imported from the
Caribbean, this palm-sized snuff box was filled with tobacco
from the Americas and personalised by the miniature within
its lid. This portrays an aristocratic European at her morning
toilette being brought hot chocolate — made from Central
American cacao and enslaved-produced Caribbean sugar
— by a Black servant. Attired in yellow 'Indian' livery, this
African attendant would have been considered as 'exotic'
as the chocolate, sugar and tobacco.

84

William Kent (design) · 1685—1748
and unrecorded makers
Pair of upholstered armchairs
1738—44 · mahogany and beech (with other
later woods), modern yellow silk damask covers
trimmed with brass nails and original cast brass
corner bosses

Fitzwilliam Museum, University of Cambridge: M.7A-2021 and
M.7B-2021 · purchased and conserved with the Colin Granville Elliot
Legacy Fund, 2021 · originally made for Charles, Viscount Bruce, later
3rd Earl of Ailesbury (1682—1747), for Tottenham House, Wiltshire
photo: © The Fitzwilliam Museum, Cambridge

These height-of-fashion 'elbow chairs' are carved from
mahogany, a tropical hardwood whose English name derives
from 'm 'oganwo', a term used by the Yoruba and Ibo peoples
of West Africa. Enslaved African people on British-owned
Caribbean plantations were forced to fell mahogany trees to
clear land for plantation crops, resulting in lasting ecological
damage. At first, merchant ships used it as ballast. But,
following a Parliamentary Act of 1721, which allowed timber
from British possessions in the Americas to be imported duty
free, mahogany became the most widely used wood for British
furniture. It was valued for its relative cheapness, ease of
working, resistance to furniture beetle, red colour and lustre.

85

David Le Marchand · 1674—1726
Portrait of Elizabeth Eyre · 1659—1705
1700 · African elephant ivory

Fitzwilliam Museum, University of Cambridge: M.12-1946
given by the Friends of the Fitzwilliam Museum, 1946
photo: © The Fitzwilliam Museum, Cambridge

The ivory-carver David Le Marchand used a piece of African
elephant tusk, prized for its colour, workability and sheen, to
carve this virtuoso low-relief profile-portrait of the aristocratic
Elizabeth Eyre. Neither patron nor artist probably considered
how the heavy elephant tusks were transported on the backs
of captive African people to West African ports, where both
were sold as commodities.

Slave-produced commodities

Peggy Brunache

These fashionable and expensive containers for serving chocolate, coffee, tea, sugar, snuff and tobacco [82, 86—89] represent material articulations of eighteenth-century British and European colonialism, signifying Europe's global importance to itself and the world, and reverberating its historical ideals into the future. These seemingly innocent and innocuous objects advertise a sinister belief held by many Europeans between the seventeenth and nineteenth centuries: that ownership and consumption of luxury goods — and even Black and Indigenous bodies — were legitimate spoils of war and colonial ventures. The painted scenes of Europeans dominating the landscape and lauding it in domestic settings [see 73, 74, 83] are meant to remind one of the supposed natural order of things, at least within the white supremacist world view, and the subservient positions of enslaved African and subjugated Indigenous peoples.

86

Unrecorded makers
Chocolate pot and cover
Nymphenburg Porcelain Factory, Germany · *c.*1765 hard-paste porcelain, enamels and gilding

Fitzwilliam Museum, University of Cambridge: C.61 & A-1950 · given by Mrs Frances Louisa Dickson, Honorary Keeper of Ceramics, 1950 photo: © The Fitzwilliam Museum, Cambridge

This expensive and fashionable porcelain pot was made in southern Germany for serving hot chocolate, an exclusive drink introduced from Mesoamerica by Spanish colonisers in the 1600s. Made from sugar-sweetened cacao paste, chocolate was valued in Europe as a stimulant, aphrodisiac and cure-all. This pot's rounded belly evokes the Mesoamerican *tecomate*, a drinking vessel formed from the bottom of a dried gourd, while its classical-inspired decoration Europeanises it.

87

Unrecorded makers · *Coffee pot*
probably Leeds manufactory, probably decorated in the Netherlands
*c.*1780—90 · lead glazed earthenware (Creamware) and enamels

Fitzwilliam Museum, University of Cambridge: C.1067 & A-1928 · bequeathed by
Dr J.W.L. Glaisher, 1928 · photos: © The Fitzwilliam Museum, Cambridge

Coffee became the most fashionable drink in early eighteenth-century Europe,
consumed in literary cafés and coffee houses but also bought from street-vendors.
This pot was probably made in Leeds and exported to the Netherlands for decoration
and sale. It may have been used to serve coffee sweetened with sugar, two goods pro-
duced by enslaved people in the Dutch-owned plantation colonies in the Americas.

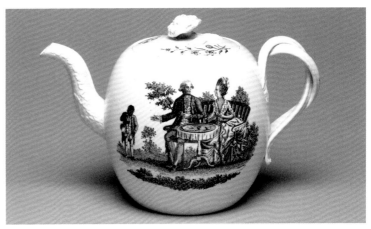

88

Unrecorded makers · *Teapot*
Wedgwood factory, Staffordshire, transfer print by Guy Green,
Liverpool · *c.*1780 · earthenware (Queensware), transfer prints

Fitzwilliam Museum, University of Cambridge: C.729 & A-1928
bequeathed by Dr J.W.L. Glaisher, 1928 · photo: © The Fitzwilliam Museum, Cambridge

In the later eighteenth century, Chinese tea supplanted coffee as Britain's preferred
hot drink and was commonly drunk with enslaved-produced Caribbean sugar. To
match the boom in demand, tea-wares were produced to suit all pockets. This teapot,
made from a cheap alternative to porcelain and using the latest printing technology,
was decorated with a popular design that shows a wealthy white couple having tea
prepared by a Black servant.

89

Unrecorded makers
Sugar bowl and cover
Mennecy Porcelain Manufactory,
France · 1760 · soft-paste
porcelain, enamels

Fitzwilliam Museum, University of Cambridge:
C.1 & A-1959 · purchased with the Duplicate
Objects and Donation Fund, 1959 · photo:
© The Fitzwilliam Museum, Cambridge

This pot for holding refined white sugar
was made in France as part of a high-
end tea or coffee service for wealthy
Europeans. Used for medicine, cooking,
preserving, fermenting, flavouring and
sweetening, cane sugar was produced
by enslaved African people working
in horrific and inhumane conditions
on European-owned plantations in
Caribbean colonies. Demand drove
production, and increasing imports
led to lower prices, meaning sugar
became affordable to most.

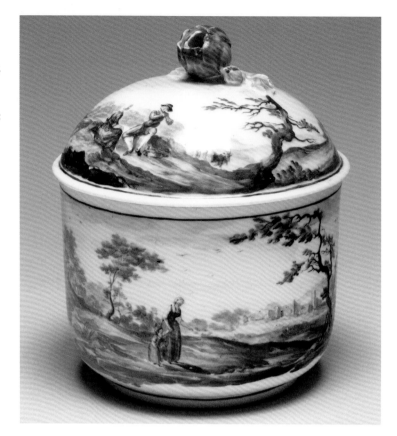

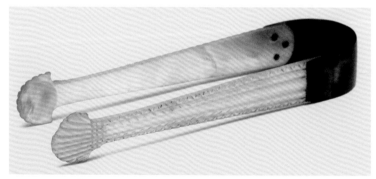

90

Unrecorded makers · *Sugar tongs*
probably England or France · probably late eighteenth or
early nineteenth century · mother of pearl and tortoiseshell;
copper rivets

Museum of Archaeology and Anthropology, University of Cambridge: 1921.63.173 · bequeathed
by George Spencer Perceval, 1921 · photo: Museum of Archaeology and Anthropology, Cambridge

In the later eighteenth and early nineteenth centuries, these luxury sugar tongs
were used daily to pick up sugar lumps for dissolving into fashionable hot beverages
such as tea, coffee and hot chocolate. In a simple action these tongs brought together
plantation commodities from Europe's many colonies reliant on enslaved and forced
labour. The top of these tongs is made from turtle shell, also imported from the
Caribbean. How can something so small encapsulate so much?

91

Unrecorded makers
Tobacco jar

Three Bells Factory, Delft,
Holland · *c.*1750–1820
tin-glazed earthenware;
glaze, blue paint

Fitzwilliam Museum, University of Cambridge:
C.64 & A-1997 · given by G.H.W. Rylands
in memory of his mother, Betha Wolferstan
Rylands, 1997 · photos: © The Fitzwilliam
Museum, Cambridge

This Dutch tobacco jar presents
a powerful fantasy of uncontested
white supremacy. On the dockside in
Havana, Cuba, an Indigenous man holds
a long-stemmed pipe and stands as if
in relaxed conversation with a seated
European merchant. Two barrels of
tobacco leaf await loading onto a ship
bound for Europe. The real process of
tobacco production — the European
seizure of land from Indigenous people
and enslavement of African labourers
— occurs off-stage.

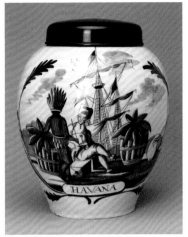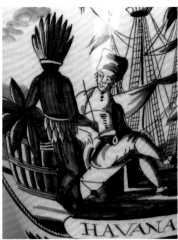

These ideals of colonialism and consumption are juxtaposed with
the fragment of an undecorated clay tobacco pipe [92], probably
once a luxury possession of an enslaved person, forced to toil in
Brazilian gold mines — the consumption of tobacco equally enjoyed
by both the enslaved African person and the European slaver. And
yet, so little can be ascertained about the original owner of the clay
pipe. Unlike the intricate decoration on the European items that
signify power, status and wealth, one can only imagine what, if any,
designs once embellished the enslaved person's pipe, and what this
might have symbolised. For like the archives of slavery, the lifeways
of enslaved African people are at best marginalised but in the main,
their existence and contributions to the early modern era are
erased altogether. However, material possessions like this visually
insignificant but culturally vital pipe fragment help us to 'read
against the grain' and (re)discover the dynamic lives that enslaved
people created for themselves as resilience and resistance against
the chattel slavery of the Atlantic world.

92

Unrecorded maker
Tobacco pipe fragment

probably Ouro Preto, Brazil
probably eighteenth or
nineteenth century · clay

Museum of Archaeology and Anthropology,
University of Cambridge: 1927.225
bequeathed by Professor Sir William
Ridgeway, 1927; given to him by Arthur
Tisdall Samuels, 1926; collected by Samuels
in 1925, after the pipe had been excavated
earlier that year from an old compound for
enslaved workers, Ouro Preto gold mines
photo: Museum of Archaeology and
Anthropology, Cambridge

This fragment of a rough clay pipe
was excavated from a site of enslaved
people's homes in a goldmining region
in Brazil. Until 1888, when Brazil
became the last country in the western
hemisphere to abolish slavery, enslaved
men, women and children worked six
days a week under horrendous conditions
in gold mines. They nevertheless raised
families, tended crops, created their own
culture and perhaps, in rare moments
of rest, smoked a pipe of tobacco.

'Sugar Cane John Canoe'

Sokari Douglas Camp

Missing the multicultural celebrations of Notting Hill Carnival, during the 2020 lockdown, I began researching its Caribbean origins, which led to my discovering the nineteenth-century watercolour prints of Isaac Mendes Belisario. I learned about the Jamaican festivals called Jonkonnu (or 'John Canoe' in English) where indentured plantation workers celebrated by dressing in colourful, hand-me-down clothes: admiral's hats, bright-buttoned soldiers' jackets, layers of petticoats, etc. The gender fluidity of these carnival characters attracted me, with petticoat costumes often being worn by male performers. So, too, their fantastic head-gear — decorated with feathers, depicting house-boats, plantation houses and more — all of which reminded me strongly of still-surviving West African masquerade traditions. Because Belisario's prints clearly demonstrated these masquerade traditions thriving in the Caribbean, I realised that even with only one day of precious freedom allowed each year, the plantation workers celebrated life in a joyous return to the revels of their African roots.

In this sculpture, which I've called *Sugar Cane John Canoe* [93] the tall feathers of the admiral's hat have transformed into sugar cane, the premier Caribbean crop that produced the refined sugar cubes presented on the silver teaspoons below. Also displayed are boxes of tea, contemporised with their globally recognised brand logos of Typhoo and Tetley. It was Caribbean sugar, produced by enslaved African people on British-owned plantations, that sweetened the tea pouring into London from colonial plantations in India and Ceylon (Sri Lanka). Drinking this heady, fashionable brew became a symbol of wealth and power, quickly becoming central to the idea of Englishness itself [see 82, 88—90]. Rising imports of both sugar and tea stimulated 'demand' for the other, a vicious cycle which increased the 'demands' imposed on enslaved or indentured labourers on opposite sides of the British Empire.

My dancing *Sugar Cane John Canoe* masquerader holds his arms tightly behind his back like an Irish dancer, or perhaps like a captive person indicating servitude and compliance? Accounts record how enslaved people were often forced to dance on deck during the long and horrific so-called 'Middle Passage' voyage from the coast of Africa to the Caribbean [see 64—65], as a way of exercising them to keep them fit. I assume that Africans were introduced to European dance steps, jigs, sailors' hornpipes, and so on. I like the way the lines create figurative forms in this dance style and encourage the viewer to question the origin and authenticity of the choreography. In this performance, John Canoe — whose name is a corrupt English rendering of a Ghanaian chief, who traded with and fought against British and Dutch colonial interests in the Gold Coast — is up on his toes, dancing defiantly on the Union Jack, which I wanted to spotlight as the undeniable 'owner' of these contested spaces and entangled, multilayered histories.

93

Sokari Douglas Camp
born 1958
Sugar Cane John Canoe
2021 · mild steel and acrylic paint

© Sokari Douglas Camp CBE, private collection, London · Courtesy of the Artist and October Gallery, London · photo: as above

In 2021, Sokari Douglas Camp made the *Jonkonnu Masquerade* series in which enslaved performers wear costumes referencing the Jamaican Jonkonnu festival, her own Nigerian Kalabari heritage and contemporary issues. Dressed in a stylised admiral's hat bedecked with imagery relating to slave-produced sugar and colonial-style English tea-drinking, *Sugar Cane John Canoe* dances on the Union Jack, to spotlight the 'owner' of this multilayered history.

'Sasabonsam'

Mary-Ann Middelkoop

'Well do I remember our greatest terror when out at night on the forest path', wrote Mary Kingsley (1862—1900) in 1899. The English ethnographer was talking about *sasabonsam*, an evil spirit of human shape, rooted in Ghanaian beliefs. Living in the tallest trees of the forest, *sasabonsam* or *asabonsam* as it was sometimes called, was believed to be a frightening, hairy creature with iron teeth, red eyes, bat-like wings and long, snaky legs that hung down, with which it would occasionally 'hook up' unwary people that passed by and feed on them. It also had a tail with which it distracted its victims. Hunters, who went to the forest and were never heard of again, were believed to have been caught by the fear-instilling creature.

According to Doran Ross's 1984 account, Osei Bonsu (1900—1977), one of the most important and revered woodcarvers of twentieth-century Ghana, is said to have invented what would become the standard version of *sasabonsam* when he included it as the finial element of a linguist staff that he carved in 1925. Bonsu was born in Kumasi in October 1900, the son of Kwaku Bempah, a carver and drummer who himself was taught to carve by court sculptors in the palace. His son started carving at a young age, and was apprenticed to his father until he was 17 years old. He then became an independent carver in his own right, and went on to receive numerous commissions from local chiefs in the years that followed. Throughout his impressive 60-year career, Bonsu was the chief carver of no less than three Asantehene, the ruler of the Asante (or Ashanti) people. In 1924, under the patronage of the anthropologist Captain Robert S. Rattray (1881—1938), Bonsu (together with his father and elder brother) made numerous wood carvings for the British Empire Exhibition at Wembley.

The Bonsu family were renowned carvers and became vital knowledge providers on all aspects of Ashanti culture to Rattray, who also included several images of their carvings, though anonymously, in his book *Religion & Art in Ashanti* (1927). A part-time teacher at three colonial schools between 1933 and 1956, Bonsu, whose carving showed a naturalistic, modern style with a typically smooth finish, is said to have commented on a sculpted figure once, 'Is this how God created you?' Yet his own work occasionally shows a different, sculpturally innovative response to the same subject. By the late 1930s, the Akan artist, then based at Achimota, was often asked to carve his signature style figures, drums, staffs and umbrella heads for colonial dignitaries, some of whom would then donate his pieces to European museums.

This large mahogany carving of *sasabonsam* by Bonsu [94] with horns, an imposing beard, short upper arms outstretched to display its wings and long sinuous legs that morph into outstretched hands (rather than feet) for trapping human prey, was acquired by Arthur C. Spooner (1906—1996) during his extended colonial service in West Africa from 1929 until 1963. To prepare for his

94

Osei Bonsu · 1900—1977
Sasabonsam
*c.*1950 · mahogany

Museum of Archaeology and Anthropology,
University of Cambridge: 2015.249
given by Mrs Sylvia Spooner and Professor
Edward T. Spooner, 2015 · acquired by
Arthur C. Spooner between 1929 and 1963
photos: Museum of Archaeology and
Anthropology, Cambridge

The Akan *sasabonsam*, a vampire-like
creature, lurks in the forest canopy to
hunt prey. On both sides of the Atlantic,
people referred to *sasabonsam* some-
times metaphorically to represent a
person who enslaves, harms or tortures
others for his own pleasure. Osei Bonsu,
a prominent sculptor from the Asante
city of Kumasi, Ghana, carved this
symbolic representation of the forest
spirit in the 1950s. Bonsu was often
asked to carve his signature style
figures for colonial dignitaries.

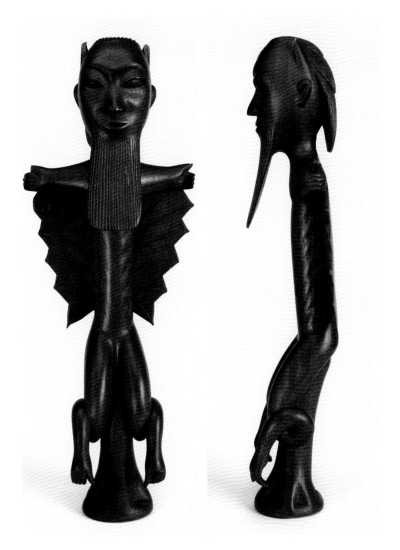

95

Unrecorded photographer
'Ashanti Legendary Figure, Sasabonsam'
Ghana · late 1940s

Museum of Archaeology and Anthropology,
University of Cambridge: Spooner Collection
file P.167005.SPN · given by Mrs Sylvia
Spooner and Professor Edward T. Spooner,
2015 · photo: Museum of Archaeology and
Anthropology, Cambridge

A postcard sent by Arthur C. Spooner
to his children on 15 October 1950
showing Osei Bonsu carving a
sasabonsam at Achimota, Ghana.

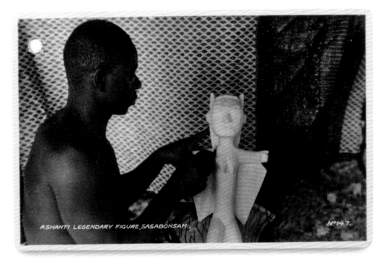

96
Osei Bonsu · 1900—1977
Sasa boa · 1935 · wood
(probably mahogany)

Museum of Archaeology and Anthropology,
University of Cambridge: 1936.205 · given by
Captain Robert P. Wild (1882—1946), having
been acquired from Osei Bonsu during Wild's
colonial service in West Africa (1920—38)
as Inspector in the Mines Department of
the Asante region · photos: Museum of
Archaeology and Anthropology, Cambridge

Enslavers stereotyped African people
as savages and cannibals to justify
enslavement. But for enslaved people,
it was the enslavers who were some-
times represented by evil spirits that
hunted them as prey: they took their
bodies and turned their work into cash
crops for mass consumption. The animal
form of the vampire-like *sasabonsam*,
known as a *sasa boa*, 'sasa' meaning
'ghost' and 'boa' animal, represents this
danger among Akan people including
those displaced to the Americas.

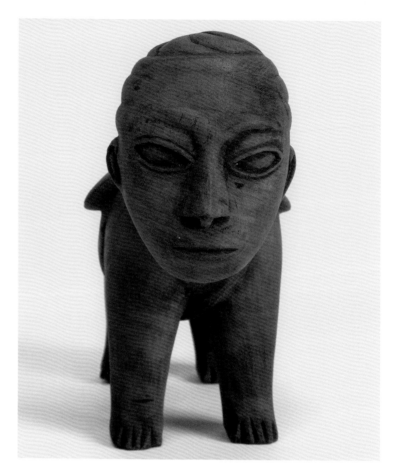

service, Spooner had studied at Clare College, Cambridge, in 1928
and 1929 for the Cambridge Colonial Service diploma, after which
he was posted to the Gold Coast as a Cadet in the Administrative
Service. He enjoyed a successful career rising through the bureau-
cratic ranks to become Senior District Commissioner, Ashanti, in
1946 and finally Assistant Chief Commissioner of the Northern
Territories of the Gold Coast in 1951. Spooner was an admirer
of Bonsu's work and, in mid-October 1950, sent his children a
photograph of Bonsu at work on a *sasabonsam* figure, now in the
collection of the Museum of Archaeology and Anthropology in
Cambridge [95]. On the back, Spooner wrote: 'Air Mail · 15/10/50
This is a picture of Osei Bonsu the woodcarver with love · Daddy.'
In 2015, the Spooner collection was donated to the Museum of
Archaeology and Anthropology, Cambridge.

The second sculpture [96] is believed to be the mythical creature
sasa boa ('sasa' meaning 'ghost' and 'boa' animal), the animal form
of *sasabonsam* with a human, elongated, egg-shaped head, animal
body and bird's wings decorated with abstractly carved feathers,
on its back. Rather than fearful and frightening, this *sasa boa*
radiates a calm and affable appearance. According to a catalogue

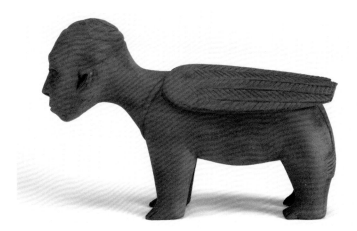

card in the Museum of Archaeology and Anthropology, 'The carving was made in 1935 by the woodcarver Osai [sic] Bonsu'. It was either commissioned directly, or purchased from Bonsu that same year by the engineer Captain Robert P. Wild (1882–1946), who was appointed as an Inspector in the Mines Department of the Asante region in 1920, where he worked until his retirement in 1938. Wild was an avid collector and excavator, and he regularly donated his materials, including mineral specimens, to museums in England. He also seems to have been a patron to Bonsu.

In 1936, Wild presented the Pitt Rivers Museum in Oxford with a similar sculpture, which has an inscription painted in black and white pigment on its side, part of which says: 'figure of Sasaboa Densia, animal form of Sasabonsam said to live in the ground'. It also records its maker as 'Osei Bansu in Kumasi', with the spelling error in the surname later corrected to 'Bonsu'. Another thirteen carvings believed to be by Bonsu, five of which were commissioned by Wild, including three *sasa boa* and a *sasabonsam* figure, are now in the British Museum, London, thanks to Wild's bequest of his entire collection.

Despite their likeness being trapped by Ghanaian artists and translated into finely worked wood carvings in the 1930s, which were then in turn acquired by colonial officials and gifted to ethnographic museum collections in Europe, *sasabonsam* or *asabonsam* still exert power and fear in the imagination. In *Black Leopard, Red Wolf*, the first book of the 2019 fantasy *Dark Star Trilogy*, Jamaican writer Marlon James draws on African history and mythology, including both terrifying creatures:

'We should leave. They travel in two, his kind' Leopard said. 'His brother?' 'They live in trees and attack from above, but I have never heard of one this far from the coast. He is Asabonsam, the flesh eater. His brother, Sasabonsam, is the bloodsucker. He is also the smart one. We should leave now.'

Further reading
Doran H. Ross, 'The Art of Osei Bonsu', *African Arts*, vol. 17, no. 2 (February 1984), pp. 28—40, 90

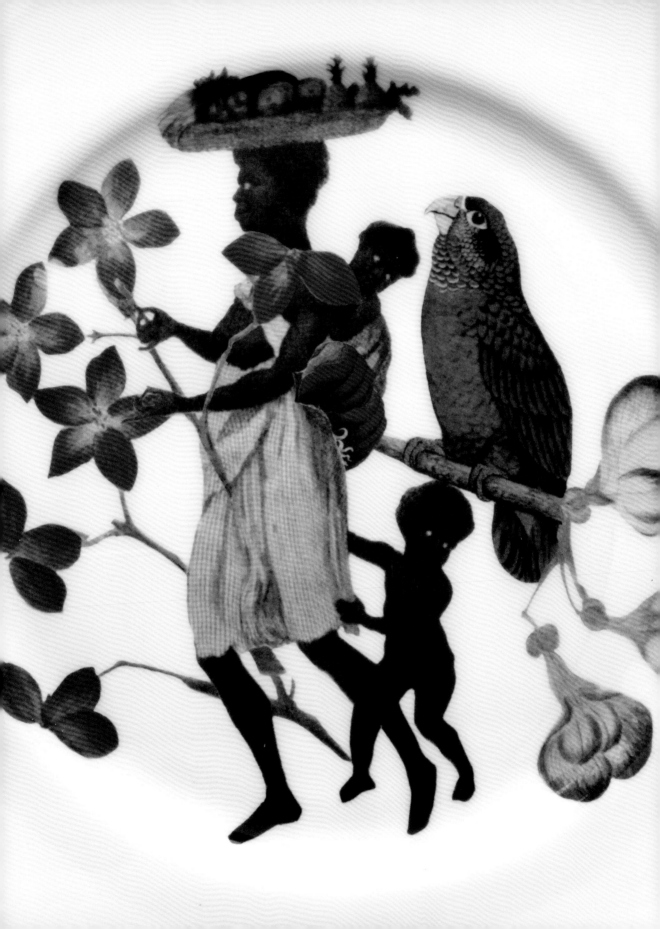

4

Plantations: production and resistance

In the Americas, from the early 1500s until 1888, most enslaved people lived and worked on plantations. On these large agricultural estates, which they were forbidden to leave, they toiled long hours, without pay, to grow crops such as sugar, tobacco and coffee for export to Europe.

Despite the enormous dangers of resisting, enslaved people did challenge the plantation system by withholding labour, rising against enslavers and escaping. A tiny proportion were able to buy their freedom.

The final formal act to end enslavement in the Americas was an 1888 law in Brazil.

But political authorities restricted the terms of emancipation. Britain's Parliament, for example, imposed an apprenticeship system that required people freed from slavery to work for former enslavers for up to six years. Legal emancipation did not mean full freedom.

Detail of 114

Production, knowledge generation and exploitation

Detail of 103

As well as producing crops, plantations were sites of scientific knowledge. Many specimens in Cambridge collections, from plants to birds' eggs, come from these estates. Enslaved and free Black people contributed to major scientific discoveries, but their role was unacknowledged.

The emancipation movements of the nineteenth century did not compensate enslaved people for their unpaid labour, exploited skills or lost loved ones. Many free people had no choice but to remain working on plantations for former enslavers.

Enforced poverty shaped work conditions and the environment in the nineteenth-century Americas.

Idealising brutal labour

Chiedza Mhondoro

Frans Post (1612—1680) arrived in Dutch Brazil in 1637. He had been commissioned by Johan Maurits, Governor of Dutch Brazil from 1636 to 1644, to visually document the commercial and colonial development in the region. Here, he depicts with apparent 'eyewitness' detail the cycle of processing sugar destined for world markets [97]. A well-organised mill is at the centre of this scene, amidst Brazil's native and untamed flora. An oxen-driven cart laden with sugar cane has stopped just outside the large building with an open facade on the right. Labourers feed the cane into a grinder propelled by a watermill at the edge of the building. The empty cart in the foreground presumably returns to the fields to collect more sugar cane, continuing the routine. In the distance, boats on the

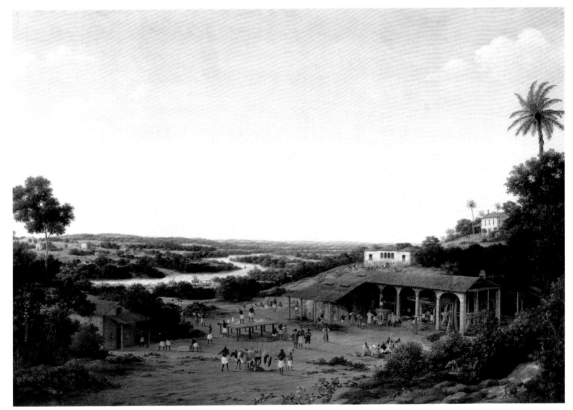

97

Frans Post · 1612—1680
A Sugar Mill Driven by Water with Ovens where Sugarcane Juice is Boiled to make Sugar · c.1650—5 · oil on canvas

Musée du Louvre, département des Peintures: 1724 · from the French Royal Collection
photo: © RMN-Grand Palais (musée du Louvre)/René-Gabriel Ojeda

In this painting, Dutch painter Frans Post erases the violence of enslavement on a plantation in Dutch Brazil. Instead, he creates a reassuring visual fiction of idyllic, harmonious industry. In the midground, enslaved people work a water-powered sugar mill, while in the background, ships on the river wait to transport the produce to Europe. This picture, commissioned by the region's new governor, helped to establish the plantation landscape as a popular genre of painting that permitted patrons in Europe a guiltless enjoyment of enslaved-produced goods.

winding river transport the processed sugar cane juice away and towards the European consumer. The single towering palm tree on the right and wildlife in the foreground serve to underline the tropical location of the scene.

Post painted multiple variations of sugar mill scenes throughout his career, both in Brazil and — as with this painting — after his return to Holland. These retrospective paintings combine observation and fantasy for a seventeenth-century Dutch audience. They also speak to the importance of Dutch art in representing norms around enslavement and ordered colonial agricultural production, deliberately hiding the extreme violence and brutality of plantation life. The browns of the earth, buildings and skin tones harmonise with the deep greens of the flora and the hazy blue sky making the presence of the mill, a Dutch imposition in this Brazilian landscape, appear natural. The enslaved workers, included as staffage, animate the composition and in their clean clothes and neat formations imply a serene, natural industriousness. Post presents a reassuring and comforting image of plantation life to his mid-seventeenth-century viewers, who would have benefited, directly or indirectly, from the Netherlands' increased prosperity, due in large part to its colonial enterprises.

Post's depiction of the sugar mill is, of course, highly sanitised and idealised. It omits to show the intensive and dangerous manual labour required to plant and process the sugar cane, the stifling buildings without cooling systems where the cane was boiled and the hazardous equipment, the enslaved labourers with severe burns, maimed limbs and amputations, and the countless people who died inhumanely. The brutal history of sugar production in European colonies remains hidden in Post's imagination, just as it does in the visual tradition of appealing plantation pictures that became popular from the mid-seventeenth century and remained fashionable among European viewers until the nineteenth century.

Further reading
• Pedro and Bea Corrêa do Lago, *Frans Post, 1612—1680: catalogue raisonné* (Milan, c.2007)
• Liza Oliver, 'Frans Post's Brazil: Fractures in Seventeenth-Century Dutch Colonial Landscape Paintings', *Dutch Crossing: Journal of Low Country Studies*, vol. 37, no. 3 (2013), pp. 198—219

Merian and Redouté: entomological and botanical knowledge generation

Henrietta Ward

The German naturalist, entomologist and artist, Maria Sibylla Merian (1647–1717), travelled to the Dutch colony of Surinam in 1699 with her younger daughter, Dorothea Maria Graff (1678–1743). They returned to Amsterdam in 1701, much earlier than intended, due to Merian's ill health. Driven by her curiosity and fascination with the life cycle of insects, particularly those that had never been seen or observed before by Europeans, Merian self-funded their journey by selling many of her drawings and insect specimens. She knew that her findings in Surinam would be of great interest to scholars and collectors across Europe and so wrote up her observations as quickly as possible after her return and had them published in 1705 in her book *Metamorphosis insectorum Surinamensium* [*The Metamorphosis of the Insects of Surinam*] [98]. In addition to information and images about Surinamese insects, her encyclopaedic study included many 'exotic' reptiles and plants portrayed by a European for the first time, and further information of ethnographic interest. Lavishly illustrated with hand-coloured engravings and full of new data, it caused a sensation with ripples felt far beyond the world of insect lovers.

98

Maria Sibylla Merian

1647–1717

Metamorphosis insectorum Surinamensium

(Amsterdam, 1705)

Cambridge University Library: MH.2.22 given from the Royal Library to the University Library by George I, 1715 · photo: reproduced by kind permission of the Syndics of Cambridge University Library

Perched on a guava tree, a pink-toed tarantula kills a hummingbird. The pioneering German naturalist Maria Sibylla Merian, who painted this detailed scene, took interest in enslaved women's botanical knowledge. However, she used it in her research without acknowledgement. As tarantulas very rarely prey on birds, the scene may reflect a story told to Merian by an enslaved woman about Anansi, the wise trickster character in Akan folk-tales who takes the form of a spider.

Such a significant undertaking would not have been possible without the knowledge and cooperation of the Indigenous and enslaved people in Surinam with whom Merian collaborated. In Merian's *Metamorphosis* and *Study Book* (her working journal), she describes how unnamed Indigenous people brought her caterpillars and butterflies from the rainforest while unnamed enslaved African people would accompany her on expeditions, clearing the route ahead of her. Merian's *Metamorphosis* also provides harrowing details about the maltreatment of enslaved people in Surinam, especially captive women, 'who are not well treated when they are in the service of the Dutch'. In the text accompanying her illustration of *Flos pavonis* (peacock flower), for example, she describes how pregnant 'black slave women of Guinea and Angola' would use its seeds to induce abortions, 'not wanting their children to be slaves like them'. Merian further records that 'It is only when they are very well treated by their master that

99

Maria Sibylla Merian
1647—1717

Sisyrinchium with blue morpho butterfly (Morpho helenor or Morpho achilles)

*c.*1701 · watercolour on vellum

Fitzwilliam Museum, University of Cambridge: 1146B · given by A.F. Griffith through the National Art-Collections Fund, 1925 · photo: © The Fitzwilliam Museum, Cambridge

In *c.*1701, Merian painted this highly detailed watercolour of a blue morpho butterfly. She had just returned to Amsterdam with her daughter and an Indigenous attendant from a two-year field trip in the Dutch colony of Surinam, northern South America, along with around 20 boxes of specimens. These included butterflies, beetles, hummingbirds and glow-worms, many of which appeared in her ground-breaking study *Insects of Surinam* published in 1705.

100

Pierre Joseph Redouté
1759—1840
Lobelia surinamensis
now known as
Centropogon cornutus
1813 · watercolour
and bodycolour over graphite
on vellum, margins ruled in red
and gold ink

Fitzwilliam Museum, University of Cambridge:
PD.122-1973.39 · bequeathed by Henry
Rogers Broughton, 2nd Lord Fairhaven, 1973
photo: © The Fitzwilliam Museum, Cambridge

This plant is so bold that it breaks out of
its golden frame. Redouté celebrates the
flowering of the bellflower *Centropogon
cornutus*, a plant from the Dutch colony
of Surinam. He painted it at Malmaison,
the garden created by Empress Joséphine
of France. Joséphine was born into a
family that owned enslaved people
in Martinique, a French colony in the
Caribbean. Under Joséphine's direction,
Malmaison became one of France's
leading botanical collections.

they want offspring. Sometimes they even kill their children. They
believe that they will be reborn in their own country, with their own
friends and in a state of freedom. They told me this themselves.'

When she returned to Amsterdam, Merian brought back many
plant and insect specimens to study or sell there. Amongst these
was likely the blue morpho butterfly (*Morpho helenor* or *Morpho
achilles*), which is distinctive for its striking, blue-striped wings
and found across much of South America. Merian has depicted the
butterfly from the dorsal and ventral views with great accuracy,
indicating that she must have drawn it from life [99]. Merian also
brought back an 'indianin' woman, probably from the Carib tribe.
Now far away from the natural habitat of her insect subjects,
Merian would have relied upon the Indigenous woman's knowledge

of plants and insects in the formulation of her book: this collaborator undoubtedly enriched Merian's text but she remains unnamed and unacknowledged.

Unlike Merian, the Belgian artist, Pierre-Joseph Redouté (1759 –1840) did not leave Europe and only travelled a short distance from Paris to see the exotic plants then growing in the garden of Joséphine de Beauharnais (1763–1814), wife of Emperor Napoleon I (1769–1821). As 'Painter to the Empress', Redouté would have been a frequent visitor to Château de Malmaison, where plants such as the *Lobelia surinamensis* (now known as *Centropogon cornutus*) flowered [100]. The plant is native to Trinidad-Tobago, the Windward Islands and Tropical America including Suriname. The plant's earlier synonym hints at its geographical locality and the region with which it was commonly associated, but also indicates the location where the naturalist who named this species encountered it.

The plant may have been sourced by the empress to recall the colours and flowers of her childhood home: Joséphine grew up on a sugar cane plantation in Martinique, which had been a French colony since 1635. The *Lobelia surinamensis* was included in her *Descriptions des plantes rares cultivées à Malmaison et à Navarre* [*Descriptions of Rare Plants Grown in Malmaison and Navarre*], published in 1813, alongside many other plants originating from the Antilles, Australia, the Guianas, India, Mexico, Peru and South Africa. The publication, while asserting her botanical knowledge and reputation, reveals her connections to seed and plant gatherers posted across the globe including Nicolas Baudin (1754–1803) and Félix Delahaye (1767–1829) in Australia, François André Michaux (1770–1855) in North America and Aimé Bonpland (1773–1858) in South America, all of whom, in their 'discovery' of 'new' plants, would have relied on the incomparable local knowledge and accumulated experience of Indigenous and enslaved people.

Further reading
• Musée national des châteaux de Malmaison et de Bois Préau (France), *L'Imperatrice Josephine et les sciences naturelles* (Paris, 1997)
• Ella Reitsma, *Maria Sibylla Merian & Daughters: Women of Art and Science*, Amsterdam: Rembrandt House Museum; Los Angeles: J. Paul Getty Museum (Zwolle, 2008)

Botany, empire and enslavement in Cambridge collections

Edwin Rose and Lauren Gardiner

Interest in collecting plants has connected Cambridge to diverse people and places since the early eighteenth century. The Martyn collection, held within Cambridge University Herbarium, was compiled by successive professors of Botany, John Martyn (1699–1768) and his son, Thomas Martyn (1735–1825), who dominated Cambridge botanical teaching and collecting for over 90 years. The Martyns established a botanical museum, including a substantial herbarium collection known as a '*Hortus siccus*' (literally meaning 'a dry garden'), to store specimens acquired from correspondents across the British Empire.

Although John Martyn taught at Cambridge between 1732 and 1762, his main residence was just outside London in the village of Chelsea where his neighbours included Philip Miller (1691–1771), head gardener at the Chelsea Physic Garden, and the noted physician and plantation owner Hans Sloane (1660–1753), whose collection formed the basis of the British Museum in 1753. Connections with Sloane and Miller forged links with travellers in the West Indies. These include William Houstoun (1695–1733), a Scottish physician and botanist who, under Sloane's patronage, collected plants from across the West Indies and Central America to stock a new botanic garden in Savannah, Georgia.

Some of Houstoun's specimens have ended up in Cambridge, including this example of *Salix humboldtiana* [102] from the city of Veracruz in New Spain (now Mexico). Writing to Sloane from Veracruz on 5 March 1731, Houstoun referenced the active role Indigenous — often enslaved — people played in collecting specimens:

I wrote to you about three months ago from Jamaica and sent you a collection of Plants from this place and Campechy and among which was Contrayerva. After the vessel was cast away, I designed to have gone up to Province of Jalappa, to enquire about the Plant of that name, but could not obtain leave of the governour, tho' I made use of the Doctor's interest. However I have sent up an Indian who has brought me down 4 small roots of it which I hope will grow, and I believe we shall find it a Plant quite different from the Marvel of Peru.

Houstoun to Sloane, 5 March 1731, British Library, MS 4052

However, the role of these Indigenous collaborators was not recorded when Houstoun's botanical research in 'America Meridionali' was converted, posthumously, into book form [101]. This great undertaking was directed by Joseph Banks, President of the Royal Society and advisor to the Royal Botanic Gardens at Kew, and resulted in *Reliquiæ Houstounianæ: seu Plantarum in America Meridionali*, which was published privately in London in 1781. Written in Latin to limit readers to a select group of naturalists, this important early European compendium of West Indian botany was not intended for public sale. Indeed, one reviewer described how

101

Reliquiæ Houstounianæ: seu Plantarum in America Meridionali

London, 1781

In 1781, Joseph Banks, President of the Royal Society and advisor to the Royal Botanic Gardens at Kew, authorised the publication of the findings from William Houstoun's research in Veracruz, eastern Mexico. Houstoun's name appeared on the title page, but the names of the enslaved and Indigenous people who contributed to the research were not recorded. The entire book is in Latin — restricting the findings to those with a so-called 'classical' European education.

it was 'printed at his [Banks's] expense, and liberally distributed to learned societies, public libraries and botanists in different parts of Europe.' The initial readership of *Reliquiæ Houstounianæ* was definitely exclusive with knowledge access tightly controlled: Banks presented copies to those people whom he considered to be involved in significant botanical collecting, or as diplomatic gifts. That said, the accompanying engraved illustrations did enjoy wider circulation because Banks permitted these to be printed separately, and some were given to global travellers who showed them to Indigenous people when looking for similar species. Despite having been dead for nearly half a century, Houstoun's name appears twice on the title page. The names of the enslaved and Indigenous people who contributed to his research are not recorded nor acknowledged in the text.

Thomas Martyn continued to develop the University's botanical collection during the late eighteenth century and students were encouraged to visit the purpose-built botanical lecture room and museum to examine specimens that were seen to give an insight into the extent and utility of God's creation. Martyn received several specimens from Alexander Anderson (1748—1811), Superintendent of the St Vincent Royal Botanical Garden, including *Simaruba excelsa* (now known as *Picrasma excelsa*) [103], a plant native to the West Indies. Many enslaved people worked in the Garden, cultivating and collecting plants from the region. Anderson also employed John Tyley, a mixed-race artist originally from Antigua, whose numerous botanical illustrations were held in high regard. Many of Tyley's artworks are now held by the Linnaean Society of London — including his signed watercolour drawing of a breadfruit tree [see 107] — and add valuable context to the plant specimens Martyn received. These botanical specimens connect teaching, research and slavery in eighteenth-century Cambridge. Through tracing their provenance, it is possible to uncover how the knowledge and expertise supplied by Indigenous and enslaved people were used to construct new accounts of the natural world in eighteenth-century Cambridge.

Further reading

• Lauren M. Gardiner, 'Cambridge University Herbarium: Rediscovering a Botanical Treasure Trove', *Journal of Natural Science Collections*, 6 (2018), pp. 31—47
• Edwin D. Rose and Lauren M. Gardiner, 'Networks of Knowledge: The Library and Herbarium of John Martyn at Cambridge,' *Pulse*, 48 (2021), pp. 5—8
• Edwin D. Rose, 'Empire and the Theology of Nature in the Cambridge Botanic Garden, 1760—1825', *Journal of British Studies* (published online, 29 May 2023), pp. 1—32 doi:10.1017/jbr.2023.10

102

Specimen of Salix humboldtiana (Salicaceae)
from Veracruz · dried pressed organic matter

Cambridge University Herbarium, Department of Plant Sciences,
University of Cambridge: CGE00007065 · donated to the University
as part of John Martyn's *Hortus siccus* collection, 1763 · photo:
Cambridge University Herbarium

In March 1731, unnamed Indigenous and enslaved Black people
collected this cutting from a willow tree, together with many
other plants in Veracruz, Spanish colonial Mexico, for William
Houstoun. Houstoun — a surgeon employed by British sugar
plantation owners to keep the enslaved workforce alive and
thus prevent the loss of profit — was reliant on local people to
gather these specimens. Houstoun sent these plants to various
collectors, including John Martyn, second Professor of Botany
at Cambridge, whose collection started Cambridge's first
Herbarium and Botanical Museum in 1763.

103

Specimen of Picrasma excelsa (Simaroubaceae)
from St Vincent · dried pressed organic matter

Cambridge University Herbarium, Department of Plant Sciences,
University of Cambridge: CGE00007366 · part of Thomas Martyn's
herbarium collections held in the University Herbarium · photo:
Cambridge University Herbarium

Enslaved people in St Vincent probably cut this specimen from
a tree that can grow 25 metres tall on the orders of Alexander
Anderson, Superintendent of the island's Royal Botanical
Garden. This plant, commonly known as the Jamaican Quassia,
can both heal or harm: it is a food, a medicine against fever
and parasites, and a poison. Anderson sent this specimen to
Thomas Martyn, who followed his father as the third Professor
of Botany at Cambridge, and added this plant specimen to the
University collections.

Anonymised collectors and collaborators in natural history

Jack Ashby

Natural history museums such as the University Museum of Zoology in Cambridge are full of specimens labelled and published as having come from eminent white individuals such as Charles Darwin, Alfred Russel Wallace and — in the case of these green heron eggs from the Caribbean island of St Croix [104] — Alfred and Edward Newton (the former was Britain's most famous nineteenth-century ornithologist and the University's first Professor of Zoology and Comparative Anatomy; and his brother Edward was a colonial administrator). Moreover, natural history libraries are full of learned zoological and ornithological books and journals with articles by white academics. Cambridge is no exception. The library in the Department of Zoology, for example, has bibliographic holdings of outstanding historical importance, thanks in great part to Alfred Newton who bequeathed his personal library to the Museum of Zoology in 1907. During his lifetime, Newton played a key role in founding the British Ornithologists' Union in 1858, and its quarterly 'Magazine of General Ornithology', the *Ibis*, in 1859. Newton frequently published his research in the *Ibis*, including an article on the birds of St Croix, which he co-authored with his brother, in its first ever volume [105] — seen here in Newton's own personal copy. The choice of research location is explained by the fact that the Newton family owned a plantation on St Croix.

Similarly, the Fitzwilliam Museum Library also has extensive historic scientific holdings, including the extremely rare multi-volume *Birds of America*, which was published between 1827 and 1838 by subscription. According to its Prospectus, authorship was credited entirely to the French-American naturalist John James Audubon (1785—1851): 'The birds of America, engraved from drawings made in the United States and their territories. By John James Audubon [...] Published by the author'. Audubon, like Newton, was able to pursue his bird studies thanks to his family's wealth derived from the profits of a sugar plantation on Saint-Domingue (Haiti) and a lead mining estate at Mill Grove on the Perkiomen Creek in Pennsylvania, both of which relied on the labour of enslaved people. So significant was *Birds of America* [106] with its 435 engraved hand-coloured plates that, following Audubon's book-promotion visit to Cambridge in 1828, a subscription was taken by the Syndicate (Board of Directors) in order to purchase it for the only-just-founded and not-yet-built Fitzwilliam Museum as one of its earliest acquisitions. This groundbreaking scientific compendium brought Audubon global fame: in Britain, for example, the Royal Society recognised his achievement by electing him as a Fellow, the second American to be honoured in this way, after Benjamin Franklin. The inherited slavery-derived wealth and status of prominent figures such as Audubon and the Newtons were no doubt factors in enabling them to develop their positions, their collections and their ideas. We have a responsibility to acknowledge these legacies in our museums today.

104

Two eggs laid by a green heron (Butorides virescens)

collected by Thomas, Castle of St Croix
20 March 1858

University Museum of Zoology, Cambridge: UMZC s.p. 220
information written on eggs includes outdated taxonomic name:
Herodias virescens · courtesy of the University Museum of Zoology,
Cambridge · photo: © The Fitzwilliam Museum, Cambridge

On 20 March 1858, Thomas, a young emancipated Black man living on the Newton estate on St Croix, climbed a tree to collect these green heron eggs. His discovery appeared, without credit, in the *Ibis* — the first scientific journal in Britain for ornithology, co-founded by Alfred Newton. One of these eggs was illustrated as no. 6 in the journal. Thomas's case highlights a hierarchy imposed by Western academia. Although Indigenous and enslaved people had knowledge, it was only recognised as science when it was published.

105

Birds' eggs from St Croix

plate XII from an article co-authored by Alfred and Edward Newton, *Ibis Journal*, volume 1 (1859)

Zoology Department Library: AN.35(1) · Alfred Newton's personal
copy · courtesy of Balfour & Newton Libraries, Department of
Zoology · photo: © The Fitzwilliam Museum, Cambridge

This detailed illustration documents birds' eggs discovered on St Croix. Alfred Newton, a renowned scientist whose family owned a plantation on this Caribbean island, and his brother, Edward, a colonial administrator, had been considered the ones to make these findings, published in the first volume of the *Ibis*. New research reveals, however, that credit for collecting three of these eggs should in fact have gone to three recently emancipated Black ornithologists living on the Newton plantation: Andrew, Thomas and Robert. Alfred Newton's name adorns the Zoology Library in Cambridge.

Celebrated scientific giants used these collections to underpin their world-changing theories and lucrative publications as well as more everyday observations about the natural world. Their contributions have fundamentally shaped our understanding of life on earth, as well as our place in it. And these specimens continue to be used in novel science today. If we are to continue to talk about such collections in a historical context, it is vitally important that we understand the true stories behind them. Deeper research into how these specimens came together is allowing us to celebrate the contributions, expertise and labour of others who have hitherto been omitted from the many tellings of the history of science. For example, although not properly credited at the time, we now know that Audubon was assisted by enslaved people as he travelled across America gathering the specimens that informed his *Birds of America*. Similarly, although Alfred Newton and his brother Edward claimed in their 1859 article on the birds of St Croix that the eggs they depicted were 'obtained' by them, thanks to research undertaken by historian Jake Subryan Richards on the unpublished notes of Edward Newton, we now know that some of these eggs, including the green heron's, were actually collected by three emancipated Black men: Andrew, Thomas and Robert.

It is hardly surprising that not every specimen in a given collection was gathered by the person it has been named after, since they could not have done it alone, and so recognising and acknowledging this does nothing to diminish their enormous contributions to the history of science. But it does raise the question of how their hitherto unnamed collaborators are recognised and acknowledged, and it also challenges the popular notion of the lone genius who receives all the plaudits. In reality, science (like so many other academic disciplines) is more often than not a highly collaborative and iterative process. The fact that at least three people — who have until now been anonymised — are responsible for finding some of the eggs depicted on this diagram [105] is emblematic of how colonial collections were generally amassed and how disciplines developed. We have only recently started this corrective work, but we are already finding that we can locate the contributions of local, Indigenous and other 'hidden' collectors of colour from within the archives and celebrate them too.

Adding the work of these previously erased people into the stories of discovery, of science, of museums and of our societies only makes these histories richer. And failing to do so would mean that museums are not telling those histories truthfully, which is bad practice to say the least. By identifying and acknowledging the individuals who truly lie behind our collections, we open them up to a greater diversity of people; and we render the specimens and stories more accessible by highlighting the fact that people like themselves also played vital roles in major scientific developments. And that museums are about them too. Continuing to fail to do that only underestimates our museums' relevance.

Further reading
• S. Das and M. Lowe, 'Nature read in black and white: decolonial approaches to interpreting natural history collections', *Journal of Natural Science Collections*, vol. 6 (2018), pp. 4—14
• J. Drew Lanham, 'What do we do about John James Audubon?', *Audubon Magazine*, Spring 2021: https://www.audubon.org/magazine/spring—2021/what-do-we-do-about-john-james-audubon

106

John James Audubon

1785–1851

Purple martin

from *Birds of America*
(1827–38), volume 1, plate 22

Roseate Spoonbill

from *Birds of America*
(1827–38), volume 4, plate 321

Fitzwilliam Museum, University of Cambridge:
PB 1-2021 and PB 4-2021 · photo:
© The Fitzwilliam Museum, Cambridge

Naturalist and artist John James
Audubon used the work and know-
ledge of enslaved people to create
many ornithological scenes for his
spectacular four-volume work, *Birds
of America*. Audubon never credited
these people in his publication, which
was paid in part by a subscription
taken by Vice-Chancellor Martin
Davy (1763–1839) for the Fitzwilliam
Museum, following Audubon's visit to
Cambridge in 1828.

John Tyley and his breadfruit tree

Isabelle Charmantier
and Julie Chun Kim

107

John Tyley
born c.1773—after 1823
Artocarpus incisus
[Breadfruit tree]
date unknown · watercolour

The Linnean Society of London: MS/608
purchased from Roseberys auction house,
2020 · photo: permission of the Linnean
Society of London

At first glance, the breadfruit tree stands as testimony to the success of British imperial efforts to transfer specimens from the Pacific Ocean to the Caribbean, in order to feed enslaved plantation workers and reduce rebellions. John Tyley, an artist of colour from Antigua, was remarkably innovative in his depiction. Unlike most European botanical artists, he included a figure, indeed that of an enslaved man, enjoying a precious moment of rest.

The scene is a peaceful one: a man sits on a rock in the shade of a tree [107]. While the tree dominates the centre of the image with its leafy spreading boughs, the man underneath draws attention to himself because of his stillness. His pose is contemplative, suggestive of someone enjoying a moment of quiet reflection and even ease. Yet the fact that the man is wearing only blue pantaloons and no shirt indicates that he is an enslaved labourer. And the tree is a breadfruit tree, which was associated in the eighteenth century with slavery since it was imported from Tahiti to the Caribbean to feed the region's enslaved population and prevent hunger-related rebellions. We know that the tree is a breadfruit tree because the artist included a handwritten Latin caption at the bottom of this work reading 'Artocarpus incisus', an old scientific name for the breadfruit tree (its current scientific name is *Artocarpus altilis*). There is one more set of words near the caption, above it and to the right: reading 'J Tyley del'. This signature identifies the work's 'delineator' or creator as John Tyley, an artist and free person of colour from Antigua. This painting is therefore highly significant in being an early example from the Americas — and perhaps the earliest surviving one from the British Caribbean — of a Black subject represented by a Black artist.

Tyley would have been intimately familiar with the significance of the breadfruit tree since he worked as a botanical illustrator at the St Vincent Royal Botanical Garden from approximately 1793 to 1800. Under the direction of garden superintendent Alexander Anderson (1748—1811), the St Vincent Royal Botanical Garden played a key role in the distribution of breadfruit around the Caribbean. What exactly Tyley thought about breadfruit and slavery is unknown, as are most of the details of his life, but we do know that he was engaged in political activities and that this activism shaped his life and career. Specifically, Tyley was exiled from St Vincent by colonial authorities in 1800 for engaging in 'seditious' correspondence. This exile happened at the same moment that many other people of colour were being persecuted for engaging in political activity in the wake of the Haitian and other Caribbean revolutions, including the Second Carib War in St Vincent (1795—7). After leaving St Vincent, Tyley eventually returned to Antigua, where, in 1823, he helped to author a petition asking for increased rights and privileges for free people of colour.

John Tyley was a highly gifted artist and recognised as such. In letters, Anderson described Tyley as 'self taught' and his talent as a 'natural acquisition'. Only 14 signed paintings by Tyley, including this one, are known to survive, but he painted many more unsigned works, including some intended for a catalogue of the plants in the St Vincent Royal Botanical Garden that Anderson planned but never published. That Tyley, an artist of African descent working in a Caribbean world defined by racial inequality, signed his own work is truly extraordinary, a bold act of laying claim to the art he so meticulously created.

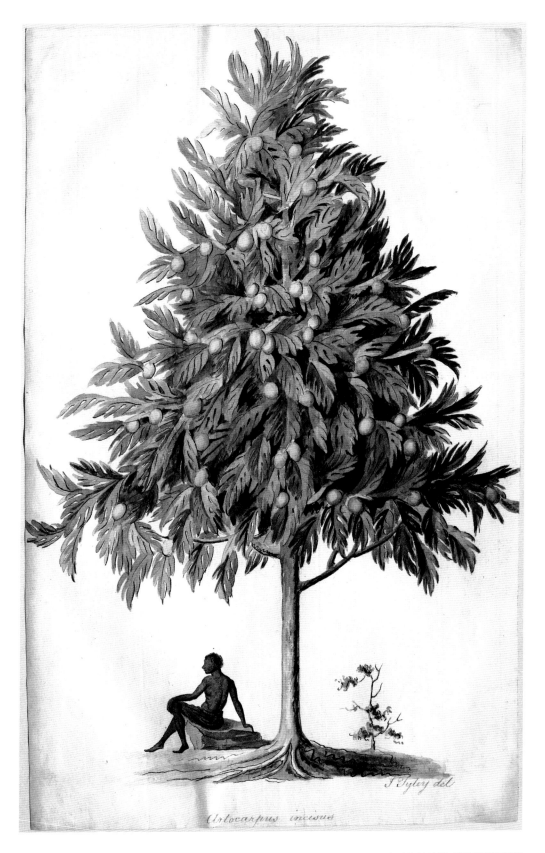

Artocarpus incisus

J. Tyley del

All known Tyley works are to be found today in the botanical collections of the Linnean Society of London and the Hunt Institute for Botanical Documentation. With the exception of this watercolour, they are primarily botanical illustrations, focusing in minute detail on the flowers, fruits and leaves of diverse plants. The breadfruit tree departs from these works in that it depicts the tree as a whole and also includes a human figure.

Further research is underway that will hopefully unlock the significance of this beguiling image: is this an illustration that Tyley made while he was working in the St Vincent Royal Botanical Garden, and is this a depiction of one of the garden labourers, the vast majority of whom were enslaved African people? What does the sapling growing under the older tree's shadow represent, especially since it does not look like a young breadfruit tree? Could the tree crown's triangular shape be an evocation of the revolutionary French liberty tree? In addition to being contemplative, is the man's pose also heroic, even deliberately recalling famous works of Classical sculpture, such as the *Torso Belvedere*, which Tyley might have known through prints that were in wide circulation?

Regardless of the answers that emerge, Tyley's active choice to depict a Black subject within his botanical illustration enmeshes his art in broad and pressing questions about enslavement, abolition, revolution and humanity.

Further reading
• Alexander Anderson, 'Draft catalogue of the plants of St Vincent Botanic Gardens', MS/607, The Linnean Society of London
• Alexander Anderson's papers, Botanical Drawings, MS/609, The Linnean Society of London
• John Tyley, 51 drawings of plants, Hunt Institute for Botanical Documentation, Carnegie Mellon University, Pittsburgh, PA
• Julie Chun Kim and Isabelle Charmantier, 'John Tyley at the Linnean Society. Honoring a Caribbean botanical illustrator', *The Botanical Artist: Journal of the American Society of Botanical Artists*, vol. 27, no. 2 (June 2021), pp. 32—3
• J'Nese Williams, 'Plantation botany: Slavery and the infrastructure of government science in the St Vincent Botanic Garden, 1765—1820s', *Berichte zur Wissenschaftsgeschichte*, vol. 44 (2021), pp. 137—58

Plantation violence

On plantations, a small number of owners and overseers controlled the daily lives of enslaved people, who comprised the majority of the inhabitants. The captive labourers were forced to produce crops for the economic benefit of plantation owners. Enslavers physically, psychologically and sexually assaulted the enslaved. Children of enslaved mothers were born enslaved. A plantation bell used to order the brutal working day, later owned and displayed by a Cambridge college, embodies this relentless violence.

Donald Locke's artworks highlight the regimented nature and physical confinement of the plantations, and his materials and forms allude to resistance movements. Jacqueline Bishop's ceramics reflect on both the exploitation of women and of natural resources on plantations.

Content notice
This subsection contains particularly racist and graphic images of the oppression of Black people on plantations in South America and the Caribbean.

Detail of 112

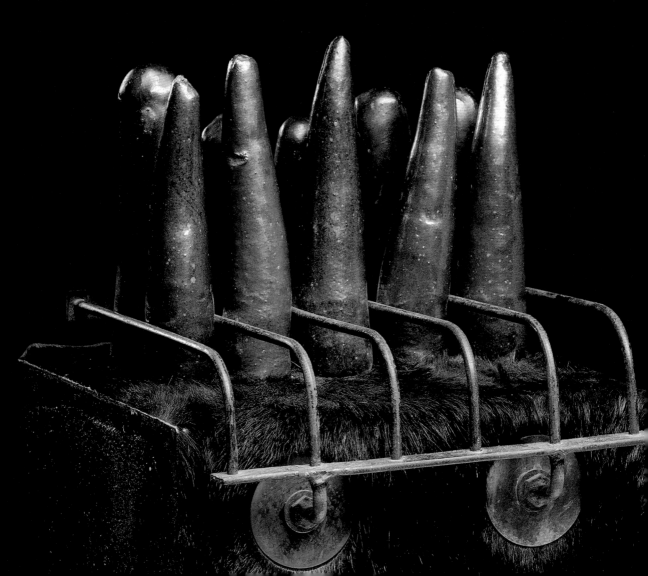

'De Catharina' plantation bell

Victoria Avery*

Some bells are notable for their size, lengthy inscriptions, beautiful decoration, quality of casting or beauty of sound. The De Catharina bell [108] has none of these qualities: its scale (c.61 cm diam.) is typical, it is totally unadorned except for a minimal cast-in Dutch inscription, 'DE CATHARINA 1772' ('The Catharina, 1772'), it is an inferior cast that has been further compromised by being underwater for many decades and its ring is, apparently, unpleasant. To all intents and purposes therefore, a rather dull and boring bell, unexceptional and easily overlooked. However, appearances can be deceptive, and this superficially unproblematic bell materialises violent, complex and entangled histories that unite Cambridge and Atlantic enslavement. Given that most bells are associated with peaceful and joyful functions, it is a cruel irony that this bell was created as an active instrument in the eighteenth-century European slavery economy, used to dehumanise enslaved African people and maximise profit for Dutch plantation owners. It is also ironic that it was subsequently displayed and even rung on very rare occasions by a Cambridge college aware of but, until recently, for the most part indifferent to its provenance and original purpose.

Recent research led by Dr Colin Higgins and Dr Pauline Kiesow, as part of St Catharine's College ongoing legacies activities, has revealed more about the origins and subsequent history of the De Catharina bell, which can be summarised as follows. It was almost certainly cast in 1772 (given that the inscription is cast-in and not added later, as some reports erroneously claim), most likely in a bronze foundry in the Dutch Republic and shipped to the 'Demerary' colony in Guyana, then Dutch Guiana [see map 3, p. 181]. This was a fertile area on the Demerara River exploited by the Dutch West India Company (WIC), mainly for sugar and coffee production. Its inscription links it unequivocally to the De Catharina sugar plantation located on the Demerara's west bank, conveniently opposite Borssele Island, which served as the area's main trading and administrative hub, and which was the capital of Demerara between 1755 and 1782 (during which time the bell was cast).

According to a 1759 Dutch map of the Demerara plantations, De Catharina included a horse-powered sugar mill and its main crop was sugar but it also had land given over to 'broodgronden'. From J. van Donselaar's *Woordenboek van het Surinaams-Nederlands* (Coutinho, 1989), this now obsolete term (literally meaning 'bread grounds' in English) appears to refer to designated 'provision grounds' whose purpose was to provide the city of Paramaribo and the surrounding plantations with food in times of need, for example, when imports from the Netherlands were blocked. It is likely that the main crop cultivated in the De Catharina 'broodgronden' was cassava, a staple food in the Guianas as well as in the entire Caribbean, which was often considered equivalent to bread (being referred to as bread and turned into bread-like products, and so on). Other crops may also have been cultivated on this land,

*I am grateful to Colin Higgins for his assistance with this text, and for his vital role in the loan of the bell to the exhibition. I would also like to thank Julie Chun Kim for her explanations of 'broodgronden'.

Unrecorded makers · *Bell*
made for De Catharina sugar
plantation, Demerara, Dutch
Guiana (present-day Guyana)
bell-foundry, Dutch Republic
1772 · copper-tin alloy
(probably bell metal)

St Catharine's College, Cambridge
photo: St Catharine's College, Cambridge

In 1772, this bell was cast for the
De Catharina sugar plantation in
Demerara, a Dutch colony in present-
day Guyana. Like other plantation bells,
it was rung to signal the start and end
of the oppressive working day for the
enslaved workforce — a sound signifying
brutality. In 1960, a former student of
St Catharine's College, who worked for
a British sugar corporation, found and
donated the bell to his old Cambridge
college. It was prominently displayed
at the front entrance and occasionally
rung, for example, on Armistice Day.
In 2019, after its direct connections
to enslavement were fully understood,
it was removed. To undermine the
violence embodied in this object, we
have chosen to illustrate it here as
overthrown.

including breadfruit trees. As Isabelle Charmantier and Julie Chun
Kim explain in their entry on John Tyley's watercolour [see 107],
the breadfruit tree became associated in the eighteenth century
with slavery since it was imported from Tahiti to the Caribbean
to feed the region's enslaved population and prevent hunger-
related rebellions.

Why the De Catharina plantation bell was cast in 1772 is not known,
and nor exactly how it was used. However, it is fair to assume that
it would have been rung in the same way that other so-called 'slave
bells' were: to signal the start and end of the arduous and relentless
workday of the enslaved men, women and children, and possibly
also to announce the sale of additional estate produce from the
'broodgronden' at the plantation's entrance. While its sound may
have been welcome to the plantation's owners and overseers, and
to prospective produce buyers, it would have been traumatic and
triggering to the enslaved workforce, signifying nothing but brutal
labour, violence and oppression. The traumatic ringing of the bell
likely continued under British rule after the Napoleonic Wars.

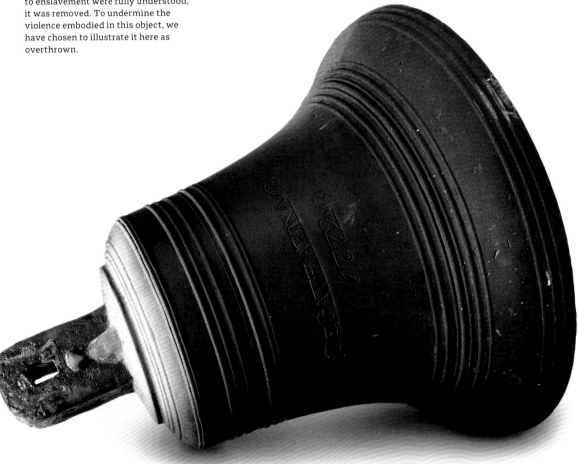

At an unrecorded point, this bell ended up in the Demerara River adjacent to the plantation, presumably violently toppled during the Demerara uprising of 1823, or after the abolition of slavery in the British Caribbean in the 1830s. In 1958 or 1959, it was spotted, semi-submerged in the river, by Edward Arthur Goodland, an alumnus of St Catharine's College, Cambridge (graduated 1933), who was working in Guyana as a Technical Director of Bookers Sugar Estates. Goodland had the bell dredged out of the river, cleaned off and was (according to a later recollection by his sister) 'thrilled to read the inscription'. Given the coincidence of saintly name, Goodland decided to present the bell to his old college, and had it transported from Georgetown to Cambridge in 1960. Despite being aware 'that it could have been a "plantation bell" for regulating the time-table [sic] of the slaves' (as a College report noted at the time), the College went ahead and hung it in a utilitarian concrete belfry adjacent to the Porters' Lodge. It was even occasionally used, possibly when the Chapel bell was out of commission to call College members to dinner and prayers; and certainly, in recent memory, rung by the porters each year to mark Armistice Day. In 1994, the bell was temporarily taken down while the College went to the expense of rebuilding its belfry in more attractive brick, but then re-hung.

It was only in 2019, when its direct connections to enslavement and empire were fully understood, that the De Catharina bell was permanently taken down and a research project undertaken to determine other historic links between the College and the slave trade. The College agreed to lend it to the Rijksmuseum in Amsterdam for its 2021 exhibition on slavery, where it was displayed with four other plantation bells as the 'opening moment' of the show. In 2020, St Catharine's College initiated negotiations about returning it to Guyana, subject to the agreement of the Guyanese High Commissioner and the National Museum at Georgetown.

The De Catharina bell thus encapsulates how Cambridge's part in history is often hidden in plain sight, and how objects with entangled pasts have started to become catalysts for driving change, forcing colleges to undertake vital research into their historical links with slavery. Its current limbo status reminds us of ongoing debates about restitution, reparation, future justice and the University's responsibilities moving forward.

Donald Locke's 1970s 'Plantation Series'

Victoria Avery
with Brenda Locke

109

Portrait of Donald Locke (1930—2010) in his London studio

early 1970s

Courtesy of The Artist's Estate
© The Artist's Estate, Atlanta, Georgia, USA
photo: Brenda Locke

As part of the object selection process for the *Black Atlantic* exhibition, I was privileged to meet Brenda Locke, widow of Guyanese-born, British- and US-based artist Donald Locke (1930—2010), stepmother to artist Hew Locke, and Executor of the Donald Locke Estate in Atlanta, Georgia. Over Donald Locke's 50-year practice, his work centred on a complex interweaving of physical elements where transcultural meanings and memories were expressed via visual clues. The layering and collaging of paint, pigment, found objects and materials such as wood, bone, metal, plexi and photographs, reinforced these cultural memories. Given Donald Locke's fundamental importance to the development of British art from the 1960s onwards, Habda Rashid (Senior Curator of Modern and Contemporary Art at Kettle's Yard and the Fitzwilliam Museum) and I were keen to include a select group of his work, ideally pieces not normally on public view, to give *Black Atlantic* visitors fresh insights into his creative practice and to give broader historical context to some of the more contemporary works on display. Moreover, inclusion of a significant group of works by Locke was felt desirable given that his oeuvre as a whole resonates so profoundly with many of the key exhibition themes. Indeed, reflecting in the mid-2000s on his work to date, Locke concluded that his ultimate, if unconscious, aim had been:

to try to encompass and bend to the will of the imagination, every aspect of the life and experience of Black people in the New World — their political and sociological structures, the landscapes they inhabit, their physical uniqueness, the folk-lore and myths which crowd their imagination, and the socio-economic legacies they inherited from the past.

Given Brenda Locke's unique and profound insights into her husband's work, we asked her if she would be willing to help us choose the most appropriate pieces. After we explained the breadth and compass of *Black Atlantic* and our hopes for the Locke component to Brenda, she drew up a list of available works that spanned Donald's long career. After several discussions, and some tough decisions, Habda and I chose four related but contrasting works from Donald Locke's *Plantation Series* — two from the Locke Estate [110–111] and two from a private collection in London [112–113]. Donald's New York gallery, Skoto Gallery, then contacted the owners, Lorenzo Legarda Leviste and Fahad Mayet, with an informal loan request on our behalf and put me in direct touch. Lorenzo and Fahad willingly agreed on the spot, delighted to assist us in bringing the 'quartet' together, aware that the last time these artworks had been seen together in the UK was in the 1989 Hayward Gallery exhibition, *The Other Story*.

The component sculptures for *Plantation Series* were made in London between 1972 and 1979 — so half a century ago now — at what was a critical moment in Donald's creative journey. Brenda pointed us towards comments that Donald had made in the early 2000s when drafting a (sadly never completed) history of Guyanese art. Herein, he discussed how his native land was still scarred by visual legacies of the colonial plantation system and how his *Plantation Series* sculptures were:

metaphors where forms are held in strict lines, connected as if with chains held within a structure of metal bars and grids, analogous to the system whereby one group of people were kept in economic and political subjugation by another group [...] It is the nearest I came to making a political statement [...] In the Caribbean, the most dominant sociological event is the plantation system. I grew up at a time when the plantation system was still in existence. It dominated the sky; it dominated your life from beginning to end.

Donald's introduction to his unfinished monograph contains further insights into the preoccupations that lay behind *Plantation Series* and the lasting impact that the legacies of chattel slavery had had on him and many other Guyanese artists of his generation:

The Dutch were amongst the earliest settlers on the Guyana coast. They set up plantations, towns and villages designed on the grid system they transplanted from Holland; streets, walkways, drainage and transportation canals, as well as private and public property borders had a rigid, north-south orientation and met one another at strict right angles [...] The influence this has had over the centuries on the psychological make-up of the people who live in Guyana — for them the effect has been enormous, compelling and well-recognised by most Guyanese of the pre-independence generations. Its influence on the visual arts has also been profound and dominating, in some cases amounting to an unwritten,

110—111

Donald Locke · 1930—2010
Redoubt
1972 · ceramic, wood, formica and steel
Mounted Bullet (Trophy)
1974 · ceramic, wood, fur and metal

From 1972 to 1979, while in London, Donald Locke created
a pioneering body of work. He massed and mounted bullet-
like forms, reminiscent of sugar canes, lingams or phalluses,
into rigid confined assemblages. They speak to the restraint
and forced loss of identity imposed by the plantation system.
Evoking the continued effects of enslavement after legal
emancipation in the Americas in the nineteenth century, as
well as the racial inequalities and injustices of the 1960s and
1970s, these works engaged with the nascent discourses among
Black activist-artists around entrapment and subjugation.

psychological manifesto of irresistible force. This sense of being literally 'boxed in' was recognised by generations of Guyanese who, in the pre-independence days, endured this condition with a draining sense of powerlessness. It was quite common to hear the phrase, the 'outer world' being used to describe advanced countries, literally the rest of the world which lay beyond the Atlantic horizon [...] Combined with other factors, it created what I have called the 'tendency towards squares and the box'. Most of my generation, even half a century away from home still remember vividly, daily experiences shaped and governed by this geometric eye so to speak, vision they were born with.

This explains the cage-like confining and oppressive structures that recur throughout the *Plantation Series* sculptures. They also recall historic European engraved plans and maps of colonial plantations, such as the mid-eighteenth-century coffee plantation ground-plan reproduced in Stedman's publication about Surinam, then part of Dutch Guiana [see 12]. In her talk entitled, 'Volumetric Space and Donald Locke: Artistic Attempts to Understand a Context' (delivered as part of 'The Plantation Complex' panel at the 2021 Association for Art History's Annual Conference), art historian Tiffany C. Boyle spoke of the 'mathematical aspect' of these sculptures as 'a universalising pulse' that 'relates [it] to the square of the box and grid as a visual response to the ruthlessness of plantation-era economics, and the resulting topography of Guyana'.

The rigid containers and framing devices of Locke's *Plantation Series* are filled with unexplained, rather threatening assemblages of abstract 'bullet' forms, arranged in tight formations of serried, suffocating lines as if captured, trapped and restrained, thereby evoking a sense of subjugation and loss of identity related to slavery. As Tate curator Andrew Wilson explained in his 2015 online catalogue discussion of Locke's related *Trophies of Empire*:

The 'bullets' can be understood in a number of unspecified ways as both agents and victims of violence: as figures stripped of identity, as phallic forms or lingams that are displayed in a self-celebratory manner or alternatively fettered and emasculated as trophies of the big game hunter. The forms can also be seen as reminiscent of pieces of sugar cane, the crop to which enslaved people were bound and the foundation for colonial wealth.

Donald Locke's shift towards the square, box and grid in the 1970s coincided with his use of matte black to envelop his work. This was a deliberate choice as Locke was keen to explore how the colour black has been interpreted within European thinking as diametrically opposed to the colour white. Thus, it is seen as being its inverse, directly interconnected to it, and defined by it. The colour black has also been regarded as ambiguous and undefinable being neither formed by light nor really attainable as a true colour. As Boyle went on to argue eloquently in her 2021 paper:

112—113
Donald Locke · 1930—2010
Plantation Piece #1
1973 · ceramic, steel and fur
The Cage (Black Painting)
1977 · acrylic on canvas,
fur, steel grid

collection of Lorenzo Legarda Leviste
and Fahad Mayet · photo: © Estate of
Donald Locke · photographer: T.W. Meyer

The mathematical square and the matte black enveloping Locke's work as refusals can be understood as the negation of 1. visual pleasure, 2. of the labour to create such visual pleasure, and 3. of the exhibition circuit and art market. The total dominance of black in the artist's palette at this time should also be understood as mourning — for having left Guyana to pursue his artistic practice in the post-independence period of nation founding — but also as a gesture towards Black pride, and to the political advancements taking place in the transnational context of the time. When I say refusal, I am specifically thinking in terms of writer and academic Saidiya Hartman's use of the phrase. In her 2019 book Wayward Lives, Beautiful Experiments, *she notes how, 'one thing was absolutely clear: the practices of refusal — shirking, idleness, and strike — a critique of the state and what it could afford; and an understanding that the state is present primarily as a punishing force, a force for the brutal containment and violation and regulation and eradication of Black life.'*

All of the above goes to explain why Brenda, Habda and I considered it vital to have this group of sculptures displayed and recontextualised within the *Black Atlantic* exhibition frame and catalogue. Indeed, all the more as Donald always felt that his ground-breaking and activist series had not received the recognition it deserved being too controversial and radical at the time it was made. Our public display is part of a long-overdue, broader and ongoing reassessment by cultural institutions of Locke's work, as well as by art historians, who are reinterpreting and repositioning it within broader transcultural, interdisciplinary and Black studies research. Fifty years on, Donald Locke's *Plantation Series* sculptures and other works from the 1970s are still powerful and provocative: they ask uncomfortable questions, resist the status quo and challenge the enduring legacies of the transatlantic slave trade.

Further reading

• *The Other Story: Afro-Asian Artists in Post-War Britain*, exhibition catalogue, Hayward Gallery (London, 1989)
• *Back to Black, Art, Cinema and the Racial Imaginary*, exhibition catalogue, Whitechapel Art Gallery (London, 2005)
• Donald Locke, *Out of Anarchy: Five Decades of Ceramics and Hybrid Sculptures (1959–2009): The Work of Donald Locke* (Newark, NJ, 2011)
• https://www.tate.org.uk/art/artworks/locke-trophics-of-empire-t14319 (posted by Andrew Wilson in January 2015)
• https://eu-admin.eventscloud.com/website/2065/the-plantation-complex/ (for overview of 'The Plantation Complex' panel at the 2021 Association of Art Historians Annual Conference)

'History at the Dinner Table'

Jacqueline Bishop

One of my earliest memories is the mahogany cabinets in the homes of the women in my family. From my grandmother, I initially have fragmentary memories of a dark brown highly polished object with thick glass windows that stood like a god at the centre of her living room, in which she placed and retracted delicate objects — bone China dishes. This cabinet would follow her from rented house to rented house until it landed in the last house she lived in, her house in the small district of Nonsuch, our ancestral district, high in the purple blue mountains of Jamaica.

It was in those purple blue mountains of Jamaica where I would meet another mahogany cabinet, this time in the home of my great-grandmother, filled similarly with China dishes treated with reverence. The dishes in these cabinets were spectacular. Very colourful. Used only on special occasions — Sunday dinners. Weddings. Funerals. Birthdays. Easter and Christmas holidays. Some of them in the shape of a fish. They all denoted faraway places — had fruits we did not know, carriages and palaces, European royalty.

As an adult and artist, I started asking questions about these dishes. What gave rise to the luxury of those faraway places? Enslavement in the place I called home. How might I change the narrative of those plates to tell my story? By indigenising the plates with the fruits and flowers I grew up with and by placing my Jamaican and Caribbean Atlantic world history at the centre of those plates. It is hard to find actual images of the atrocities of slavery since Caribbean enslavers were sensitive to criticism from the metropole about the institution of slavery, so they invited visual artists to the region to paint bucolic landscapes to hide the horrors [see 97]. Natural history as both a science and an art form, with its focus on novelty and the fantastic, is tied to the slave trade. Not only were specimens carried on slave ships from the 'New World' back to the metropole [see 102—104], but natural history artists often journeyed back and forth on slaving vessels.

My plates [114] are an attempt to address the inhumanity of the institution of slavery. For while I am seduced by the beauty of the China plates of my childhood and I operate within the decorative traditions of ceramic plates and natural history painting, I also seek to imbue the women on my plates with beauty, dignity and humanity. Much of the inspiration for *History at the Dinner Table* is drawn from reading Captain John Stedman's *Narrative, of a five years' expedition, against the revolted negroes of Surinam, in Guiana [...] from the year 1772, to 1777* (London, 1796) and seeing the illustrations used in that work, '80 elegant Engravings, designed from nature by the Author' [115]. Indeed, several of the images on *History at the Dinner Table* are drawn from that source. I became fascinated with the story of the enslaved mixed-race woman Joanna, as recounted in Stedman's narrative, and which was published in Boston in 1838 as a separate book, *Narrative of Joanna: An Emancipated Slave, of Surinam*.

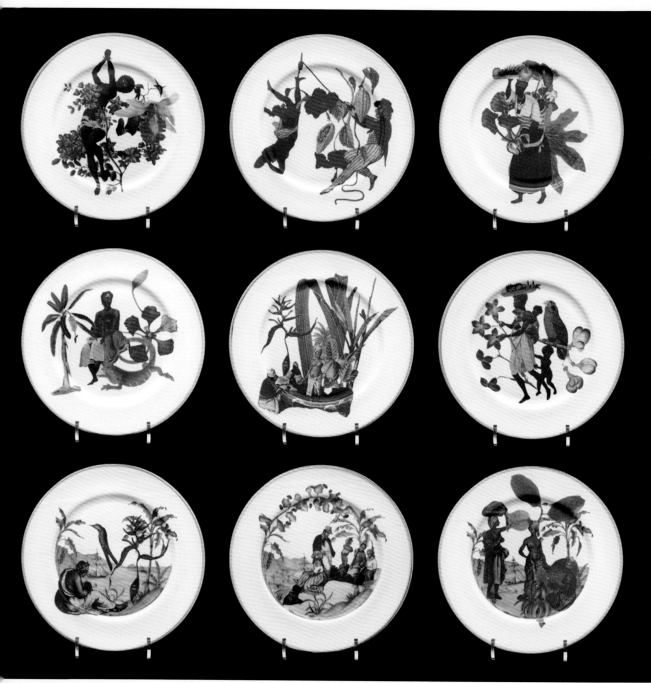

114

Jacqueline Bishop · born 1971
History at the Dinner Table · 2021
18-plate dinner service · first of an edition of
three sets · bone china, print transfers, gold lustre

In 2021, Jacqueline Bishop created a dinner service recalling
her Jamaican grandmother's prized bone china crockery, which
'painted with bright, cheerful carriages and palaces, often hid
a violent history of slavery and colonialism by European
countries'. The plates show the horrors of plantation violence
but also emphasise the dignity and fortitude of the enslaved
— particularly women — deliberately framing them with
beautiful Caribbean fauna.

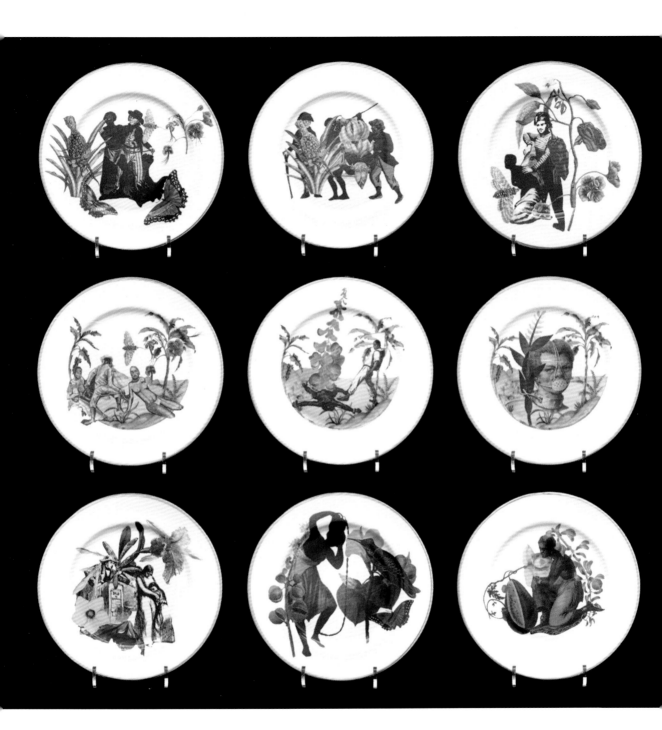

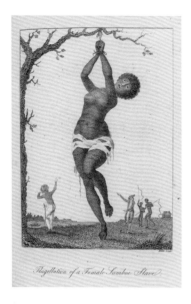

Flagellation of a Female Samboe Slave.

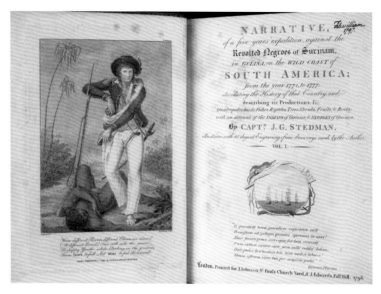

115

Captain J.G. Stedman
1744—1797
Narrative, of a five years'
expedition, against the
revolted negroes of
Surinam, in Guiana […]
'Flagellation of a Female
Samboe Slave' (unnumbered
plate), frontispiece and title
page (London, 1796)

Fitzwilliam Museum, University of Cambridge:
PB 17-2020 · bequeathed by Richard,
7th Viscount Fitzwilliam, 1816 · photo:
© The Fitzwilliam Museum, Cambridge

I marvelled at the fact that — having married Stedman, had a son with him and gained her freedom — given a choice, she chose to remain in Surinam rather than return with Stedman to Europe where she was sure she would be an outcast and a perpetual outsider as a woman of colour during the period of enslavement.

Joanna and the questions she raised for me became such a fixture in my mind that I started researching images of enslaved women, which of course were not that easy to come by because of the subterfuge of planters. The few images I found though were often brutal and showed women at the lowest points in their lives — one being flogged naked onboard a slave ship. I wrapped large red hibiscus flowers around her to give her back some modesty. Another was of a mother being separated from a child both being sold at auction. What else could I do to offer some hope and salvation but envelop them in nature? I found historic images of women as labourers and nurturers, women as mothers — with only the environment as a source of nurturing, healing and beauty within such a harsh oppressive context. One of the surprises of making the work was that often hidden in plain sight was a ship close by — the source of dislocation and alienation. I oftentimes think of _History at the Dinner Table_ as a homage — to China plate-making, to natural history painting, but most especially to my great-grandmother, grandmother and mother and to all the women before them, nameless, but whose likenesses are captured in these historic images.

Remembering

From the earliest attempts to establish slave colonies in the Americas, enslaved people freed themselves from slavery and formed communities in places that enslavers found hard to reach, such as on mountainsides, in swamps and along winding rivers. These self-liberated people were known as Maroons. The objects they made use symbols from Africa and the Americas to create a new visual language. These objects also helped the Maroons and their descendants to build communities that endure today.

The effects of Atlantic enslavement are still with us. Our socio-economic and political structures are moulded by persistent racial inequality. These structures shape how we produce and consume goods, how we display art and artefacts, and how we develop scientific knowledge.

Grada Kilomba's *Table of Goods* invites us to remember the people who lived and died in enslavement and reflects on our collective future. Alexis Peskine's *Ifá* reconstitutes cash crops of coffee and timber into a haunting self-portrait that recalls how the Black Atlantic presence runs deeply in the blood of many still living today.

Detail of 119

Suriname Maroon art

Justin M. Brown

The Maroons are the descendants of enslaved African people who escaped from plantations and established autonomous settlements in the inland rainforests of Suriname and French Guiana. For three centuries, they have acted as independent communities, building unique cultural institutions and social structures at the margins of the colonial and post-colonial world. The history of the Suriname Maroons represents a history of resistance and resilience in the Black Atlantic.

Over many generations, the six Maroon communities in Suriname — namely, the Aluku, Kwinti, Matawai, Ndyuka, Paramaka and Saramaka — have cultivated distinct artistic practices, which they have continually developed and renewed. One example is the woodcarving practices of the Eastern Maroon groups known as the Ndyuka and Paramaka, who inhabit the areas along the Marowijne and Tapanahoni Rivers. Among both groups, woodcarving is exclusively practised by men, who learn the art in communal settings from a young age. Although the practice of woodcarving is passed down from one generation to the next, artists elaborate on conventional forms as they acquire artistic prowess, as seen in the intricate, symmetrical interlaced and grooved bands carved in low relief into the interior of this shallow wooden dish made by an unrecorded Paramaka woodcarver [116] and in the chevrons, zigzags, concentric circles, crosses and other geometric decorations carved into this large food paddle [117].

The dynamic quality of Maroon art is due to an openness to multiple sources of inspiration. Artworks produced in the last century exhibit visual qualities common to such distant art forms as Kongo textiles and Wayana painting, including geometric motifs, formal balance, cross patterns, interlacing and concentric designs. These designs can be seen on the wooden stool made by a Paramaka artist [see 14]. Within Maroon communities, stools play an important role in daily life as both domestic and ceremonial objects. A stool is owned by an individual and retains a connection with that person after death. This custom is related to the stool traditions of the Akan and Baule peoples of West Africa, although the forms of some Maroon stools may have also been inspired by the stool-making practices of Indigenous peoples, notably the Kali'na.

Access to various materials afforded Maroon artists the freedom to explore new decorative techniques. The advent of commercial paints during the nineteenth century precipitated the brightly coloured wood carvings associated with the Eastern Maroons. These two paddles [see 15 and 118] are prime examples of Eastern Maroon art. The slightly smaller paddle, intended for a woman, was made and decorated by an unrecorded Paramaka artist. Paramaka men make canoe paddles and give them as gifts to women, usually a wife or prospective wife, who would use it for travelling by canoe between villages and gardens.

116

Unrecorded maker, Paramaka Maroon people
Dish
Sipaliwini District, Suriname probably mid-twentieth century, before 1965 · wood

Museum of Archaeology and Anthropology, University of Cambridge: 1966.174 A acquired on a student-led Cambridge expedition to Langa Tabiki, 1965 · photo: Museum of Archaeology and Anthropology, Cambridge

This dish was made by an unrecorded woodcarver from the Paramaka community, one of the six Maroon groups in present-day Suriname. Its design appears identical no matter the viewing point, and the intricate carving in low relief has both harmony and a sense of play. Cambridge students on an expedition to Langa Tabiki in 1965 purchased this and other Maroon objects, which they donated to the Museum of Archaeology and Ethnology, now the Museum of Archaeology and Anthropology.

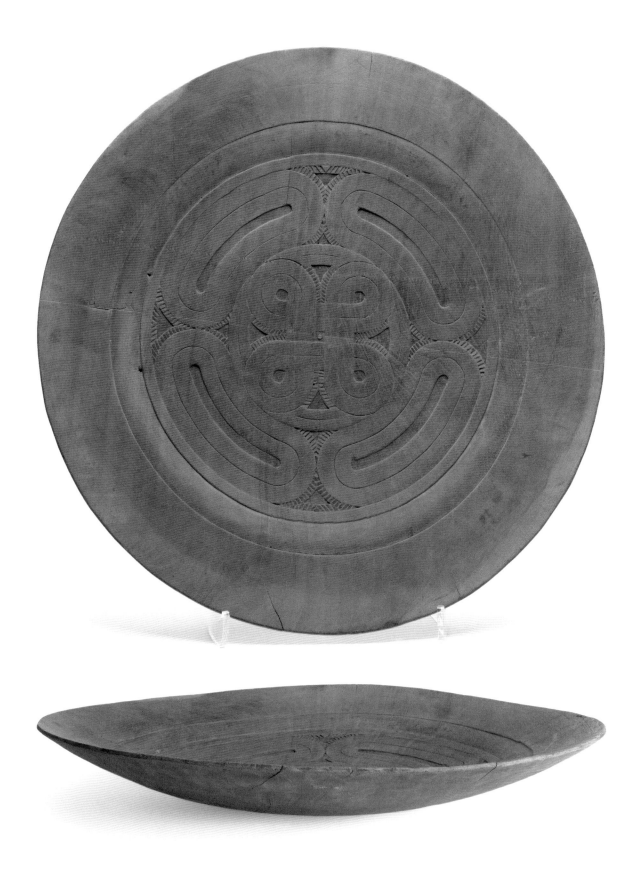

The larger paddle, intended for a man, was made by an unrecorded Ndyuka artist [118]. Ndyuka men would use such paddles to transport cargo on canoes between villages and the coast. The pristine condition of the two paddles suggests that they were acquired new. In the twentieth century, it became increasingly common for Maroon artists to make and sell paddles and other decorated objects to visitors.

Maroon art balances continuity and innovation, allowing artists past and present to cultivate artistic practices responsive to transformation in social and material realities. By improvising upon conventional forms, Maroon artists have continually enacted their heritage of adapting to unforeseen circumstances.

Further reading
• Sally Price and Richard Price, *Maroon Arts: Cultural Vitality in the African Diaspora* (Boston, 1999)
• Sally Price and Richard Price, *Afro-American Art of the Suriname Rain Forest* (Berkeley, 1980)

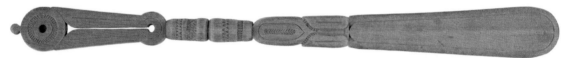

117 ▲

Unrecorded maker, Paramaka Maroon people
Food paddle
Sipaliwini District, Suriname · probably mid-twentieth century, before 1965 · wood

Museum of Archaeology and Anthropology, University of Cambridge: 1966.176 B · acquired on a student-led Cambridge expedition to Langa Tabiki, 1965 · photo: Museum of Archaeology and Anthropology, Cambridge

The maker of this food paddle incorporated intricate geometric patterns into a functional object. The symmetry of the triangles in the mid-section are offset by two contrasting symbols: the circular design of the hilt and the cross on the blade. The cross may refer to Christianity, one of the religions worshipped by the Paramaka, alongside Winti — a belief system originating among the enslaved African people of Suriname.

118 ▼

Unrecorded maker, Ndyuka Maroon people
Maroon man's canoe paddle
with carved handle and painted blade
Suriname · probably mid-twentieth century, before 1965 · wood and pigment

Museum of Archaeology and Anthropology, University of Cambridge: 1966.180 B · acquired on a student-led Cambridge expedition to Langa Tabiki, 1965 · photo: Museum of Archaeology and Anthropology, Cambridge

People from two Maroon communities made paddles for canoes, their chief form of transport, and for the tourist market. The smaller one is for a Paramaka woman [see 15], this larger example for a Ndyuka man. In each case, the bright, contrasting colours evoke a person's individuality and protect them from any external attempt to force them into a pattern of control. The intricate carvings on the handle may evoke Kongo, a political power whose origins lie in West Central Africa, or the patterns from Ndyuka cloth-making.

'Table of Goods'

Grada Kilomba

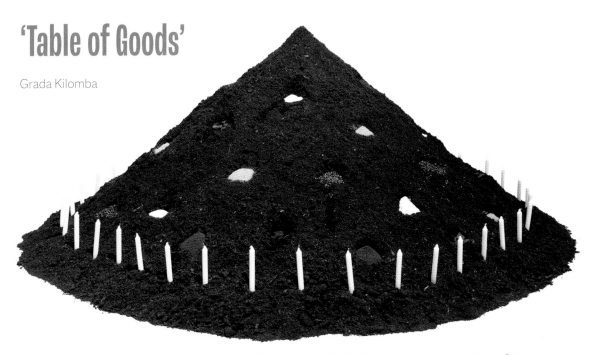

119

Grada Kilomba · born 1968
Table of Goods

2017 · soil, sugar, coffee beans, ground coffee, cocoa, dark chocolate and candles

collection of Marguerite Steed Hoffman
photo: courtesy the artist and Goodman
Gallery · © the Artist and Goodman
Gallery · [not in exhibition]

In 2017, Grada Kilomba created a mound of soil, coffee, sugar, dark chocolate and cocoa to bring together the plantations in the Americas and fashionable taste in Europe. The enslavement of millions of African captive people and their descendants inextricably link these places and goods together. We have all inherited the world that Atlantic enslavement created. The candles invite us to honour these people, to reflect on their histories and to contemplate the possibility of future repair.

Table of Goods (2017) is both an installation and a performative work, where soil becomes a representation of the colonial historical repetition of owning land and people [119]. Using a subversive poetic language, I wish to confront colonial concepts of ownership, exploitation and erasure, which were essential mechanisms for the production of three commodities: sugar, cacao and coffee — all non-essential for human nutrition but obsessively desired by Europeans [see 82, 86, 87, 89, 90].

This decolonial shrine is a reversal of the Black Atlantic plantation economy. In this work, I recommodify those colonial goods, which were the base of the transatlantic slave trade for hundreds of years and resulted in the death of millions of people in order to create the wealth of European empires and meet insatiable market demand.

The candles bring to mind spiritual votives which are lit to honour ancestors, whose hard labour working the soil of plantations built the ground to the wealth and fortune of colonial oppressors. The practice of ritual, a strong and constant element of my work, is re-explored in this piece. For ritual is an essential aesthetic and spiritual practice which gives me the platform to work with different disciplines at the same time: performance, movement, staging, composition and choreography, whilst also allowing the production of memory. There have been times in history when certain rituals and ceremonies were forbidden, especially those belonging to marginalised communities. However, when you ritualise something, as I have done in this work, the means to remember are created. *Table of Goods*, therefore, is both past and present, it is never fragmented, there is always a continuity, a sense of timelessness that I find interesting to explore.

Ifá

I am here!

I come from a long, long line of strong, creative and beautiful
people who survived despite the despicable crimes inflicted on
them by hateful individuals whose feeble consciences were easily swayed
by inhumanity, bigotry and greed.

Unleashing overwhelming physical and moral violence against My People, these
weak individuals devastated entire communities, annihilated cultures and destroyed
whole civilisations. They brutalised and displaced My People until they could no longer
scream in their own languages.

They plundered and looted whatever they most craved, to build a harsh world in their own like-
ness: brutal, violent and selfish. Making captives of our strong men and powerful women, they
broke their backs, tormented their minds and abused their beautiful, uncomprehending children.

Those who could compete invested their capital: forming companies, outfitting ships, employing
ruthless men to force My People over cruel seas, torturing and starving them to feed their lust for
the ill-gotten gold of their inhuman trade. The immense profits of this despicable scheme they re-
invested: funding royal institutions, endowing universities, founding schools, setting up newspapers
and building museums like this one.

I am here!

My Grandfather's Grandfather was born in Africa and died in Brazil. My Grandfather's Father died
when he was a young boy, followed a few years later by his Mother. My Grandfather — Antonio — was 11-
years-old when he, with his young brother, built his Mother's coffin from scavenged boards and
hoarded nails. Then, he took care of all his siblings, raising them in his parents' place. These are the
unseen, never-mentioned fruits of the inhuman monster that was slavery. My whole family in Brazil
grew up in extreme poverty, entirely because of the white supremacist racism built into that
abhorrent system. Literally tens of millions of Afro-Brazilians have inherited nothing today save this
structurally maintained impoverishment, just like billions of other human beings around the planet.

Centuries of lies cover up and gloss over these misdeeds; ongoing attempts to humiliate and de-
humanise us. The simple truth is that we are not the ones who will be humiliated forever by the
report of these crimes. I know who was weak, who truly was strong. I know that no amount of
reparation can ever repay the blood price of this accumulated debt or repair the damaged
dignity and tainted pride of the perpetrators of these malevolent crimes. My People's
ancestors suffered and transitioned a long time ago. While the descendants of the
planters and slavers who received millions of pounds in recompense for their "lost
trade" reinvested again to reinforce the system by which they continue to plunder,
destroy and despoil our precious Earth.

I am here:

— and I speak for all those who endured in silence, whose
strength I inherit, whose creativity I present and whose
power I witness in speaking the Truth for My People.

Alexis Peskine

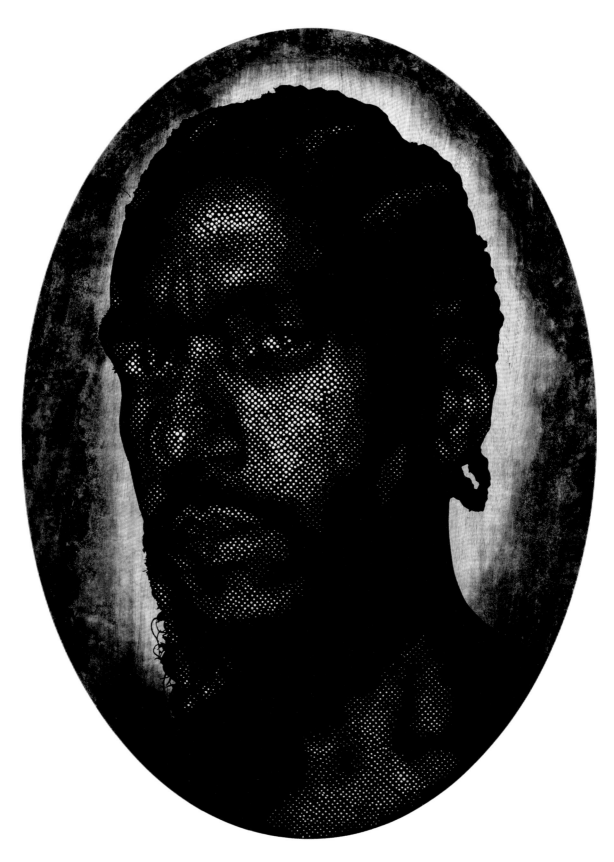

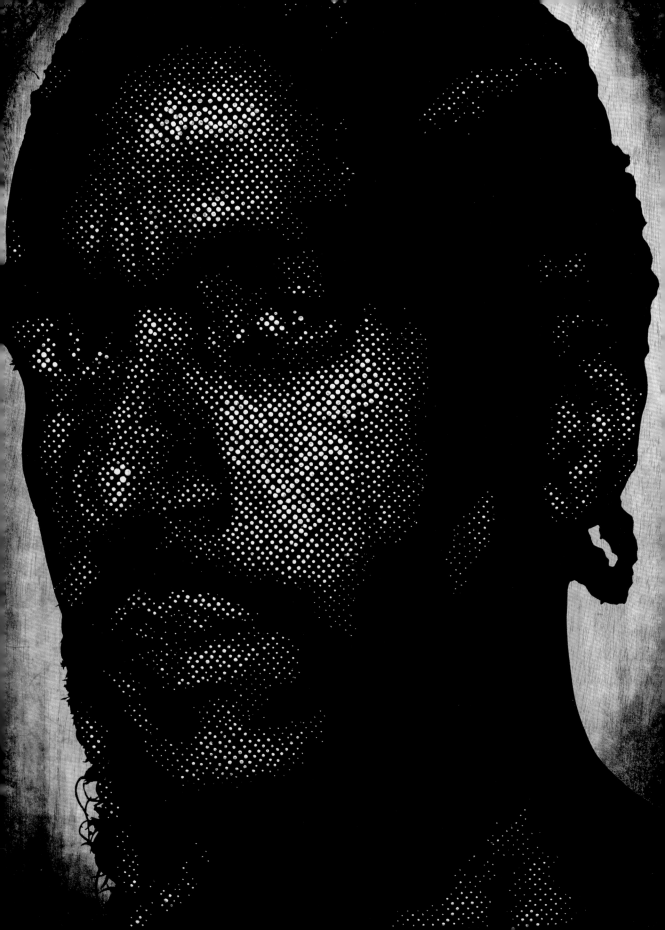

Shared futures?

Outside of this book Atlantic enslavement and Black Atlantic cultures continue to shape our world.

The Fitzwilliam Museum and other University of Cambridge Museums acknowledge that they still benefit from Atlantic enslavement in terms of their finances and collections. The Museums are making a commitment to reparative justice. More exhibitions are planned and more research will be published to share new knowledge and to keep debates alive.

What do you think a world of repair and freedom might look like? We hope you will join the conversation.

120

Alexis Peskine · born 1979
Ifá · 2020 · Wagan and Vessie green pigment, nails, green gold leaf, coffee and earth on lumber wood core

© Alexis Peskine · courtesy the artist and October Gallery, London
photo: © Alexis Peskine

Nails are used both as symbols and tools in reconstructing the image of the Black body that continues to resist injustice and violence. In this self-portrait, the artist references the 'Ifá' divination system, a body of pre-colonial, ancestral wisdom passed down among the Yoruba of West Africa and in the diaspora. Peskine situates this African spiritual knowledge as a bridge connecting the past to the future.

Maps

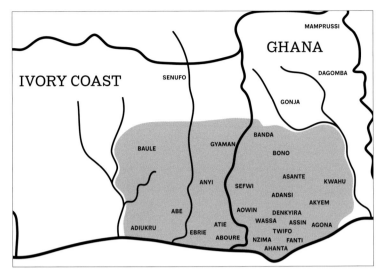

Map 1

Ghana and Ivory Coast
showing the distribution of the Akan and the 'goldweight zone' across the two nations

adapted from map published in Timothy F. Garrard, *Akan Weights and the Gold Trade* (London, 1980), p. xxii

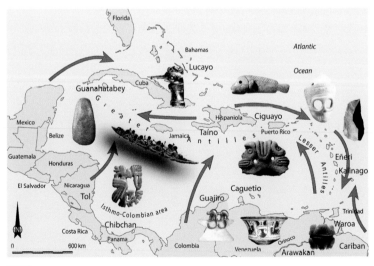

Map 2

The Caribbean
showing hypothetical precolonial local, regional and pan-regional networks of Indigenous peoples and the exchange of goods and ideas from 6,000 BCE—1492

by Menno L.P. Hoogland and Corinne L. Hofman · adapted from map published in Christopher R. DeCorse (ed.), *Power, Political Economy, and Historical Landscapes of the Modern World: Interdisciplinary Perspectives* (2020), p. 56, fig. 3.1 · © Menno L.P. Hoogland and Corinne L. Hofman, 2020

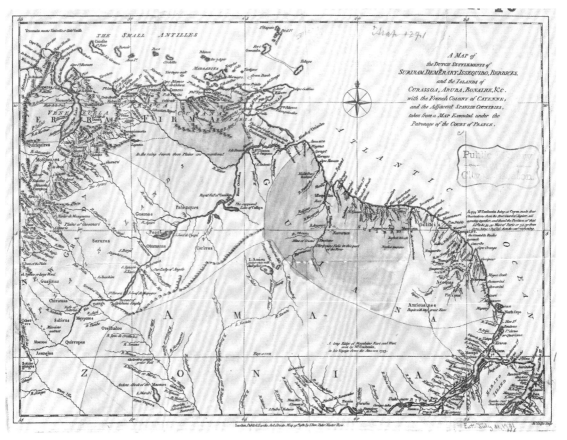

Map 3

John Lodge

A map of the Dutch settlements

of Surinam, Demerary, Issequibo, Berbices, and the islands of
Curassoa, Aruba, Bonaire, &c: with the French colony of Cayenne,
and the adjacent Spanish countries taken from a map executed
under the patronage of the court of France
(London: John Bew, 1781)

Biographies

Curators

Jake Subryan Richards is Lead Curator of *Black Atlantic: Power, People, Resistance*. He is Assistant Professor of international history at the London School of Economics and Political Science. His research and teaching concerns the histories of the people of the African diaspora, Atlantic empires, and enslavement and emancipation. Jake has published research in *Past and Present* and *Comparative Studies in Society and History*. His article on anti-slave-trade law won the Royal Historical Society's Alexander Prize (2019) and his PhD thesis was co-winner of the Prince Consort and Thirlwall Prize and Seeley Medal (2021). Richards is a British Art Network Emerging Curator (2022) and a BBC Radio 3/ AHRC New Generation Thinker (2021).

Victoria Avery is Co-Curator of *Black Atlantic: Power, People, Resistance*. She has been Keeper of European Sculpture & Decorative Arts at the Fitzwilliam since 2010 prior to which she was Associate Professor in the Department of Art History at the University of Warwick. Vicky has lectured and published widely on all aspects of the decorative arts and sculpture, most recently *Michelangelo: Sculptor in Bronze* (2018); and is leading a new digital research project, 'Representations of Black People in European Sculpture, 1450–1950'. Vicky has curated numerous interdisciplinary exhibitions, including *Treasured Possessions* (2015); *Madonnas & Miracles* (2017); and *Feast & Fast* (2019–20), from which she is co-editing a multi-author volume, *The Pineapple from Domestication to Commodification: Representing a Global Fruit*, for the Proceedings of the British Academy (2024).

Wanja Kimani is Exhibition Project Curator of *Black Atlantic: Power, People, Resistance*, having previously been Research Associate on the 'Art and Work in East Africa: New Engagements in Art Curating' project at Newcastle University. Co-founder of Guzo Art Projects, Wanja has worked on international exhibitions with numerous artists based in East Africa. Her curatorial practice is informed by her artistic practice, which encompasses performance, film, text and textiles. In 2021, she was commissioned by the Women's Art Collection to respond to their exhibition, *Maud Sulter: The Centre of the Frame*. In 2022, she represented Kenya at the 59th Venice Biennale. Her research interests lie in the intersection of art, evolutionary ecology and the politics of gender and sexuality. She has published articles on contemporary art in East Africa and is currently a PhD candidate in Fine Art at Chelsea College of Arts, UAL.

Contributors and artists

Jack Ashby is the Assistant Director of the University Museum of Zoology, Cambridge. His work centres on engaging people with the natural world, chiefly through museums, and exploring the colonial biases that museums often exhibit. His books, *Platypus Matters: The Extraordinary Story of Australian Mammals* and *Animal Kingdom: A Natural History in 100 Objects* combine these scientific and social stories. Jack is a trustee of the Natural Sciences Collections Association, an Honorary Research Fellow in UCL Science and Technology Studies, and formerly sat on the Council of the Society for the History of Natural History. From 2022 to 2023 he was an Art Fund Headley Fellow.

Isaac Ayamba is a Cambridge-based educationist, community organiser and chair of the Cambridge African Network, one of

the two community groups that worked with Cambridgeshire County Council on the Equiano Bridge renaming project. He has collaborated with the University of Cambridge Museums consortium on a number of projects and is currently on its Community Panel. Isaac is also an active participant in the UCM *Connections Through Collections* project.

Jacqueline Bishop is an award-winning writer, academic and visual artist, born and raised in Jamaica, who now lives between Miami and New York City. She has had exhibitions in Belgium, Morocco, Italy, Cape Verde, Niger, the USA and Jamaica. In addition to her role as clinical full professor at New York University, Jacqueline was a Dora Maar/Brown Foundation Fellow in France (2020); a UNESCO/Fulbright Fellow in Paris (2009–10); and a Fulbright Fellow in Morocco (2008–9). Jacqueline has received several awards from the Jamaica Cultural Development Commission, as well as others including the OCM Bocas Prize for Non-Fiction for her book, *The Gymnast and Other Positions: Stories, Essays, Interviews*; The Canute A. Brodhurst Prize for short story writing; the Arthur Schomburg Award for Excellence in the Humanities from New York University; and a James Michener Creative Writing Fellowship. Jacqueline's recent ceramic work consists of brightly coloured bone china plates, such as are often used symbolically in Caribbean homes, and explores how their designs hid the violent legacy of slavery and colonialism in the Atlantic world.

Justin M. Brown is an art historian and current PhD candidate at Yale University. His research focuses on Caribbean and South American art, with a particular emphasis on the artistic traditions of African-descendant communities in these regions. He has published and presented work on topics related to the visual and material culture of enslavement in the Atlantic world. He has held curatorial and research positions at the Worcester Art Museum, the Yale Center for British Art, the RISD Museum, and the W.E.B. Du Bois Research Institute.

Peggy Brunache is a lecturer in the history of Atlantic slavery at the University of Glasgow and Director of the Beniba Centre for Slavery Studies. After training and obtaining her doctorate, she has worked as a historical archaeologist of the African diaspora, leading on archaeological projects in West Africa, the Caribbean and the United States. She developed a free, four-week online course on British Slavery in the Caribbean with Futurelearn.com, which is still live. Other public-facing projects include working with theatres, science and culture festivals. Peggy's media appearances include the Discovery Science Channel, BBC TV and ITV, and she is a regular contributor to BBC Radio programmes.

Sokari Douglas Camp studied Fine Art at the Central School of Art and Design and Sculpture at the Royal College of Art, under Phillip King. Sokari has represented Britain and Nigeria in national and international exhibitions, and has presented over 40 solo shows in venues such as the Smithsonian National Museum of African Art Institute, Washington DC, and the Museum of Mankind, London. In 2003, Sokari was shortlisted for the Trafalgar Square Fourth Plinth. Her public artworks include *All the World is Now Richer*, comprising six greater-than-life-size figures commemorating the abolition of slavery, exhibited in the House of Commons and St Paul's Cathedral, London; and *Battle Bus: Living Memorial for Ken Saro-Wiwa*, which memorialises the nine Ogoni activists arrested and executed in Nigeria for opposing the destruction of their Niger Delta homeland by European oil companies. In 2005, she was awarded a CBE. Sokari is an Honorary Fellow of UAL and SOAS.

Esther Chadwick is Lecturer in Art History at the Courtauld Institute of Art, where she specialises in eighteenth-century British art. She studied Art History at the University of Cambridge and Yale University. Before joining the Courtauld, she was a curator in the Department of Prints and Drawings at the British Museum. Esther's research addresses the political agency of art in the age of revolutions, the materiality of printed images, the visual culture of the circum-Atlantic world, and cultural connections between Britain and Haiti in the years after the Haitian Revolution. Exhibition projects have included *Figures of Empire: Slavery and Portraiture in Eighteenth-Century Atlantic Britain* (Yale Center for British Art, 2014) and *A Revolutionary Legacy: Haiti and Toussaint Louverture* (British Museum, 2018).

Isabelle Charmantier has a PhD in history of science from the University of Sheffield, and undertook post-doctoral studies on Carl Linnaeus and his writing technologies. She is also an archivist and has worked as Collections Manager for the Freshwater Biological Association in Windermere. She is currently Head of Collections at the Linnean Society of London, which has a rich library and archives, including the collections of Carl Linnaeus and numerous archives related to natural history in the late eighteenth and nineteenth centuries.

Alissandra Cummins is Director of the Barbados Museum and Historical Society. As an art historian, administrator and curator, she has contributed significantly to national, regional and international scholarship on Caribbean art, museology and heritage. A Fellow of the Museums Association UK, she has conceptualised and co-curated a series of exhibitions and publications documenting historical, modern and contemporary Caribbean artistic and museological practice. She is currently Chairperson of the Barbados National Art Gallery, and President of the International Coalition of Sites of Conscience. She was founding President of the Museums Association of the Caribbean and a former President of the International Council of Museums.

Benjamina Efua Dadzie is a researcher interested in Akan and Yoruba culture, with focus on themes of power dynamics, representation and self-determination. With a background in Archaeology and Anthropology, Benjamina is currently a PhD student at the Sainsbury Research Unit, University of East Anglia, researching a collection that emerges from a Protestant missionary presence in nineteenth-century Abeokuta, in south-western Nigeria. Benjamina was formerly the Collections Assistant in Anthropology at the Museum of Archaeology and Anthropology, University of Cambridge, where she supported the documentation of the Anthropology collection, particularly of Nigerian provenance. Before her time in Cambridge, she was a Graduate Attaché at the British Institute in Eastern Africa, a volunteer Documentation Assistant at Birmingham Museum and Art Gallery, and researched the collections of the Manchester Museum and the Royal Albert Memorial Museum and Art Gallery for her undergraduate and postgraduate theses.

Sandra De Rycker is Editions Manager and Doctoral Researcher at Dundee Contemporary Arts (DCA) Print Studio and recipient of an AHRC Collaborative Doctoral Award from SGSAH, in partnership with the University of Edinburgh and University of St Andrews. Her current research uses ethnographic and socio-semiotic perspectives to consider the collaborative printmaking studio in relation to systems of value within cultural production, highlighting the agency and significance of collaborative processes during print development. Sandra has worked with Alberta Whittle, Annis Fitzhugh (Emeritus Head of Artists Projects, DCA Print Studio) and the DCA Print

Studio team on numerous collaborative print projects from the artist's solo exhibition *How Flexible Can We Make the Mouth* at DCA in 2019, onwards.

Lauren Gardiner became Curator of the Cambridge University Herbarium in 2017, after a decade at the Royal Botanic Gardens, Kew. With a PhD in orchid phylogenetics, and an MSc in plant diversity, Lauren's botanical research has encompassed species conservation, systematics and new species description, e-taxonomy, ethnobotany, various molecular techniques, and fieldwork around the world, including in Madagascar and Indonesia. Lauren has written two popular botanical books and contributed to many others. She is active in many botanical organisations, including the RHS Orchid Committee, the Botanical Research Fund's board of governors, and several IUCN Species Survival Commission Specialist Groups.

Grada Kilomba is a Berlin-based Portuguese artist, whose works draws on memory, trauma, gender and post-colonialism, interrogating concepts of knowledge, power and violence. 'What stories are told? How are they told? And told by whom?' are constant questions in Kilomba's body of work. Performance, staged reading, video, sculptural installation and sound pieces all become conduits for Kilomba's unique practice of decolonial storytelling. Kilomba holds a Doctorate in Philosophy from the Freie Universität Berlin and has been awarded with an Honoris Causa Doctorate by ISPA, Lisbon. She has lectured at several international universities, and her works have been presented in a number of solo and group exhibitions globally.

Julie Chun Kim has a PhD in literature from Duke University and is currently Associate Professor of English at Fordham University in New York City. She has published essays on Afro-Caribbean medicine, early Caribbean food, eighteenth-century natural history, Indigenous botanical knowledge and resistance, and revolution in the early Atlantic world. She is currently working on a book about John Tyley's art and life.

Jimena Lobo Guerrero Arenas is the Senior Curator responsible for World Archaeology at the Museum of Archaeology and Anthropology, University of Cambridge. Her research interests focus on the historical archaeology of the Americas and on the history and archaeology of colonialism with particular attention to Colombia and Ecuador. She is especially interested in material culture studies, cultural heritage and museums.

Donald Locke was born in the former British colony of Guyana, South America, in 1930. After studying at Bath Academy of Art, Edinburgh University and Edinburgh College of Art, he returned to Guyana to teach for several years, before moving to London in 1971, and Arizona in 1979 on a Guggenheim Fellowship. He moved permanently to Atlanta in 1990, where he lived and worked for the remainder of his life. While in London, Locke's work was included in the *São Paulo Biennial* (1971), the *Biennial of Art*, Medellin, Colombia (1972), the V&A *International Exhibition of Ceramics* (1972), *FESTAC 77*, Nigeria (1977) and a solo exhibition at the Commonwealth Institute, London (1975). Among many international exhibitions, Locke's work has featured in *The Other Story: Afro-Asian Artists in Post War Britain* (Hayward Gallery, London, 1989–90); *Back to Black* (Whitechapel Gallery, London, 2005); *Artist and Empire* (Tate Britain, London, 2015–16) and *Life Between Islands* (Tate Britain, London 2021).

Chiedza Mhondoro works as Assistant Curator, British Art, at Tate Britain. She specialises in the art of the eighteenth century and its wider social, cultural, political, economic and international contexts. Before joining Tate, Chiedza completed

an MA at the Courtauld Institute of Art where her dissertation examined how the genre of landscape painting was co-opted to convey Britain's knowledge, transference and governance of overseas territories.

Mary-Ann Middelkoop is a post-doctoral Researcher for the AHRC/DFG-funded project 'Restitution of Knowledge: Artefacts as Archives in the (post)-colonial Museum, 1850–1939' at the Pitt Rivers Museum in Oxford, and a Junior Research Fellow in History of Art at St Peter's College, Oxford. Prior to joining the University of Oxford, Mary-Ann was a Teaching Associate in Modern Art at the University of Cambridge. She is currently an Affiliated Lecturer in Cambridge. She has previously worked as a Researcher for the Commission of Looted Art in Europe in London. Mary-Ann is co-editor of the volume *Thinking Provenance, Thinking Restitution*, which is forthcoming with De Gruyter in 2024.

Mathelinda Nabugodi is Research Associate in the Literary and Artistic Archive at the Fitzwilliam Museum, Cambridge, and a Lecturer in Comparative Literature at University College London. Her research explores the connections between British Romanticism and the Black Atlantic while at the same time investigating the period's legacy in our own time. She is working on a critical memoir, *The Trembling Hand: Reflections of a Black Woman in the Romantic Archive*, which is due to be published by Hamish Hamilton (UK) and Alfred A. Knopf (US). Work-in-progress samples from the book have won the Deborah Rogers Foundation Writers Award (2021) and a Whiting Foundation Creative Non-Fiction Grant (2022).

Joshua Nall is Director of the Whipple Museum of the History of Science at the University of Cambridge. He teaches and writes about physical sciences in the eighteenth and nineteenth centuries. His first book, *News from Mars: Mass Media and the Forging of a New Astronomy, 1860–1910* (2019) won the History of Science Society's 2020 Philip J. Pauly Prize. He co-edited both *The Whipple Museum of the History of Science: Objects and Investigations, to Celebrate the 75th Anniversary of R.S. Whipple's Gift to the University of Cambridge* (2019) and the primary source volume *Victorian Material Culture: Science and Medicine* (2022).

Alexis Peskine trained in Graphic Design before studying Painting and Photography in the US and obtaining a Master's in Digital Arts. Awarded a Fulbright Scholarship, he completed his second Master's in 2005. Alexis's paternal grandfather left Russia as a Jewish refugee, fought for the French Resistance and barely survived deportation to Dachau. Alexis's father married a Brazilian woman of African descent, ensuring the complex multi-cultural lineage his work explores, investigating identity, the Black experience and the plight of migrants and refugees in times of crisis. His sharply observed nail portraits have an emergent and disconcerting presence that confronts each spectator directly, portraying strength, determination and self-possession. Alexis launched an NGO in 2011, helping deprived inner-city youth develop as professional artists, and allowing selected individuals to participate in multicultural exchange residencies in Salvador de Bahia, Brazil; Bobigny, France; Dakar, Senegal; Essaouira, Morocco; and Kingston, Jamaica.

William Pettigrew is Professor of History at Lancaster University. A leading authority on England's overseas trading corporations, he has written extensively about the history of the transatlantic trade in enslaved African people, the East India Company, and the global contexts in which British history was made. A prize-winning author, Professor Pettigrew currently

leads a national consortium of scholars (with University College London and the University of Manchester) examining the entire population of British investors in the transatlantic trade in enslaved African people. This data will be launched online in late 2024 as the Register of British Slave Traders.

Keith Piper is a British-based artist and academic. His creative practice responds to specific social issues, historical relationships and geographical sites. An examination of the legacies of empire and imperialism has resurfaced as a re-occurring theme within his practice alongside an interest in the ways in which narrative, both recalled and imagined, can be articulated through artwork. Adopting research driven approaches, and using a variety of media, his work ranges from painting, through photography and installation to a use of digital media, video and computer-based interactivity. He currently works in the Fine Art Department at Middlesex University, London.

Habda Rashid is Senior Curator of Modern and Contemporary Art at Kettle's Yard and the Fitzwilliam Museum, with a remit to acquire works that broaden artists represented in the collections as well as shape and deliver temporary exhibitions, collections-based displays and research. In 2022 she curated *Paint like the Swallow Sings Calypso*, which brought together for the first time works from the Fitzwilliam and Kettle's Yard's collections, placed in dialogue with painting and drawings by three contemporary Caribbean artists. She has contributed texts for the forthcoming Phaidon publication *Vitamin C+ Collage in Contemporary Art* and has written on artists including Lynette Yiadom-Boakye, Elmgreen & Dragset and Michael Rakowitz. She currently sits on the Association of Art History's Curatorial Committee.

Edwin Rose is currently Principal Investigator on the AHRC-funded research project 'Natural History in the Age of Revolutions, 1776–1848' based in the Department of History and Philosophy of Science at the University of Cambridge and Advanced Research Fellow at Darwin College, Cambridge. Edwin completed a PhD in 2020 that explored practices of natural history in the late eighteenth-century British Empire that has been revised for a book under contract with the University of Pittsburgh Press. Edwin has been a postdoctoral researcher at Darwin College and Munby Fellow at Cambridge University Library (2020–1) exploring the colonial legacies of the Cambridge botanical collections.

Eleanor Stephenson is an AHRC-funded PhD student at the University of Cambridge, researching the Royal Society's connections to enslavement in Jamaica from 1660 to 1714. By focusing on the overlapping philosophical and material interest of early Fellows, including King Charles II, Eleanor's research aims to strengthen understanding of how early modern knowledge improved the English slave trade and slavery in Jamaica. Eleanor completed her BA and MA at the Courtauld Institute of Art, studying the architectural history of the British Empire. Her dissertation on country houses in Wales and the East India Company, 1760–1820, has recently been published by the University of Wales Press.

Barbara Walker was born in Birmingham in 1964, where she still lives and works. She studied at the University of Central England, Birmingham, and completed post-graduate studies at Wolverhampton University. Her experiences of growing up in Birmingham have directly shaped her practice, which is concerned with issues of class and power, gender, race, representation and belonging. Barbara's figurative drawings and paintings speak of contemporary circumstances hinged on historical events to reflect and highlight the human per-

spective on contemporary local and global issues. In 2023, Barbara was elected to the Royal Academy of Arts and short-listed for the Turner Prize. She was the 2020 Bridget Riley Fellow at the British School at Rome, having been awarded an MBE in 2019 for services to British Art. She has exhibited widely, including at the 57th Venice Biennale in the Diaspora Pavilion (2017); Dakar Biennale, Senegal (2018); Jerwood Gallery, Hastings (2018); Turner Contemporary, Margate (2019); Bristol Museum and Art Gallery, Bristol (2020); Lahore Biennale, Pakistan (2020); Tate Britain, London (2021); Cristea Roberts Gallery (2022); and Sharjah Biennial, United Arab Emirates (2023).

Henrietta Ward is the Curator of Northern European Paintings and Drawings at the Fitzwilliam Museum. She has curated several exhibitions including *Crawling with Life: Flower Drawings from the Henry Rogers Broughton Bequest* and *Making Waves: Discovering Seascapes through Drawings and Watercolours*. She is currently researching the Fitzwilliam's significant collection of flower paintings and botanical drawings with a particular focus on women painters and patrons. Before joining the Fitzwilliam in 2015, Henrietta was Curatorial Fellow at Dulwich Picture Gallery, London, and Curatorial Trainee supported by the Art Fund at the National Gallery, London. She received her History of Art BA (Hons) from the University of Nottingham and her History of Art MA from the University of Bristol.

Alberta Whittle is a Glasgow-based Barbadian whose multifaceted practice is preoccupied with developing a personal response to the legacies of the Atlantic slave trade, unpicking its connections to institutional racism, white supremacy and climate emergency in the present. Against an oppressive political background, Alberta aims to foreground hope and engage with different forms of resistance. Alberta received her MFA from the Glasgow School of Art in 2011 and is currently a PhD candidate at the University of Edinburgh. She has received many awards, most recently, the Margaret Tait Award (2018/19), a Turner Bursary and the Frieze Artist Award (2020) and a Paul Hamlyn Award for Artists (2022). Alberta has exhibited and performed in many group and solo exhibitions. In 2022, she represented Scotland in the 59th Venice Biennale with a new body of work titled, *deep dive (pause) uncoiling memory*. Notable exhibitions and projects for 2023 include: a solo presentation at the Holburne Museum, Bath; inclusion in the 14th Gwangju Biennale; a major exhibition of her career to date at the Scottish National Gallery of Modern Art (Modern One), Edinburgh; and a solo presentation at the Institute of Contemporary Art, Los Angeles.

Acknowledgements

A great many individuals and institutions have generously helped with the realisation of this book and the associated exhibition, *Black Atlantic: Power, People, Resistance* (Fitzwilliam Museum, Cambridge, 8 September 2023– 7 January 2024), outreach work and public programme. The length of our acknowledgements is testament to all the collaboration, conversations and consultation that we, together with so many colleagues within the consortium of University of Cambridge Museums (UCM), have undertaken in planning and researching *Black Atlantic*. The exhibition is the first major public-facing milestone in the UCM's *Legacies of Enslavement and Empire* project, in which our collections are interrogated through a decolonial lens, and which we envisage will lead to transformative and lasting change with institutional commitments to reparative and restorative justice.

We are grateful for various grants associated with under-taking and disseminating the research underpinning *Black Atlantic* and related programmes across the UCM. We grate-fully acknowledge support from Arts Council England, the British Art Network's Emerging Curators Group, the Cambridge Humanities Research Grants Scheme (CHRG), the University of Cambridge's Centre for Research in the Arts, Social Sciences and Humanities (CRASSH), the Esmée Fairbairn Foundation, the Isaac Newton Trust, the Fitzwilliam Museum's Marlay Group, the Paul Mellon Centre for Studies in British Art and Research England. The London School of Economics and Political Science provided logistical support. We would like to thank everyone who has helped us prepare funding applications, especially, Claire Alfrey (Senior Associate Director, Fitzwilliam Museum and University of Cambridge Development and Alumni Relations), Jo McPhee (formerly, Head of Partnerships, University of Cambridge Museums), Miranda Stearn (formerly, Head of Learning) and Jo Vine (Head of Research & Impact).

We are indebted to all lenders to *Black Atlantic* and to everyone who assisted in the often complex and lengthy loan negotiations, above all to the Museum's Registrar, Elena Saggers, for her expert and patient oversight of the whole process. We are truly indebted to colleagues across the UCM for their incredible collaborative help over the past three years, and would particularly like to thank the following directors, curators and collections managers: Jack Ashby, Charlotte Connelly, Mark Elliott, Lauren Gardiner, Imogen Gunn, Rachel Hand, Anita Herle, Liz Hide, Jimena Lobo Guerrero Arenas, Josh Nall, Eliza Spindel, Amy Tobin, Susanne Turner and Nick Thomas. Thanks, too, to Roger Lilley and other colleagues at the Museum of Cambridge, and to Richard Barnwell and other colleagues at Wisbech & Fenland Museum, above all Sarah Coleman (formerly, Articles for Change Project Officer) in connection with her research, interpretation and community engagement work on Thomas Clarkson's Campaign Chest.

The following gallerist-lenders, collectors and artist estates afforded particularly sustained help: Helen Waters at Cristea Roberts; Jo Stella-Sawicka and Kemi Sanbe at Goodman Gallery; Chili Hawes, Gerard Houghton and Oliver Place at October Gallery; Ellie Royle at The Modern Institute; and for help with Donald Locke's *Plantation Series* loans: Brenda Locke, Donald's widow and executor of the Donald Locke Estate, Skoto Aghahowa at Skoto Gallery, New York, and collectors Lorenzo Legarda Leviste and Fahad Mayet. We would also like to thank Hannah Firth at Chapter, Cardiff, Susanne Fredricks at Suzie Wong Presents, Kingston, Jamaica and Anna Lucchinetti, Maria Varnava and colleagues at Tiwani Contemporary, London, for loan-related assistance. Habda Rashid (Senior Curator of Modern and Contemporary Art) has provided brilliant help with the

contemporary loans and in trail-blazing new acquisitions. Similarly, the artistic networks and creative-practitioner insights provided by Wanja Kimani (*Black Atlantic* Exhibition Project Curator) have been instrumental. The support and encouragement of all contributing artists has been overwhelming, and we are particularly grateful to Jacqueline Bishop and Keith Piper for sustained collegiality and collaboration.

We have received a great deal of expert advice and assistance on loan requests and associated collections-based legacies research from academics, archivists, librarians and researchers across Cambridge University, Cambridge Library and Cambridgeshire Archives. We would particularly like to single out: Sonita Alleyne, Jane Acred, Robert Athol, Nicolas Bell, Amira Benninson, Trish Biers, Christopher Burgess, Sabine Cadeau, Melissa Calaresu, Jacqueline Cox, Adam Crothers, Anna Crutchley, Lizzy Ennion-Smith, Simon Fairclough, Susanah Farmer, Maggie Faultless, Colin Higgins, Mary Hockaday, Laura Housden, Dawnanna Kreeger, Jenni Lecky-Thompson, Patricia McGuire, Kathryn McKee, Sarah Meer, Martin Millett, Tamsin O'Connell, Mark Purcell, Edwin Rose, Liam Sims, Jonathan Soyars, Simon Stoddart, Eleanor Stephenson, Catherine Sutherland and Helen Weller.

We would also like to thank external colleagues (artists, academics, curators, conservators, dealers, directors and researchers) who have assisted us over the past three years with legacies-related research and loan enquiries, especially Matthew Abel, Elizabeth Asafo-Adjei, Charles Avery, Susanna Avery-Quash, Joanna Barnes, Anna Bates Patel, David Bindman, Robert Bowman, Carol Brown-Leonardi, Holly Carter-Chappell, Julia Carver, Isabelle Charmantier, Nicole Cherry, Adrienne L. Childs, Meg Clarke, Caroline de Guitaut, Lara de Merode, Gill Dent, Robin Diaper, Nicholas Draper, Janet Dugdale, Christopher Etheridge, Redman Finer, Miranda Goodby, Katy Green, Eleanor Harding, Kate Hebert, Bill Hern, Julie Hochstrasser, Corinne Hofman, Jennifer Hopkins, Jane Hughes, Emma Jones, Tim Knox, Katerina Laina, Jo Langston, Sarah Lea, Jean Claude Legagneur, Adam Levine, Brenda Locke, Robinson McClellan, Karen McLean, Penny McMahon, Catherine MacLeod, Holly Maples, Hannah Mawdsley, Ben Miller, Reggie Mobley, Keith Moore, Mark Nesbitt, Kate Newnham, Temi Odumosu, Stella Panayotova, Julien Parsons, Marsha Pearce, Tony Phillips, Jenny Powell, David Prior, Clare Pye, Laura Pye, Rochelle Rowe, Lola Sanchez-Jauregui, Gill Saunders, Nicholas Smith, Elizabeth Statzicker, Daniel Supplice, Sarah Thomas, Arthur Torrington, Tony Trowles, Holly Trusted, Sarah Victoria Turner, Lucy Wood and Zandra Yeaman. We would like to thank colleagues at National Museums Liverpool, above all the International Slavery Museum, for their time and insightful tours and discussions, especially: Sahar Beyad, Rachael Forde, Adiva Lawrence, Ian Murphy, Liz Stewart and Madelyn Walsh. For Church of England support around promoting Equiano in the Parishes of Chesterton and Soham and Cambridgeshire more generally as well as broader issues around racism and modern slavery, thanks to Ely Diocese clergy and educationalists, especially Katy Bonney, Mark Bonney, the late Jenny Gage, Philip Lockley, Jessica Martin, Alastair Redfern, Alianore Smith and Eleanor Whalley.

We would like to extend sincere thanks to everyone who kindly agreed to write 'reflection pieces' for this book, and who have so generously shared their expert knowledge with us to ensure multi-vocality and the inclusion of diverse and interdisciplinary perspectives: Jack Ashby, Isaac Ayamba, Jacqueline Bishop, Justin M. Brown, Peggy Brunache, Sokari Douglas Camp, Esther Chadwick, Isabelle Charmantier, Alissandra Cummins, Benjamina Efua Dadzie, Sandra De Rycker, Lauren Gardiner, Grada Kilomba, Julie Chun Kim, Jimena Lobo Guerrero Arenas, Brenda Locke, Chiedza Mhondoro, Mary-Ann Middelkoop, Mathelinda Nabugodi, Joshua Nall, Alexis Peskine, William Pettigrew, Keith Piper, Habda Rashid, Edwin Rose, Eleanor Stephenson and Henrietta Ward. In addition, we received many helpful insights and critical feedback from the following colleagues when they reviewed drafts of the book and/or exhibition label texts: Eseosa Akojie, Maria Holtrop, Mathelinda Nabugodi, Carey Robinson, Neal Spencer and Luke Syson.

We are equally grateful to former and current members of the UCM Legacies of Empire and Enslavement Advisory Group for undertaking a 'critical friends' function, bringing diverse expertise and perspectives and providing critique, expert comment and feedback on the exhibition and broader programmes: Sujit Sivasundaram (Chair) and Malavika Anderson, Jasmine Brady, Melissa Calaresu, Esther Chadwick, Howard Chae, Tara Choudhury, Georgina Doji, Nicholas Guyatt, Joanna Jasiewicz, Miranda Lowe, Sharon Mehari, Mónica Moreno-Figueroa, Kamal Munir, Jesse Panda, Sara Shamma and Sharon Walker, as well as UCM colleagues, Ruchika Gurung, Jo McPhee, Danika Parikh, Shereese Peters-Valton and Hannah Price. We would also like to thank the Change Makers Action Group for its input and 'critical friends' function over the past few years, and for important conversations about diversity and representation within the UCM and our audiences: namely, Malavika Anderson (former UCM Cultural Programmer) and Jasmine Brady (current Chair) together with Kefeshe Bernard, Melissa Calaresu, Esther Chadwick, Ruchika Gurung, Nick Guyatt, Liz Hide, Clare Johnson, Miranda Lowe, Ali Meghji, Kamal Munir, Esra Özyürek, Jesse Panda, Danika Parikh, Shereese Peters-Valton and Sara Shamma. Similarly, workshops and discussions with student activists from both Decolonise Art History and Architecture and Decolonise Archaeology campaigns have provided vital insights and perspectives.

Danika Parikh (UCM Legacies Research & Engagement Fellow) has been an inspirational support and critical friend throughout the preparation of *Black Atlantic*. We learnt a great deal from the *RePresent Project*, which she led on with Korantema Anyimadu and Tara Okeke, to bring historically excluded communities into museums, especially their work with the Cambridge African Network and the Museum of Archaeology and Anthropology (MAA) to bring the voices of people of African descent into MAA's galleries. With support from Jake Subryan Richards and Sabine Cadeau, Danika also led on convening the CRASSH-funded *Slavery and Freedom: Material and Visual Histories* interdisciplinary research network, whose wide-ranging workshops connected researchers working on transnational histories of enslavement, resistance, abolition, and the afterlives of transatlantic slavery, in order to share methodologies and resources, and to develop multi-disciplinary frameworks of interpreting and understanding objects. Many of the contributors to this volume are the direct result! Others resulted from her monthly online Legacies project research workshops. Danika also hosted a number of research lectures on decolonial work in museums, which were helpful forums for learning and advancing practice; and she managed an internship programme for four Collaborative Doctoral Award students — Rebekah Hodgkinson, Rhea Tuli Partridge, Meg Roberts and Alice Whitehead — to undertake valuable research into colonial collections across the UCM as part of their Open-Oxford-Cambridge Doctoral Training Programme. Together with Sarah-Jane Harknett, Danika also led on early University student consultations for the exhibition: we are grateful for the feedback from these sessions and to all the students who took part. Sarah-Jane has led on all UCM legacies project evaluation

work, including staff evaluation and surveys, which have been vital for steering the work since the project began and will provide critical data for future learning.

We have received equally vital input and robust critique from the UCM Community Panel, coordinated by Jennifer Bull (UCM Engagement Coordinator) and Niki Hughes (UCM Opening Doors Project Coordinator), and with discussions facilitated by Ruchika Gurung (UCM Communities Coordinator). This consisted of 12 local residents, each affiliated with one of the following community organisations: Cambridge Community Arts, Romsey Mill, QTI Coalition of Colour, UCM Volunteer community, Cambridge GET Group, Indian Cultural Society, Cambridge Council for Voluntary Service, Cambridge Ethnic Community Forum, and the Mill Road History Society. Thanks to support from the Esmée Fairbairn Foundation and the Collections-Connections-Communities Strategic Research Initiative, Ruchika has been able to build community partnerships with the Cambridge African Network, Cambridge African Film Festival, Afro Caribbean Society (ARU Chelmsford), Black Cantabs (UoC), FLY (UoC) and African Society (UoC) to confront the legacies of empire and enslavement within the UCM collections. Feedback from these sessions has been crucial in how to make informed choices around the display of objects with difficult histories — and which therefore have not previously been valued, displayed or appropriately interpreted — and how we approach sharing our findings with our wider audiences. We are grateful also to Niki Hughes for providing ACE and Legacies project funds to support two *Celebrating Black History in Cambridge* Interns: Jade Pollard-Crowe and Selena Scott. They created visual resources for the public to highlight stories about Black people in Cambridge that have been lost, hidden or buried over time, which will surface more prominently in the Museum's second exhibition in spring 2025. Thank you, too, to Sarah Victoria Turner, Deputy Director of the Paul Mellon Centre, and Lucy Andia at Shelbourne Films for inviting us to be part of the British Art Studies 2022 film, *The Market Woman's Story: Contemporary Ceramics by Jacqueline Bishop.*

Many other former and current UCM colleagues have provided support and advice with various aspects of the UCM-wide legacies programme, including Jennifer Bull, Ruth Clarke, Sarah-Jane Harknett, Marie Kennedy, Ella Lange, Susan Miller, Shereese Peters-Valton, Hannah Price, Jacqui Strawbridge and Rich White. Their fantastic work on ongoing initiatives such as *Power & Memory* will continue to inspire and help us confront Cambridge's colonial legacies and drive positive change. We are grateful, too, for the stimulus and support provided by David Farrell-Banks (Participatory Research and Impact Co-ordinator) as well as Ruth Clarke, Kate Noble, Habda Rashid and Jo Vine in the development of participatory methodologies and practice across the Museum, including the *Making Connections through Collections* pilot workshops that explored the Museum's acquisition procedures and how broader consultation in the decision-making process might lead to a more culturally relevant and diverse collection and public programme.

Almost every member of staff at the Fitzwilliam Museum has been involved to some extent with the preparation of this book and/or the exhibition and the associated public programmes, and we are truly fortunate to have such consummate professionals as colleagues and collaborators. We would like to extend heartfelt thanks to Luke Syson (Museum Director & Marlay Curator) and his team of Senior Leaders, especially Neal Spencer (Deputy Director, Collections & Research), Karen Livingstone (Deputy Director, Masterplan, Exhibitions & Major Display Projects), Jennifer Grindley

(Head of Communications & External Relations) and Carey Robinson (Head of Learning & Participation) who have provided sustained support and encouragement over the course of the project. We are grateful to them for establishing the Museum's *Empowering Culture* programme to ensure that Equality Diversity and Inclusion remains a shared and embedded organisational commitment as we continue our work together to become an equitable and anti-racist museum that better reflects contemporary Britain. And similarly, for rolling out the new Collections Development Strategy & Policy, which is actively encouraging the acquisition of objects that support the research and teaching of global histories of art and material culture, including contemporary pieces.

It is our great pleasure to thank most sincerely other key Fitz teams: Curatorial (especially, Martin Allen, Rich Kelleher, Elenor Ling, Jane Munro, Julia Poole, Adi Popescu, Habda Rashid, Suzanne Reynolds, Helen Ritchie and Henrietta Ward); Conservation (especially, Edward Cheese, Richard Farleigh, Kirstie French, Harry Metcalf, Susi Pancaldo, Sophie Rowe and Katerina Theodoraki; and, at the Hamilton Kerr Institute: Simon Bobak, Erma Hermens, Justyna Kedziora, Camille Polkownik, Vicky Sutcliffe as well as research scientists Nathan Daly and Flavia Fiorillo); Collections Management and Documentation (especially, Richard Carpenter, Amy Foulds, Amy Marquis, Tim Matthews and Raf Wojas); Comms & Marketing (above all, Emma Shaw and Jo Johnson); Finance led by Jacqueline Hay; HR led by Ruth Queen; Learning (with especial thanks to Rosanna Evans, Holly Morrison, Florencia Nannetti, Kate Noble and Nicola Wallis); Security and Facilities Management led respectively by Phil Wheeler and Simon Halliday; and Visitor Experience led by Grant O'Brien and our wonderful Front of House Team. We are most grateful to Diana Caulfield for expertly building up a superb legacies section in the Museum's library, which is already proving an invaluable research and teaching resource. Our grateful thanks to our colleagues at Fitzwilliam Museum Enterprises, above all Len Dunne, Sara Haslem and Ruth McPhee, for sourcing and commissioning a considered and inspired selection of exhibition merchandise and products, and in doing so promoting the work of local Black makers and businesses.

The Museum Photography Team deserves a special shout out: Mike Jones (Photography Manger) with Elaine Holder, Amy Jugg, Andrew Norman and Katie Young have, as ever, provided world-class images of the Fitzwilliam's objects as well as many of the UCM loans. A phenomenal amount of image ordering and collating, and permissions clearance, has been undertaken by Emma Darbyshire (Image Library Manager) with support from Will Wilson, and Jen Kavanagh, our freelance Picture Researcher. A huge and heartfelt thanks to you and similarly to other external colleagues involved in the production of this book and supporting the exhibition, namely, Susannah Lawson (Editorial Consultant) and Clare Martelli and Caroline Guillet (respectively, Senior Commissioning Editor and Assistant Editor at Philip Wilson Publishers/Bloomsbury Publishing) who so brilliantly steered the manuscript through to publication; and Ian Parfitt of E&P Design for the design and layout. Our thanks also to Sam Talbot, Kitty Malton and Alicia Lethbridge for their brilliant work on the exhibition's media campaign and to the team at POCC; Nana Bempah, Kevin Morosky, Jordie Wildin, Tom Dunn, Pranav Arya, Lee Levy and John DeGraft for bringing the exhibition to life for audiences so thoughtfully and vividly through the marketing and digital campaign.

Our final professional thanks go to our peerless *Black Atlantic* Exhibition Team for sustained support, unwavering belief in the

project and encouragement: internally, originally Erica Emond, David Evans and Clare Simpson, and more recently Alex Fairhead (Head of Exhibitions), Sophia Patel (*Black Atlantic* Exhibitions Project Manager), Wanja Kimani (*Black Atlantic* Exhibitions Project Curator), Jo Dillon (*Black Atlantic* Lead Conservator) and Nyl Fall (*Black Atlantic* Lead Technician) with Ellie Saggers (Registrar); and externally, Leah Kharibian, our superb Interpretation Consultant. We really cannot thank you enough for your dedication and consummate professionalism and for having worked tirelessly, and seamlessly, to bring *Black Atlantic* to fruition. Thank you, too, to Stuart Sang for your initial space audit work and for pushing us to be more radical and to dial up the 'unexpected' in terms of layout and display methods; and to Vicky Paterson for proofing all the label texts. And last, but by no means least, enormous thanks to our fabulous exhibition designers: Shaun Ihejetoh and Khalifa Abubakar and their team at West Port Architects for the 3D elements, and Carolyne Hill and her team at ChillCreate for the 2D aspects. Your thought, care and attention to detail as well as your creative flair and problem-solving capacities are second to none and have resulted in a brilliant design that masterfully and appropriately reconfigures the Founder's Galleries to create a stunning new immersive experience for our visitors.

We end by thanking our families, friends and mentors for their steadfast support throughout. For Vicky, this means: Monica Cameron and Jessica Heeb as well as wonderful family members Charles and Mary Avery, Charlotte Avery-Pillet and Pierre Pillet, Susanna Avery-Quash and James Carleton Paget, Bobbie Avery-Jones and, above all, my beloved wife Emma Jones. For Jake, this means: Naomi Carlisle, Andrea Richards, Ian Richards, Martin Myrone, Sadiah Qureshi, Richard Huzzey, Ellen McAdam, Ludmilla Jordanova, Melissa Calaresu and Nicholas Guyatt.

Index